BORIS LEIST

LARP

DISCARD

KEHRER

Live Action Role Playing (LARP) oder Live-Rollenspiel bezeichnet ein Rollenspiel, bei dem die Spieler ihre Spielfigur auch physisch selbst darstellen. Es handelt sich also um eine Mischung aus dem Pen-&-Paper-Rollenspiel und dem Improvisationstheater. Das Spiel findet in der Regel ohne Zuschauer statt. Die Teilnehmenden können im Rahmen einer Rolle, die die eigene Figur und ihre Eigenschaften und Möglichkeiten beschreibt, frei improvisieren. Die Spielfigur wird Charakter genannt. Soweit möglich, finden Live-Rollenspiele an Spielorten statt, deren Ambiente dem Szenario der Spielhandlung entspricht. Die Spieler tragen eine den Charakteren entsprechende Gewandung.

Die Szenarien der Live-Rollenspiele fallen in verschiedene Genres wie etwa Fantasy, Vampire, Western, Science-Fiction, Horror, Endzeit / Postapokalypse, Cyberpunk. Es ist jedoch jegliches Genre oder Szenario denkbar. Der Fantasie sind hier keine Grenzen gesetzt.

Live Action Role Playing (LARP) is a role-playing game, in which players physically portray their characters. It is a mixture of a tabletop role-playing game and improvisational theater. The game is generally played without an audience. The players can improvise freely within the frameworks of a role, which describes the figure and his or her characteristic features and capabilities. The game figure is called a character. When possible, live role-playing games take place at venues with an ambiance that corresponds to the scenario of the game's action. The players wear costumes appropriate to their characters.

The scenarios of live role-playing games fall under various genres, such as fantasy, vampire, Western, science fiction, horror, apocalypse / post-apocalypse, and cyberpunk. But any genre or scenario is conceivable. No limits are set on imagination.

More than ·· ·· just a game

Early in my career, I realized the power of role-playing. Players of my early games would tell me about some deeper meaning they found in my games that I had never, at least consciously, put there. Quickly I realized that at the very least I had an opportunity, maybe even a responsibility, to insure that the content I put into my role-playing scenarios would have a positive influence on the people who experienced it. Combine this with the innate human desire to be whisked away to lands fantastical and new, escaping the trials of this life in exchange for a new set of rules, new adventures, new possibilities, and you have the best conditions for fantastic live action role-playing.

Think about it this way: even young children use role-playing not only to live out fantasy futures, but also to explore and test the limits of themselves and interpersonal connections – through tea parties with a variety of individual characters, for example, or with army men fighting battles against Orks in colorful race cars. These simulations explore the variety and limits of good interpersonal behavior. Larping brings adults into a shared fantasy experience where the fantastical can become real, some of the failings and bigotries of the past or present can be removed, and a more utopian play environment can be built. In presenting a variety of characters and worlds this book gives a thoughtful and candid view into the fantastic lands and stories of the LARP community.

Some years back, a young recently married couple showed me their wedding rings with "Truth, Love & Courage" inscribed inside the band. My games, where they met, celebrate these virtues. While they felt obligated to point out that they knew the games' philosophy was a fantasy, they noted that they met through the multilevel experience of gaming on- and offline, appreciated the deep meanings these fantastic places promoted, and celebrated this in the totality of their new lives together.

These shared fantasies are far from being a waste of time. The bonds and relationships built in shared fantasies are as real as any others. In the case of my online worlds, players who get to know each other deeply online, very often seek each other out in the real world (often at LARP events) to continue and deepen those bonds. Everyone understands and clearly separates reality from fantasy, but knows that the shared fantasy adventures are just as real and just as bonding as a traditional backpacking or field trip. The most imaginative larpers often find their happiness and meaning deepened in a life that combines the immediate reality of daily life and the explorations of the fantastic realms.

RICHARD GARRIOTT DE CAYEUX A.K.A. LORD BRITISH

Mehr als
nur ein Spiel

Schon früh in meiner Karriere habe ich die Macht von Rollenspielen erkannt. Spieler meiner ersten Spiele berichteten mir von einer tieferen Bedeutung, die sie darin entdeckt hätten, ohne dass ich diese bewusst dort eingebaut hätte. Rasch begriff ich, dass ich hier die Möglichkeit, und damit verbunden auch die Verantwortung hatte, dafür zu sorgen, dass der Inhalt der von mir konzipierten Rollenspiel-Szenarien einen positiven Einfluss auf die Menschen haben würde, die sich damit beschäftigten. In Verbindung mit der dem Menschen innewohnenden Sehnsucht, sich in fantastische und neue Länder forttragen zu lassen, die Widrigkeiten unseres Lebens zu vergessen und diese gegen neue Regeln, neue Abenteuer, neue Möglichkeiten einzutauschen, ergibt das perfekte Bedingungen für fantastische Live-Rollenspiele.

Betrachten wir es doch einmal so: Selbst kleine Kinder setzen Rollenspiele nicht nur ein, um ihre Zukunftsfantasien auszuleben, sondern auch, um ihre eigenen Grenzen und die Grenzen zwischenmenschlicher Beziehungen zu erkunden und auszuloten – zum Beispiel bei Kaffeekränzchen mit einer Vielzahl anderer, sehr unterschiedlicher Freunde oder mit Miniatur-Plastiksoldaten, die in bunten Rennautos Schlachten gegen die Orks bestreiten. Diese Simulationen sind dazu geeignet, die Vielfalt und die Grenzen erfolgreichen zwischenmenschlichen Handelns zu erkunden. „Larping", also das Live-Rollenspielen, versetzt Erwachsene in eine gemeinsame Fantasie-Erfahrung, in der das Fantastische zur Realität werden kann. Misserfolg sowie Übereifer in Vergangenheit und Gegenwart können im Spiel ausgebügelt werden und eine eher utopische Spielwelt wird geschaffen. Indem es eine Vielzahl an Spiel-Charakteren vorstellt, gewährt dieses Buch einen offenen und unvoreingenommenen Blick in die fantastischen Länder und Geschichten der LARP-Community.

Vor einigen Jahren zeigte mir ein junges, frisch verheiratetes Paar seine Eheringe mit der eingravierten Inschrift „Truth, Love & Courage". Meine Spiele, über die sie sich kennengelernt hatten, zelebrieren diese Werte, nämlich Wahrheit, Liebe und Mut. Obwohl ihnen sehr bewusst war, dass die Philosophie hinter den Spielen reine Fantasie ist, hätten sie einander durch die vielschichtigen Erfahrungen beim Spielen online und offline erst richtig kennengelernt. Sie begrüßten die tiefere Bedeutung hinter den fantastischen Orten und feierten diese in der Gesamtheit ihres neuen gemeinsamen Lebens.

Solche gemeinsam erlebten Fantasiewelten sind absolut keine Zeitverschwendung. Die Bindungen und die Beziehungen, die in solchen gemeinsam erlebten, „geteilten" Fantasien aufgebaut werden, sind genauso real wie alle anderen. Im Falle meiner Online-Welten ist es oft so, dass Spieler, die einander online sehr intensiv kennenlernen, einander dann auch in der realen Welt aufspüren (oft bei LARP-Events), um diese Verbindungen im richtigen Leben fortzusetzen und zu vertiefen. Alle verstehen und trennen die Realität ganz klar von der Fantasie, sie wissen aber auch, dass die gemeinsamen Fantasie-Abenteuer genauso real sind wie eine herkömmliche Rucksacktour oder ein Schulausflug. Die einfallsreichsten „Larper" finden Glück und tieferen Sinn oftmals in einem Leben, das die unmittelbare Realität des Alltags mit der Erforschung fantastischer Reiche verbindet.

RICHARD GARRIOTT DE CAYEUX ALIAS LORD BRITISH

Tortuga is an island in the Caribbean, west of the Midlands. More than three hundred years ago, the great pirate Captain Henry Flynn founded the "State of Buccaneers" here as a place of retreat and reward for all those who freely and courageously sail the seas. The authority over the pirates has since been the governors of Tortuga, administrators of Flynn's bequest and the dons of the island. Powerful and legendary citizens of the Solar Island State of Tortuga. Seafarers, captains, traders, and heroes – or so the story goes.

"You haven't lived until you have breathed in Tortuga's sweet smell of decay and refreshed yourself with the bounties of the island!"

Tortuga – This is voodoo with its grinning deities. This is the caves of the slaves. This is the jungle, thicker than the coastal fog.

Tortuga – This is the Gubernatorial White House, seat of the Solar Counsel, the harbor fortification, and the lighthouse at night. This is the Cutthroat's Den, the tavern in which captains raise their glasses with ordinary seamen and passionate maidens and make a loud toast to the welfare of the island.

Tortuga – This is the home of Tortuga Libré and the greatest seafarers' festivals.

Tortuga – This is the legend in the West. The island, on which free men and women have built their homesteads and defend them with blood, honor, and rum.

Tortuga – This is an all-encompassing adventure in the Caribbean.
This is a tremulous taproom full of pirates and seafarers and their stories.

Tortuga – This is a harlot, a passionate maiden, who can tell you with just one simple glance: "Stick around for an hour or so. What is worth dying for, you ask me? I'll tell you! For that which you live! Tortuga!"

TORTUGA Legende ☠

Tortuga ist eine Insel im karibischen Meer, westlich der Mittellande. Dort gründete vor nun mehr als 300 Jahren der große Piraten-Kapitän Henry Flynn den „State of Buccaneers" als Rückzugsort und Belohnung für alle, die frei und mutig das Meer befahren. Statthalter des Piratenherren sind seither die Gouverneure Tortugas, Verwalter von Flynns Erbe und die Dons der Insel. Mächtige und legendäre Bürger des tortugiesischen Solarinsulates. Seefahrer, Kapitäne, Händler und Helden – soweit die Geschichte.

„Du hast nicht gelebt, wenn du nicht den süßen Verwesungsduft Tortugas eingesogen hast und Dich labtest an den Gaben des Eilands!"

Tortuga – das ist das Voodoo mit seinen grinsenden Göttern. Das sind die Höhlen der Skaven. Das ist Dschungel, dichter als Küstennebel.

Tortuga – das ist das White House des Gouverneurs, der Sitz des Solarkonsuls, die Hafenbefestigung und der Leuchtturm in der Nacht. Das ist das Cutthroat's Den, die Taverne, in der Kapitäne mit Leichtmatrosen und leidenschaftliche Maiden ihre Becher heben und lautstark auf das Wohl der Insel anstoßen.

Tortuga – das ist die Heimat des Tortuga Libré und der größten Feste der Seemannenschaft.

Tortuga – das ist die Legende im Westen. Die Insel, auf der freie Männer und Frauen ihre Heimstatt errichteten und sie mit Blut, Ehre und Rum verteidigen.

Tortuga – das ist das allumfassende Abenteuer in der Karibik. Das ist ein bebender Schankraum voller Piraten und Seefahrer und ihren Geschichten.

Tortuga – das ist eine Dirne, eine leidenschaftliche Maid, die dir mit nur einem Blick zu sagen vermag: „Verweile noch ein Stündchen. Wofür lohnt es sich zu sterben, fragst Du mich? Ich sag' es Dir! Genau für eben jenes, wofür Du auch gelebt hast! Tortuga!"

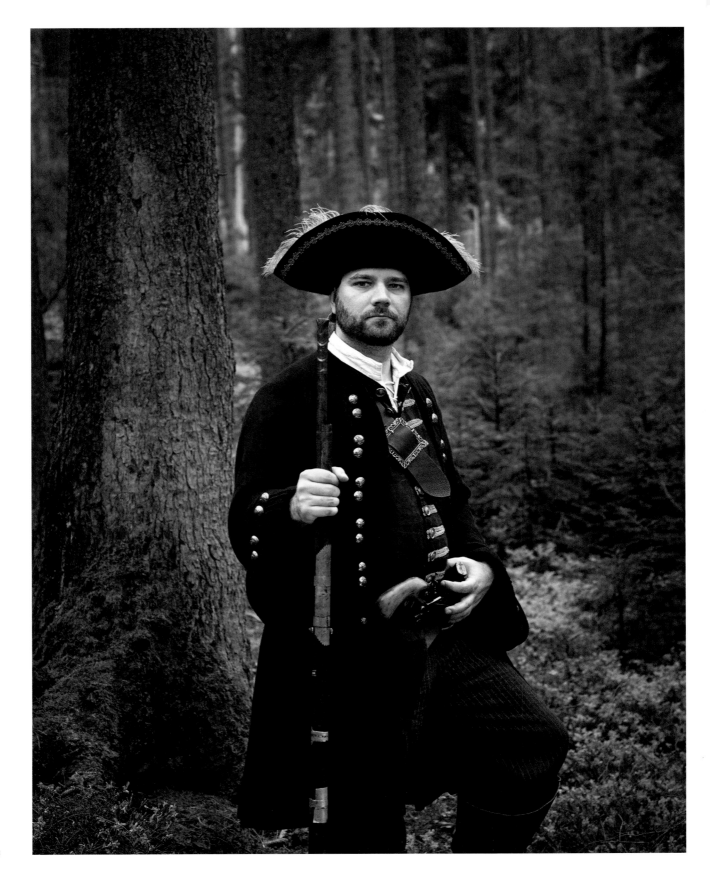

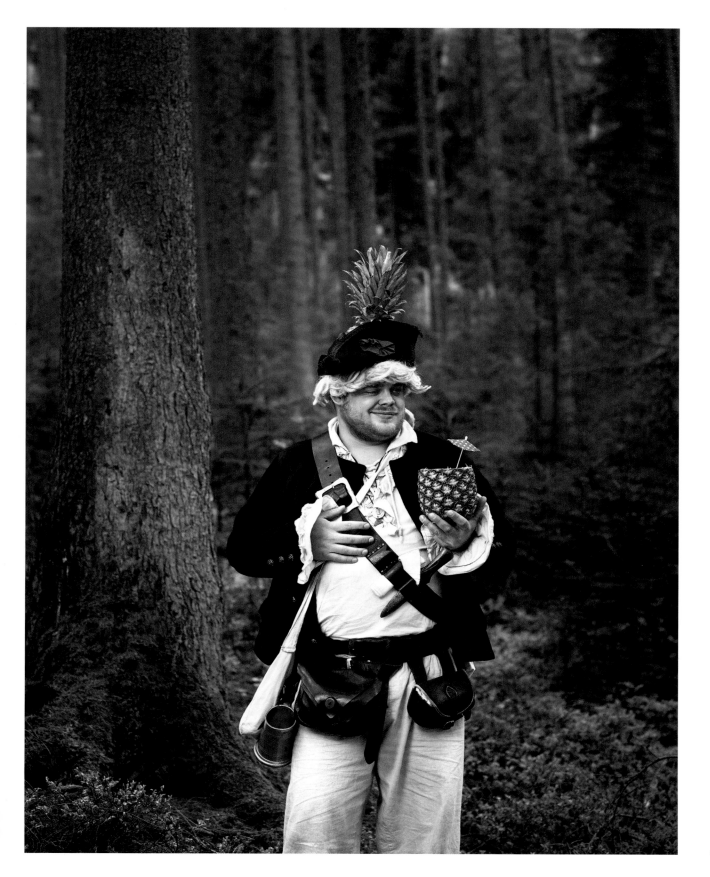

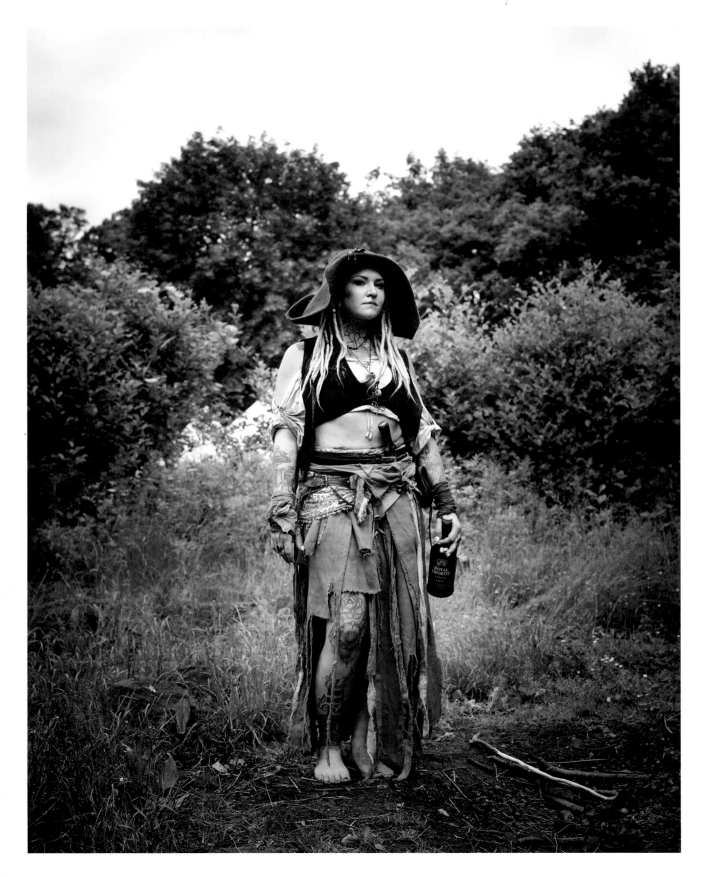

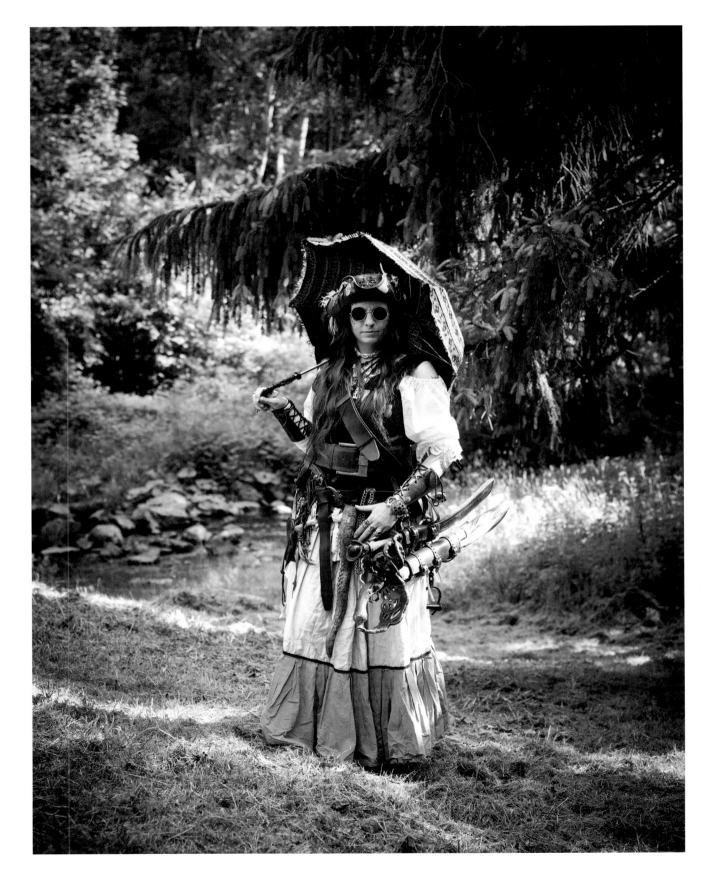

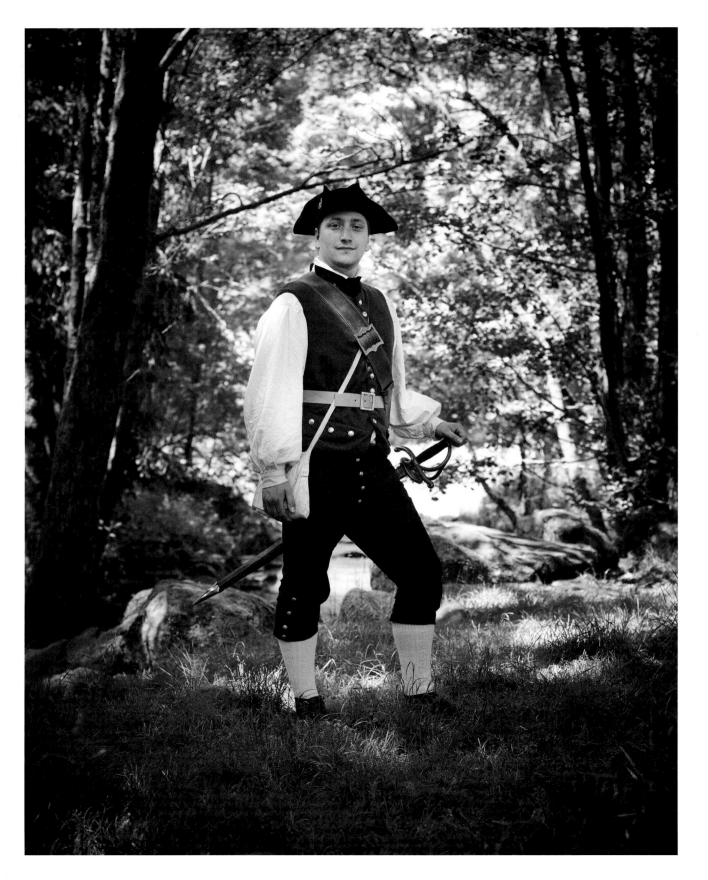

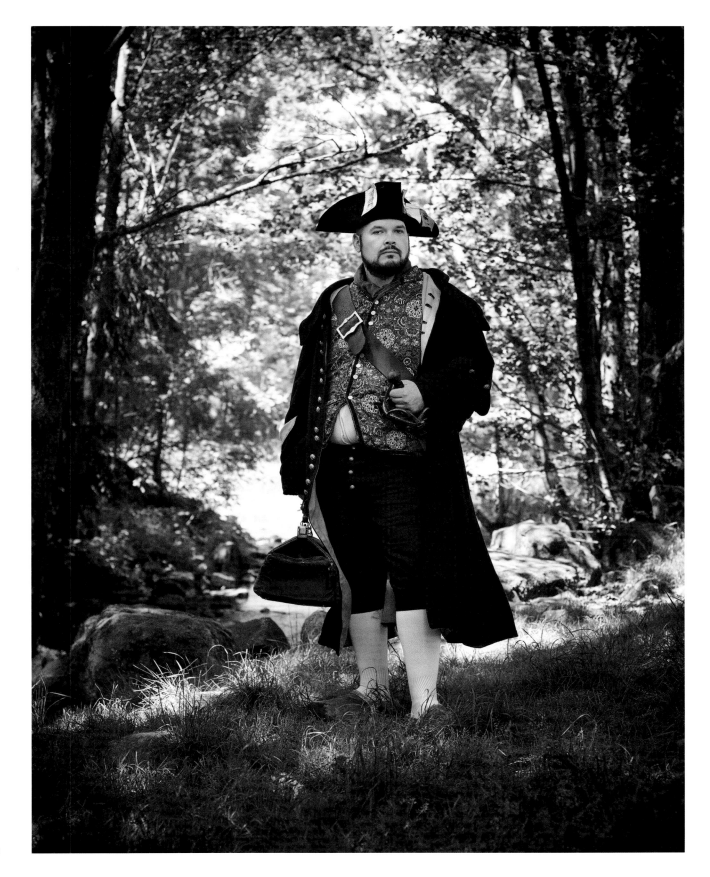

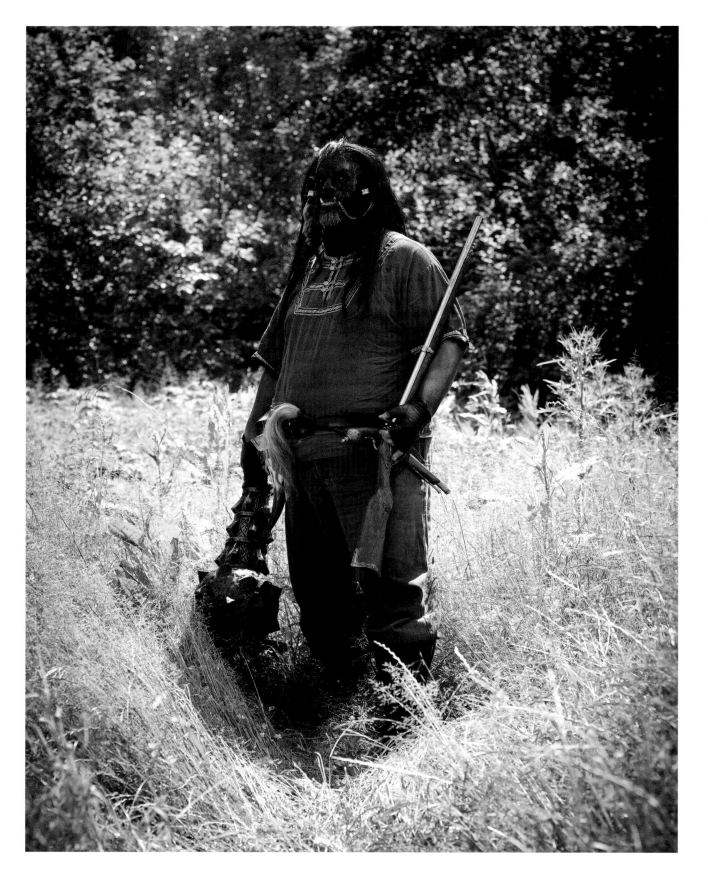

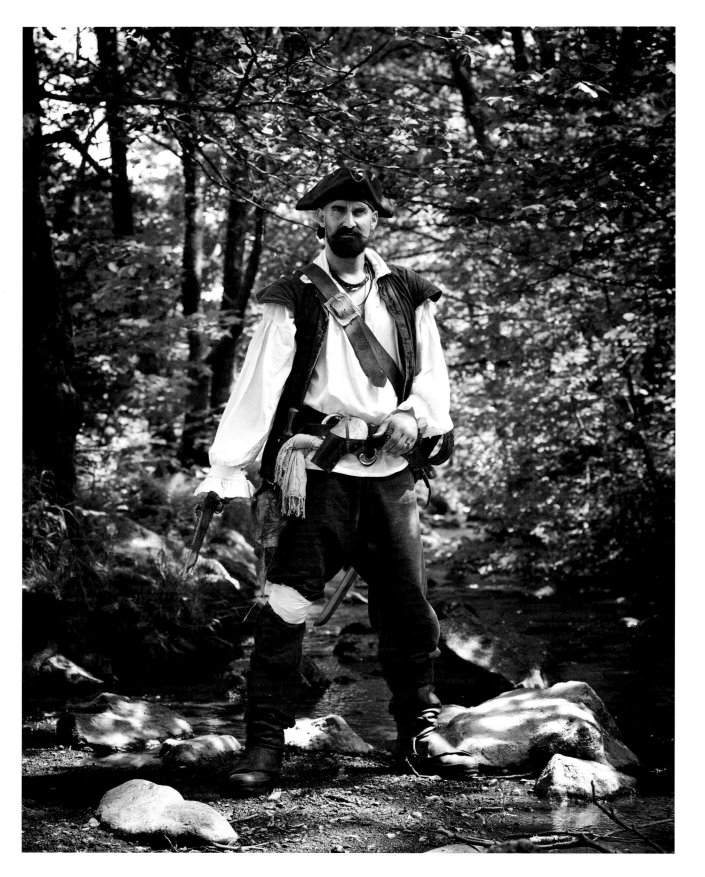

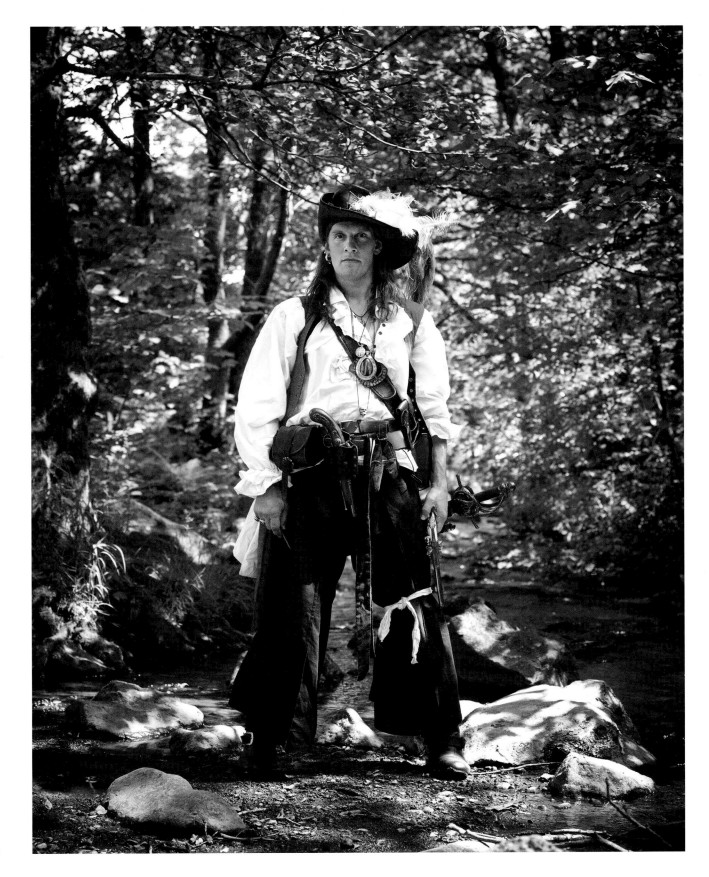

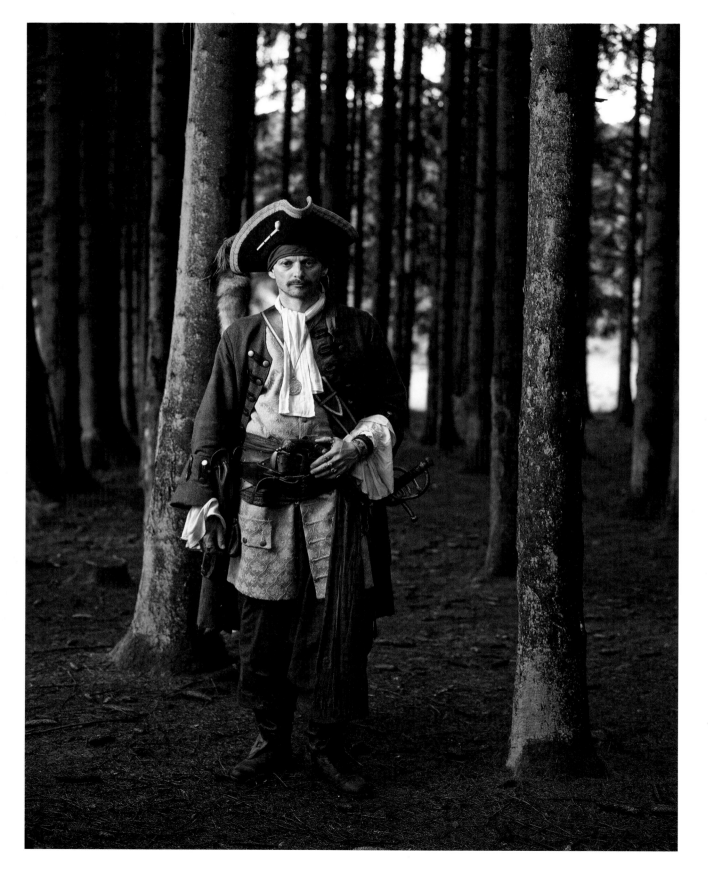

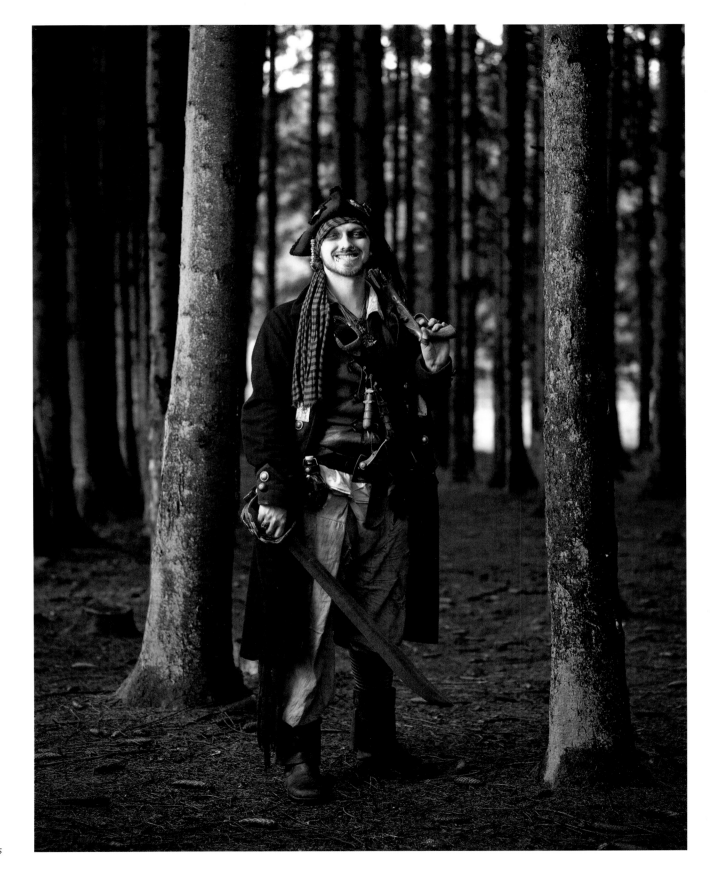

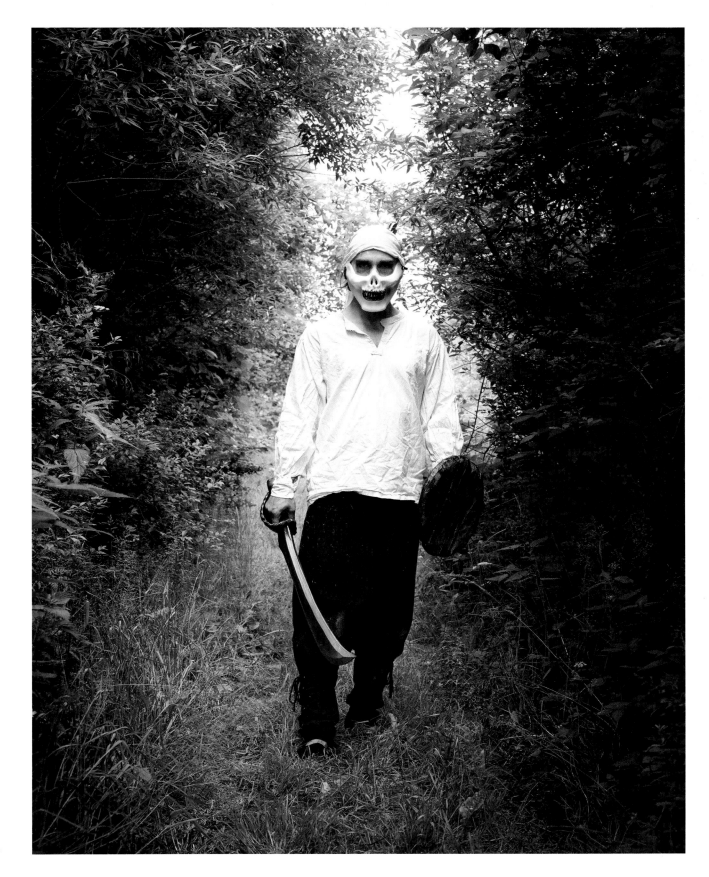

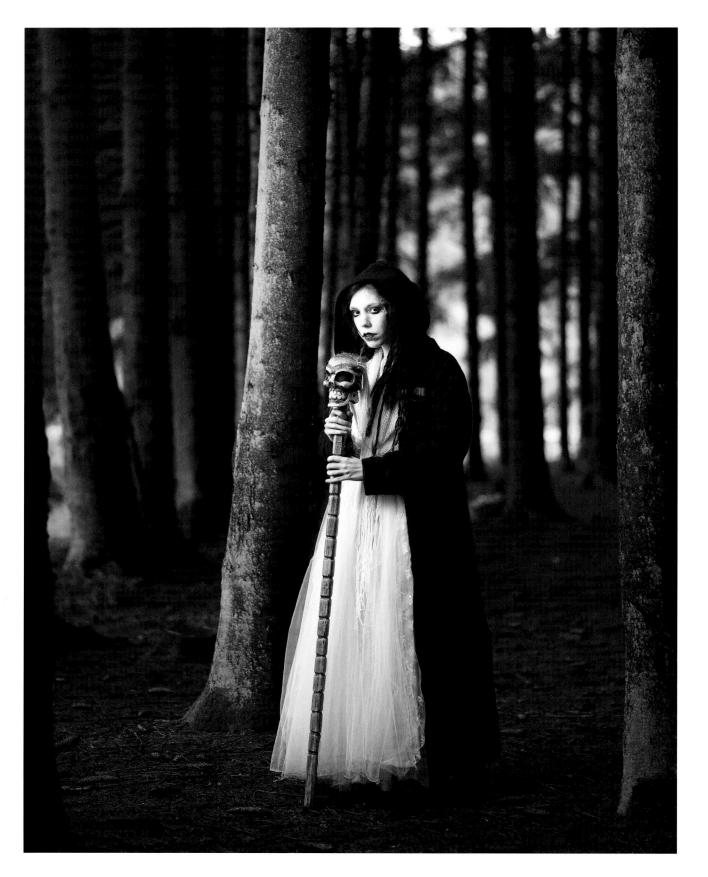

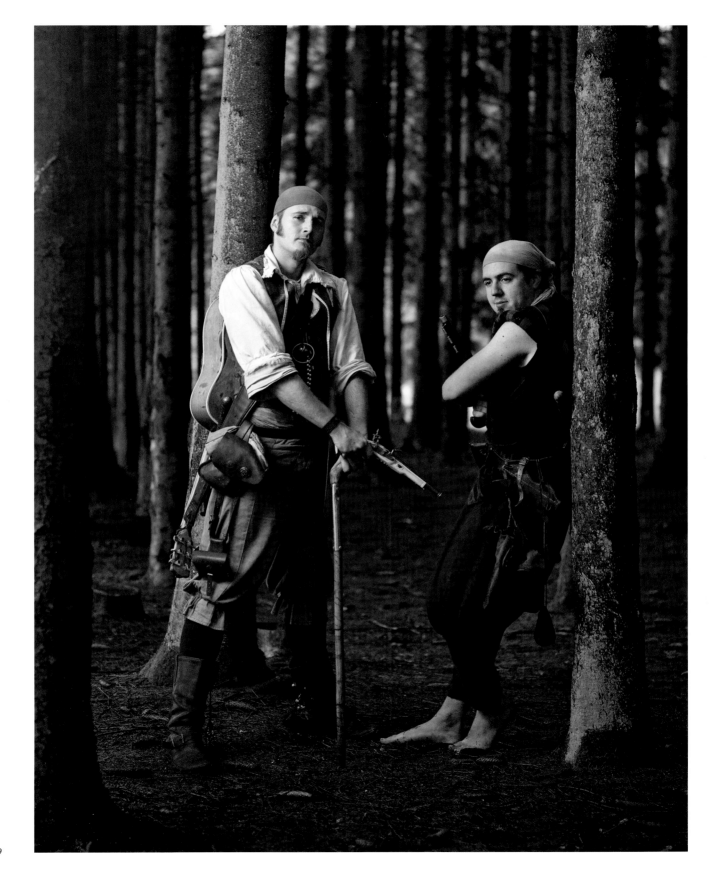

13
S./p.

Captain Nathaniel Witherspoon – Pirat und Kapitän der „Vanguard", ehemals Offizier bei der englischen Navy. Er liebt die Freiheit und die See, seine Prinzipien sind ihm heilig und seine stärkste Waffe ist sein Charme.

Captain Nathaniel Witherspoon – Pirate and captain of the Vanguard, formerly an officer with the English navy. He loves his freedom and the sea; his principles are sacred to him, and his strongest weapon is his charm.

14
S./p.

Hmmmm Bo – Erster und einziger varischer Todestrinker, Ritter der betrunkenen Ananas und Gouverneur von Tortuga, aufgewachsen in einer kleinen Hafenstadt, wo er zum Arzt ausgebildet wurde, später Schiffsarzt auf der El Cassador.

Hmmmm Bo – The first and only Varic Death Drinker, Knight of the Drunken Pineapple, and Governor of Tortuga; raised in a small harbor city, where he was trained as a physician; later, ship's doctor on the El Cassador.

16
S./p.

Betty „das S steht für Schönheit" – Schiffsmädchen der Crew von Captain Rhócken alias „The Haunted" oder „Crew of Seven Nations". Captain Rhócken ist der Vater aller Crewmitglieder. Er wurde einst verflucht und verstarb. Nur sein Kopf reist in einer Kiste immer noch mit.

Betty "the S stands for Beauty" – Ship's wench of Captain Rhócken's crew alias "The Haunted" or "The Crew of Seven Nations." Captain Rhócken is the father of all members of the crew. He was once cursed and then died. Only his head still travels with the crew, kept safe in a crate.

17
S./p.

Altuna Sturmnebel – Kapitänin von „Neptuns Stern" und Solarkonsulin von Tortuga, auch bekannt als die „härteste Tür Tortugas" (in ihrer Funktion als Türsteherin zur Ladies Night im Cutthroat's Den und Durstigen Dolch).

Altuna Sturmnebel – Female captain of the Neptune's Star and Solar Consul of Tortuga, also known as the "toughest door in Tortuga" (in her function as doorwoman on Ladies' Night in the Cutthroat's Den and the Thirsty Dagger).

18
S./p.

Ben Bembler – Als Tourist auf „Tortuga" eingereist. Ist der Besitzer der kleinen Ostringer Schankstube „The Hanging Men" und bekannt für seinen gut gemixten „Stone Fence" (einem „Ostringer Mauer" genannten Drink aus englischem Cider und Rum), er ist ein Freigeist und Mitglied der Newporter Miliz.

Ben Bembler – Entered Tortuga as a tourist. The owner of the small Ostringen taproom "The Hanging Men" and known for his well-mixed "Stone Fence" (a drink made of English cider and rum). He is a free spirit and member of the Newport militia.

19
S./p.

Dr. Benjamin E. Whedon – Schiffsarzt auf der Vanguard, zu jener Zeit auf spezieller Mission: Er sollte die Handelsbeziehungen (in Vertretung des Kapitäns) zu der Rumverwalterin von Ostringen verbessern, eine der einflussreichsten Persönlichkeiten dieser Tage.

Dr. Benjamin E. Whedon – Ship's doctor on the Vanguard, on a special mission at the time: on behalf of the captain, he was to improve trade relations with the rum administrator of Ostringen, one of the most influential people of the day.

20
S./p.

Gnak Prack – Großkahn und Diplomat gehört zum ausgerotteten Schwarzork-Stamm, welcher im Süden von Anórien an der Grenze zum Schattenland lebte. Er ist der 8. Sohn des 13. Wurfes des Oberhäuptlings Gnak Flack Kahn.

Gnak Prack – Khagan and diplomat; member of the exterminated Schwarzork (Black Ork) tribe that lived in the south of Anórien, on the border to the Land of the Shadows. He is the eighth son of the thirteenth litter of the chieftain Gnak Flack Kahn.

22
S./p.

Arrício – Chartman in der Crew von Captain Rhócken alias „The Haunted" oder „Crew of Seven Nations". So wie der Captain einst, so sind alle seine Kinder verflucht und gehorchen dem Geist des Captains, denn dieser spricht immer noch zu ihnen.

Arrício – Cartographer and member of Captain Rhócken's crew. Like the captain himself, all his children are also cursed and obey the spirit of the captain, who continues to speak to them.

23
S./p.

Logan St. Treverton alias „Pretty" – Maat der Crew von Captain Rhócken.

Logan St. Treverton alias "Pretty" – Mate in Captain Rhócken's crew.

24
S./p.

Elric „Der Fuchs" – Ein echtes Schlitzohr, verbringt seine Abende gern im „Durstigen Dolch" bei Spiel und Trank.

Elric "The Fox" – A genuine artful dodger who enjoys spending his evenings at the "Thirsty Dagger" drinking and gambling.

25
S./p.

Jaddar O'Chatta – Unehelicher Sohn eines Hamburger Seemanns und einer irischen Hafenhure aus Shannon, Westirland. Seine Seele wurde durch den Voodoo-Loa Baron Samedi versklavt. Seine Schwester ist Borawagh, die Inkarnation des guten Voodoo.

Jaddar O'Chatta – Illegitimate son of a seafarer from Hamburg and an Irish harbor strumpet from Shannon, western Ireland. His soul was enslaved by the voodoo loa Baron Samedi. His sister is Borawagh, the incarnation of good voodoo.

27
S./p.

Willem – Ein ruheloser Geist und Hüter des Weges zu Ragabash's Sumpf, zu Lebzeiten war er eher ein nichtsnutziger Tagedieb.

Willem – A restless spirit and guardian of the path to Ragabash's Swamp; during his lifetime more a good-for-nothing dawdler.

28
S./p.

Borawagh – Einer der Avatare von Tortuga, Schwester von Jadda O'Chatta und die Inkarnation des guten Voodoo.

Borawagh – One of the avatars of Tortuga, sister of Jadda O'Chatta, and the incarnation of good voodoo.

29
S./p.

Vladimier Tszibnizka und Mr. Pit (von links nach rechts) – Vladimier ist Musiker und Wirt, er stammt aus Engonien; Mr. Pit ist umherfahrender Spielmann und Meister im Entern von Schiffen.

Vladimier Tszibnizka and Mr. Pit (from left to right) – Vladimier is a musician and innkeeper from Engonia. Mr. Pit is a wandering minstrel and a master when it comes to capturing ships.

July 14, 1873, 5:30 in the morning, and the Texas sun rises once again over the small town of Fred Rai City.

Fred Rai City is actually a beautiful place to live; there's a saloon and a store. The charming ladies of the Scarlet Sisters regularly bring the hearts and loins of the townsmen to a boil, and the sheriff is guardian of law and order. If it wasn't for this damned Duke, who terrorizes the borderland between Texas and Mexico, and especially the small town of Fred Rai City, with his actions... why Fred Rai City of all places?

Mr. McKnight, proprietor of the eponymous trade mission, feels the effects of the Duke's ploys on a nearly daily basis. Transactions in the borderland were once a good source of revenue for the McKnight Trade Mission. Now, warehouses are burned down, convoys ambushed, and employees shot. No one knows who the Duke actually is. And no one knows where the ominous Duke's hatred of Fred Rai City stems from. Perhaps McKnight had his enterprising fingers in the Duke's pie, and he, in turn, is trying everything to prevent him from doing this any longer. But this doesn't explain the assaults on the town. Maybe the answer lies in the past.

In 1868, a young, wealthy businessman came to the run-down town of Fred Rai City and promised to use his money and influence to transform this nest into a flourishing city. His name was Jonathan Fargo.

Mr. Fargo got down to business with a great deal of assiduousness and enthusiasm – but a slight aftertaste remained. The residents were doubtful. Who is this man, where does he come from, why is he interested in Fred Rai City, and who is his influential and wealthy father, whom he repeatedly mentions?

In short, there was mistrust, and a great deal of it at that. And then, one day, Jonathan Fargo disappeared without a trace. It's rumored that two loads of shot might have encouraged his disappearance, but no one knows for sure. Not even the honorable Sheriff Baxter, despite all efforts, could shed light on the case. No corpse, no clues, no evidence.

THE GREAT SHOW

Fred Rai City

THE GREAT SHOW

Fred-Rai-City

14. Juli 1873, 5.30 Uhr in der Früh, und wieder geht die texanische Sonne über dem kleinen Städtchen Fred-Rai-City auf.

Fred-Rai-City ist eigentlich ein schöner Ort zum Leben, es gibt einen Saloon, ein Geschäft, die liebreizenden Ladies der Scarlet Sisters bringen regelmäßig die Herzen und Lenden zum Kochen und der Sheriff wacht über Recht und Ordnung. Wenn da nicht dieser verdammte Duke wäre, der mit seinen Handlangern das Grenzgebiet zwischen Texas und Mexiko und vor allem das kleine Städtchen Fred-Rai-City terrorisiert. Warum gerade Fred-Rai-City?

Mr. McKnight, Eigentümer der gleichnamigen Handelsvertretung, bekommt die Machenschaften des Dukes fast täglich zu spüren. Die Geschäfte im Grenzgebiet waren einst eine gute Einkommensquelle für die McKnight-Handelsvertretung. Jetzt brennen Lagerhäuser, Konvois werden überfallen und Mitarbeiter erschossen. Und niemand weiß, wer der Duke ist. Ebenfalls weiß niemand genau, wo dieser Hass des ominösen Dukes auf Fred-Rai-City herrührt. Vielleicht hatte McKnight seine geschäftstüchtigen Finger in das Hoheitsgebiet des Dukes gesteckt, und dieser wiederum versucht alles, um McKnight daran zu hindern. Aber die Übergriffe auf die Stadt erklärt das auch nicht. Vielleicht liegt die Lösung in der Vergangenheit.

Im Jahr 1868 kam ein junger, reicher Geschäftsmann in das heruntergekommene Fred-Rai-City und versprach, mit seinem Geld und seinem Einfluss aus diesem Nest eine blühende Stadt zu machen. Sein Name war Jonathan Fargo.

Mit viel Einsatz und Eifer machte sich Mr. Fargo ans Werk, jedoch blieb ein fader Beigeschmack. Die Bewohner zweifelten. Wer ist dieser Mann, woher kommt er, warum interessiert er sich für Fred-Rai-City und wer ist sein einflussreicher und wohlhabender Vater, den er immer wieder erwähnt?

Kurzum, das Misstrauen war da und es war groß. Und dann war Jonathan Fargo eines Tages spurlos verschwunden. Man munkelt, dass zwei Ladungen Schrot sein Verschwinden begünstigt haben, aber genau weiß es niemand. Nicht einmal der ehrenwerte Sheriff Baxter konnte, trotz aller Bemühungen, Licht in die Sache bringen. Keine Leiche, keine Hinweise, keine Spuren.

Two years later, the Duke's name was mentioned in public for the first time. Mexican border villages burned to the ground, and their residents died a gruesome death. Cruel, remorseless, and without mercy, he and his followers wrought havoc to the region.

Investigations came to nothing, since no one knew or wanted to say anything. And anyone who asked questions too publicly was often found hanging on a noose somewhere in the desert.

In Fred Rai City, fear grew day by day; it was nearly palpable, as though it could be cut with a knife. And the commitment on the part of Sheriff Pax and Marshal Baxter, as well as of the Texas Rangers, was nothing but a mere drop in the bucket.

In these dangerous times, the town's citizens committee decided to take a daring step. They hired the renowned director Mr. Starr to stage a story about the Duke. Well, a parody of sorts. They secretly hoped to provoke the Duke and lure him into imprudent acts.

The story began as planned. The script had been written, the actors found, and Mr. Starr, the director, who was also to play the Duke, had arrived in town. And the dress rehearsal proceeded almost without incident.
On the evening of the premier, Mr. Starr leaves the stage briefly to lend the entrance of the Duke more drama. He reenters arrogantly and gazes at his captives disdainfully. He throws a glass of water into the face of the unconscious McKnight to bring him back to reality. The play takes its course and the verbal exchange between the Duke and his victims becomes more heated. The Duke then pulls McKnight up and throws him onto the floor of the saloon, draws his Colt, and shoots him dead.

The shot echoes through the saloon and the smoke wafts through the room. Everyone holds their breath, and it suddenly becomes clear that it is no longer a stage play.

What happened? Was McKnight dead? Did the actual Duke reveal his presence? That evening, all questions would be answered...

Zwei Jahre später tauchte der Name des Dukes das erste Mal in der Öffentlichkeit auf. Mexikanische Grenzdörfer brannten, und deren Bewohner fanden einen grausamen Tod. Grausam, erbarmungslos und ohne Gnade brachten er und seine Gefolgschaft Unheil übers Land.

Nachforschungen verliefen im Sande, da niemand etwas wusste oder sagen wollte. Und wer zu offensichtlich nachfragte, der fand sich oft am Strick baumelnd in der Wüste wieder.

In Fred-Rai-City wuchs die Furcht Tag für Tag, sie war fast greifbar, als könne man sie in Stücke schneiden. Auch der Einsatz von Sheriff Pax und Marshall Baxter sowie der Männer der Texas Rangers war nur ein Tropfen auf den heißen Stein.
In diesen gefährlichen Zeiten entschloss sich das Bürgerkomitee der Stadt zu einem wagemutigen Schritt. Sie engagierten den renommierten Regisseur Mr. Starr, um eine Geschichte über den Duke aufzuführen. Nun gut, eher eine Parodie. Insgeheim hofften sie damit den Duke zu reizen und zu unüberlegten Handlungen zu verleiten.

Die Geschichte begann wie geplant. Das Drehbuch war geschrieben und die Darsteller gefunden, auch der Hauptdarsteller und Regisseur Mr.Starr traf in der Stadt ein. Auch die Generalprobe verlief fast ohne Zwischenfall. Am Abend der Premiere verlässt Mr. Starr kurz die Bühne, um dem Auftritt des Dukes, den er selbst darstellte, mehr Dramatik zu verleihen. Arrogant betritt er sie wieder und blickt seine Gefangenen abschätzig an. Dem bewusstlosen McKnight schüttet er ein Glas Wasser ins Gesicht, um ihn in die Realität zu holen. Das Theaterstück nimmt seinen Lauf und die Wortgefechte zwischen dem Duke und seinen Opfern werden hitziger. Der Duke zerrt dann McKnight hoch und wirft ihn in den Gang im Saloon, zieht seinen Colt und richtet ihn hin.

Der Schuss hallt im Saloon nach und der Rauch wabert durch den Raum. Alle halten den Atem an und plötzlich wird den ersten klar, dass das kein Theaterstück mehr ist.

Was ist passiert? Ist McKnight tot? War es der Duke? Noch an diesem Abend sollten alle Fragen beantwortet werden...

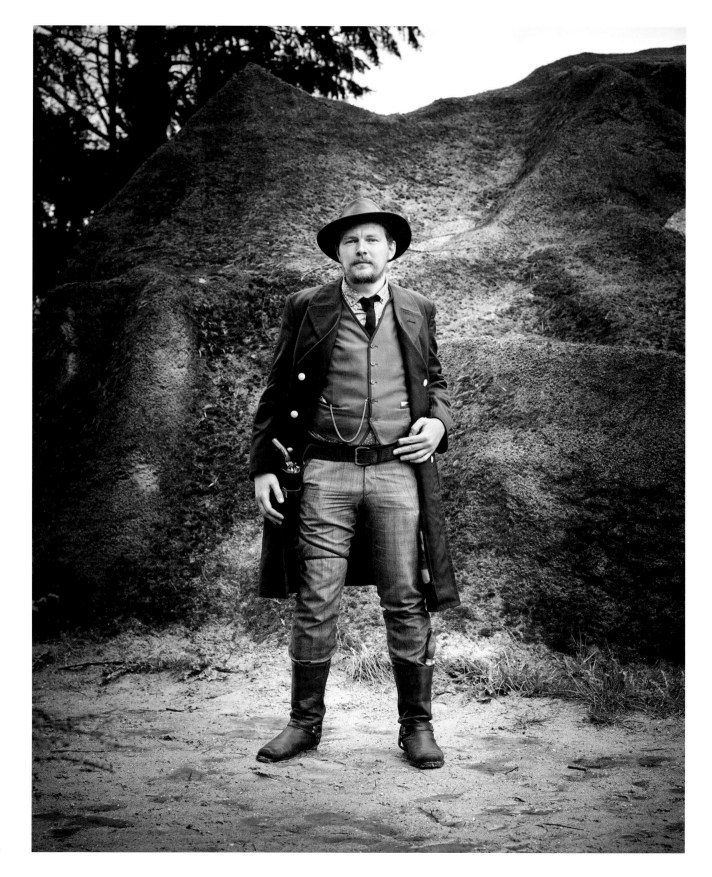

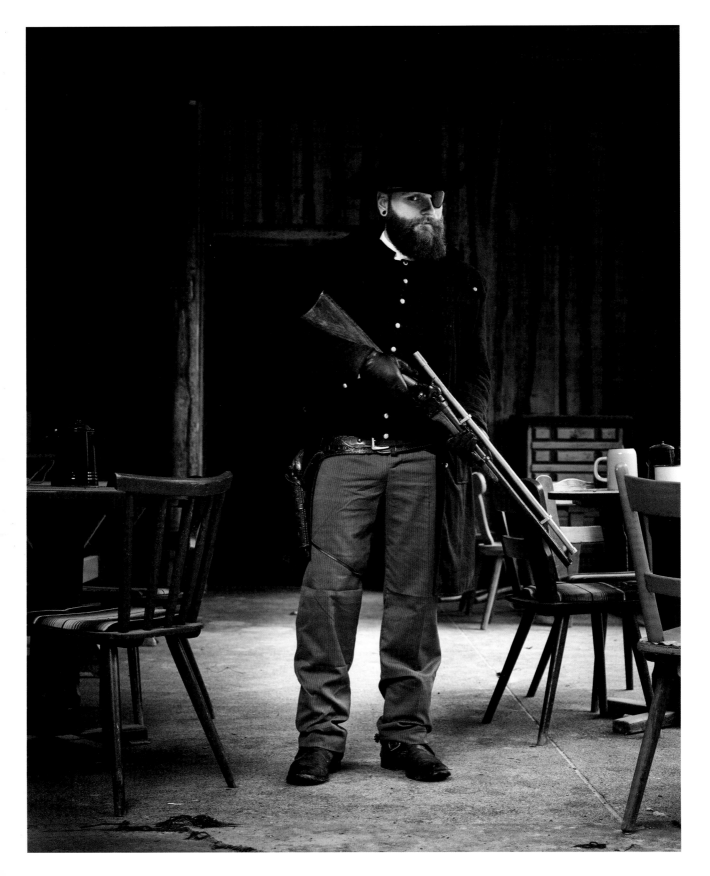

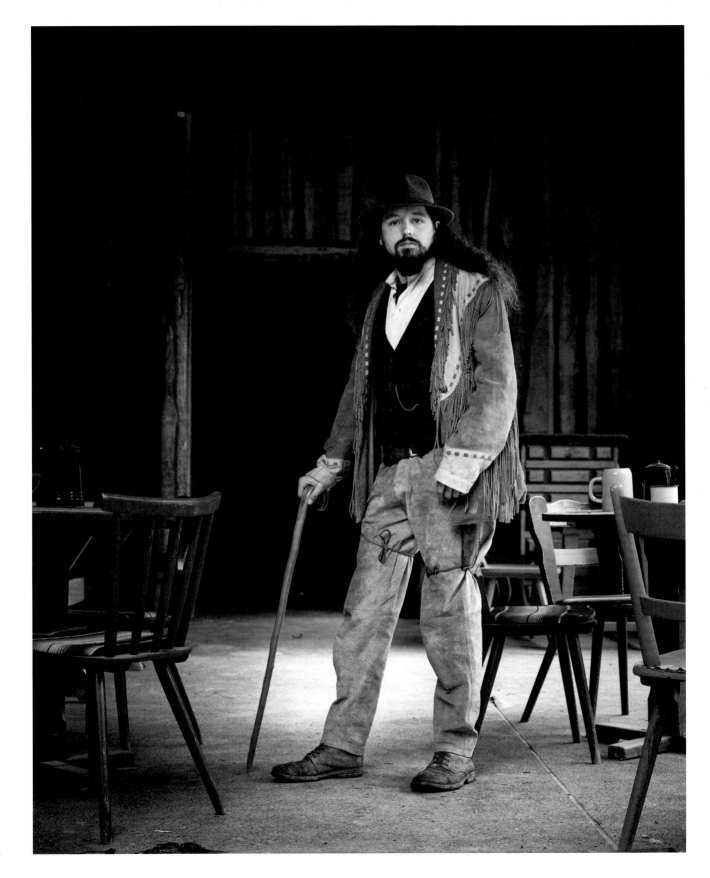

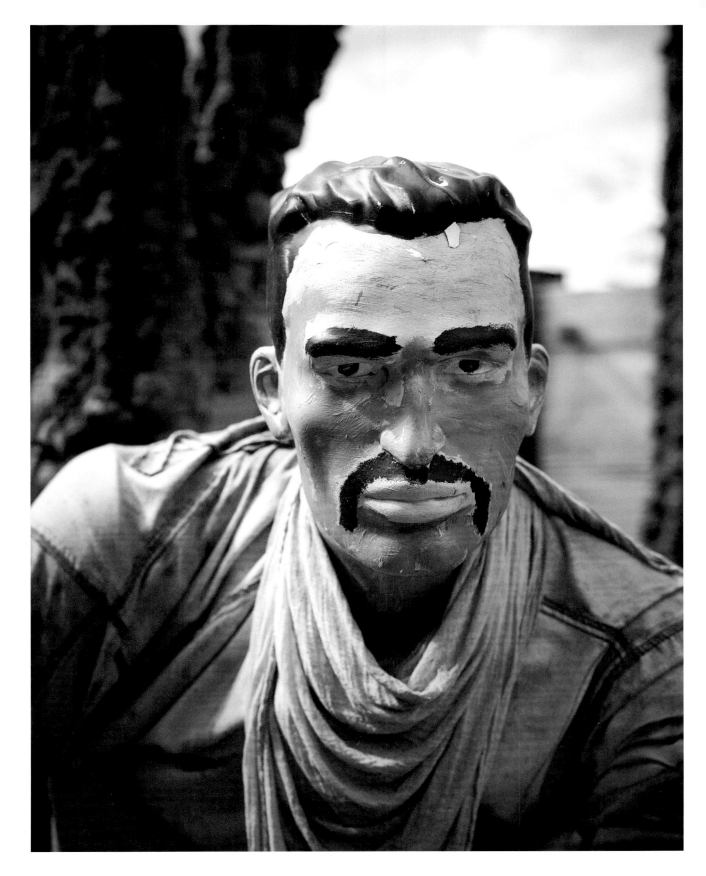

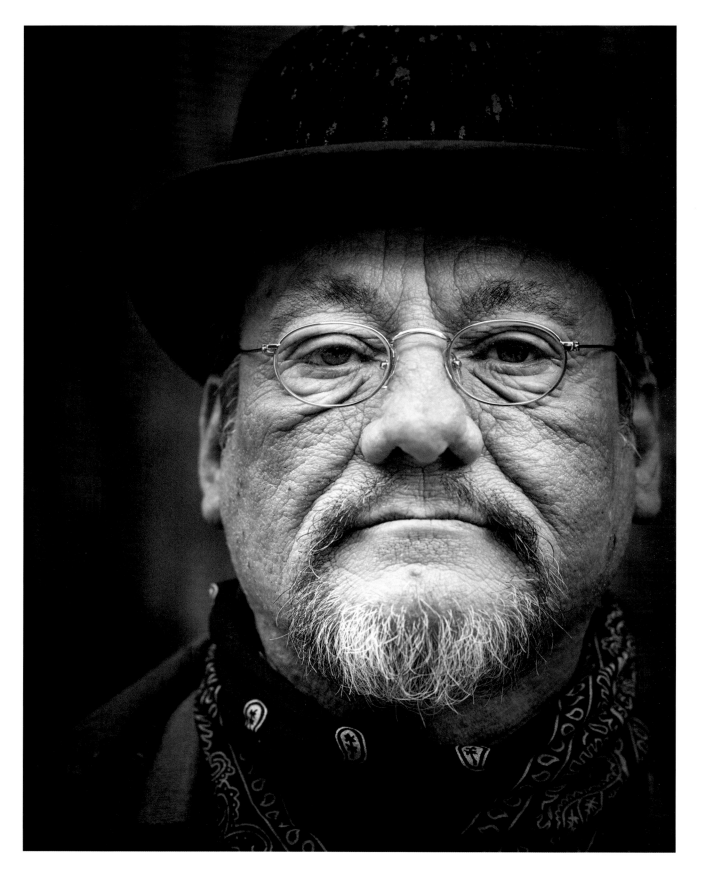

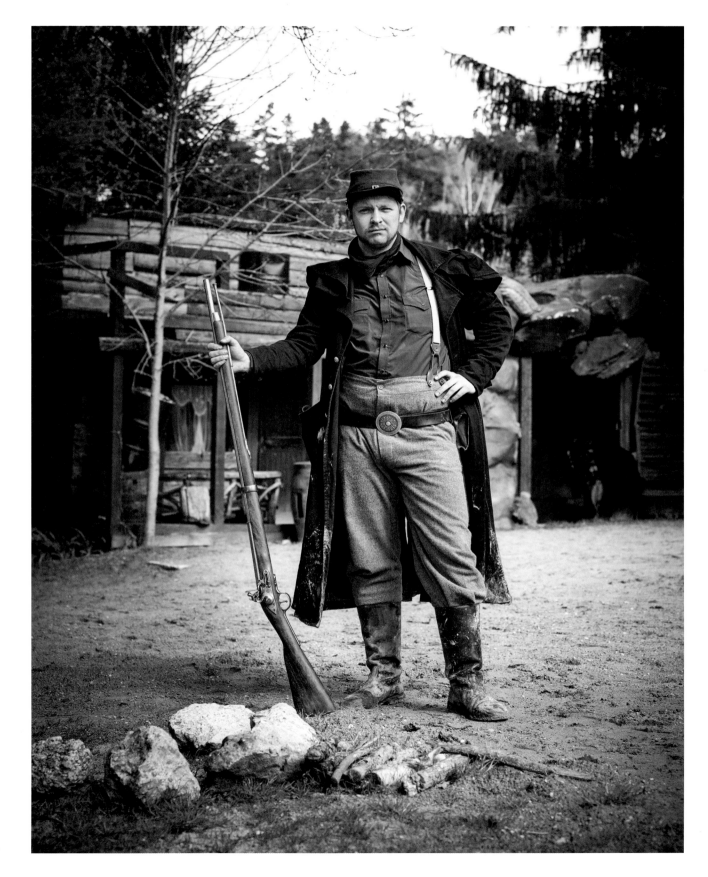

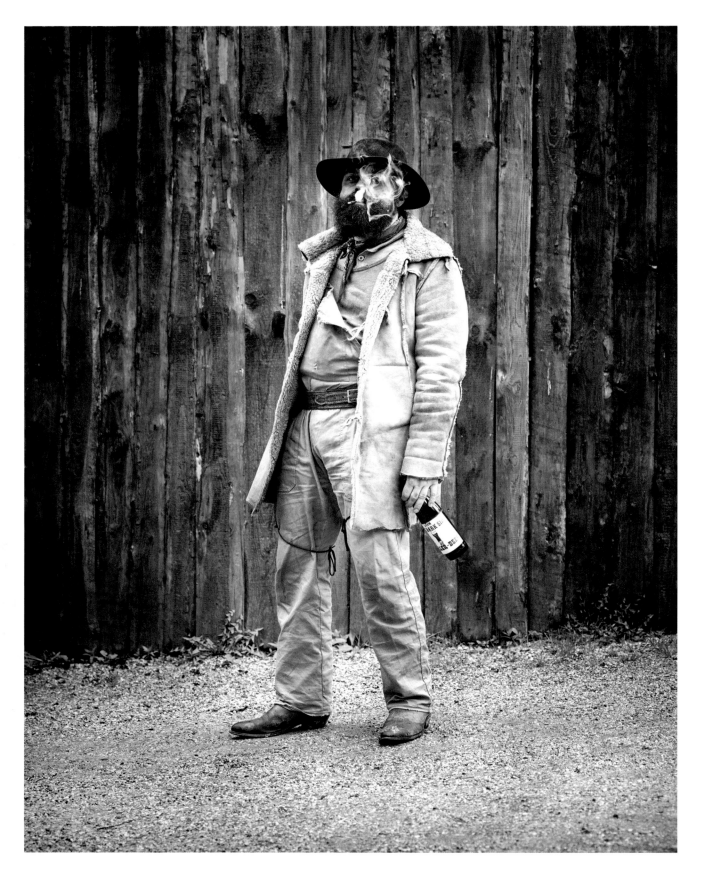

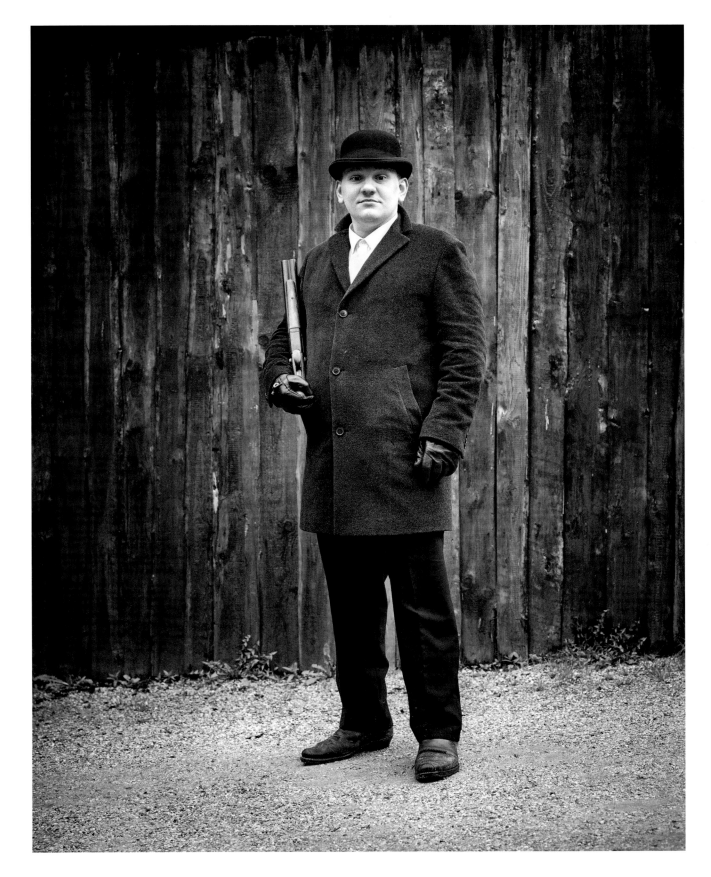

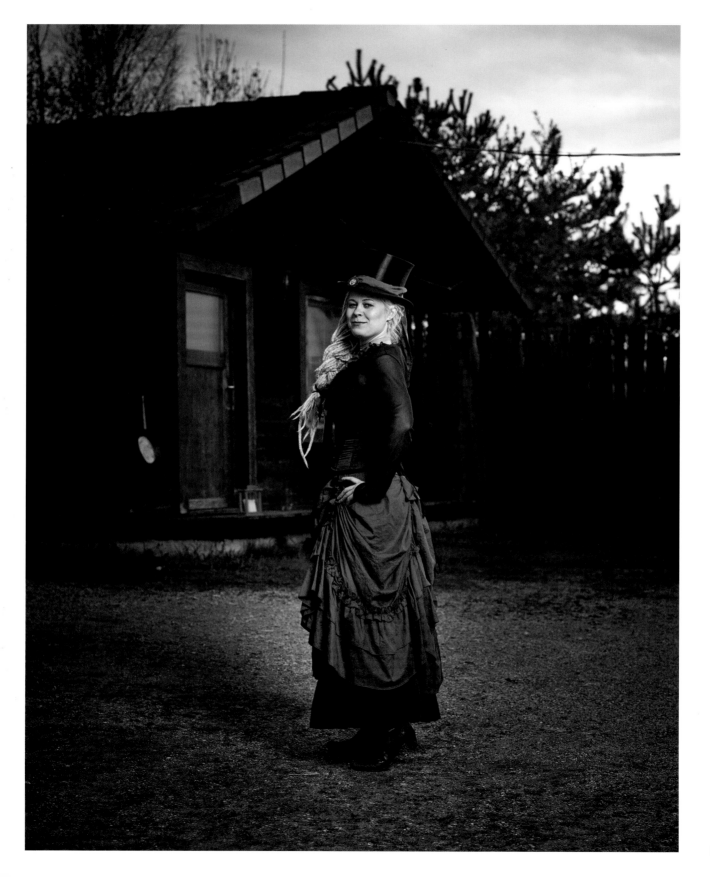

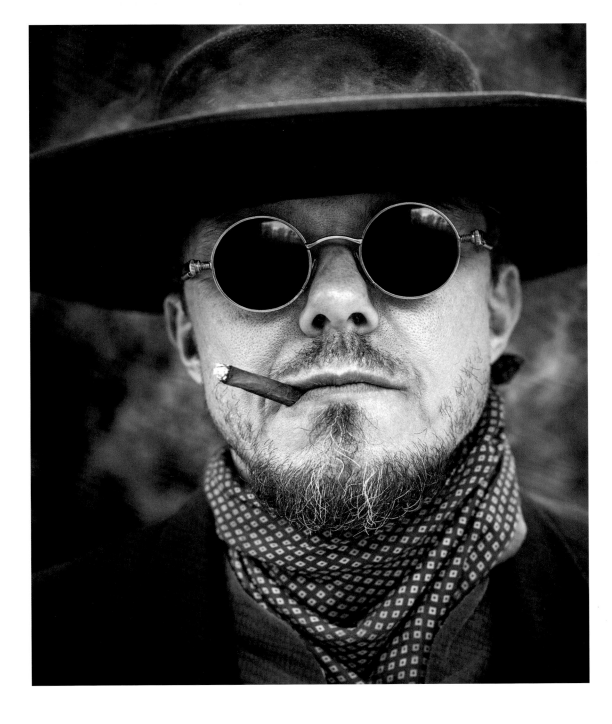

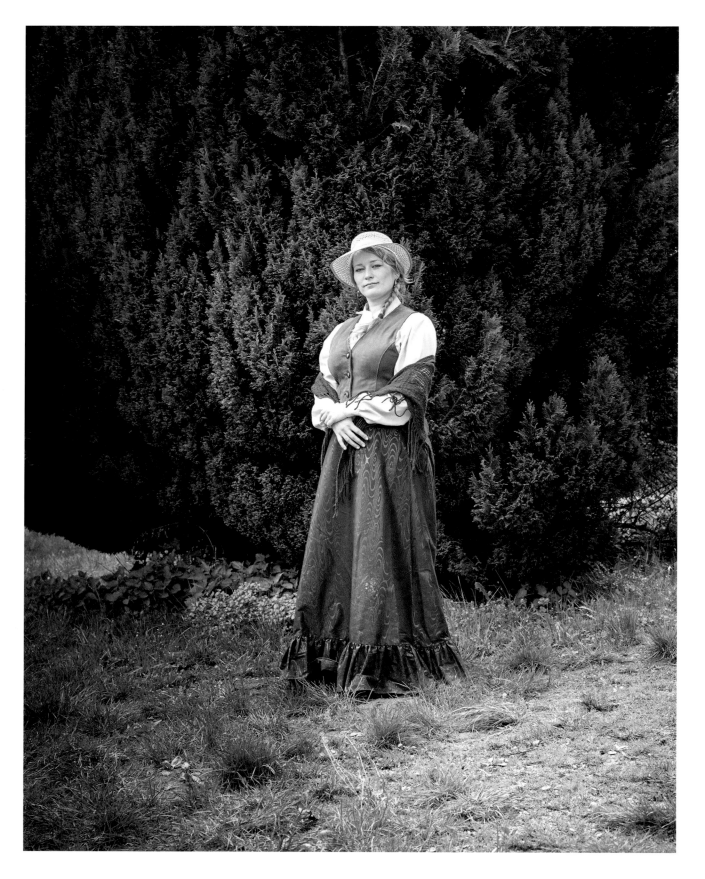

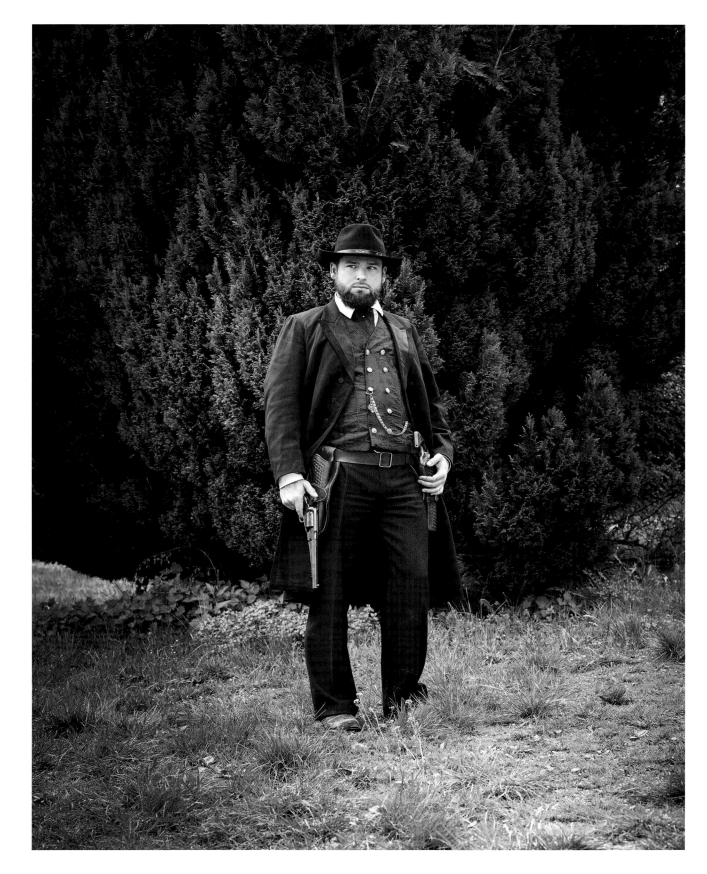

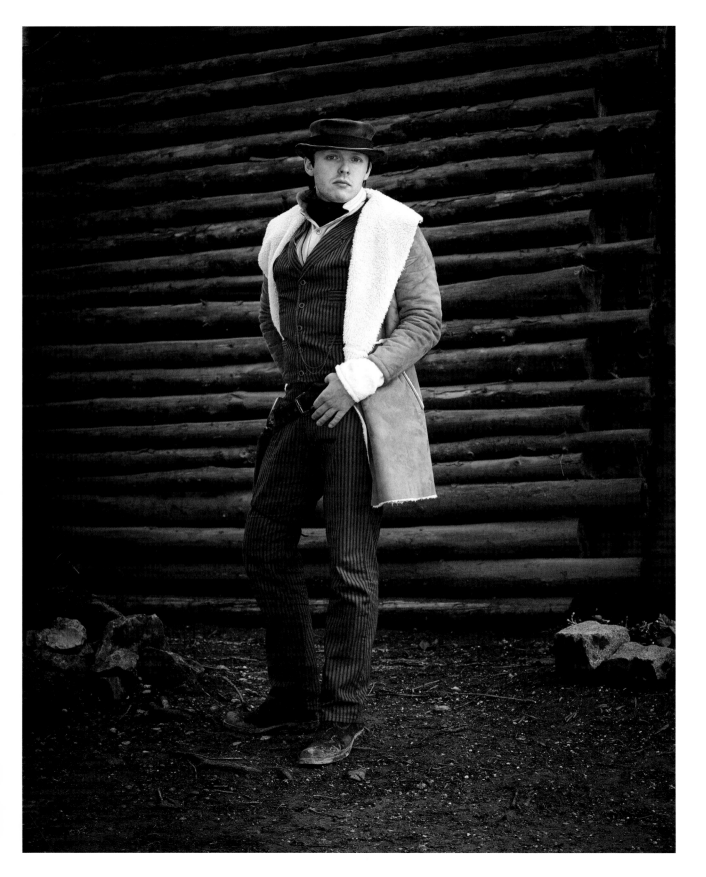

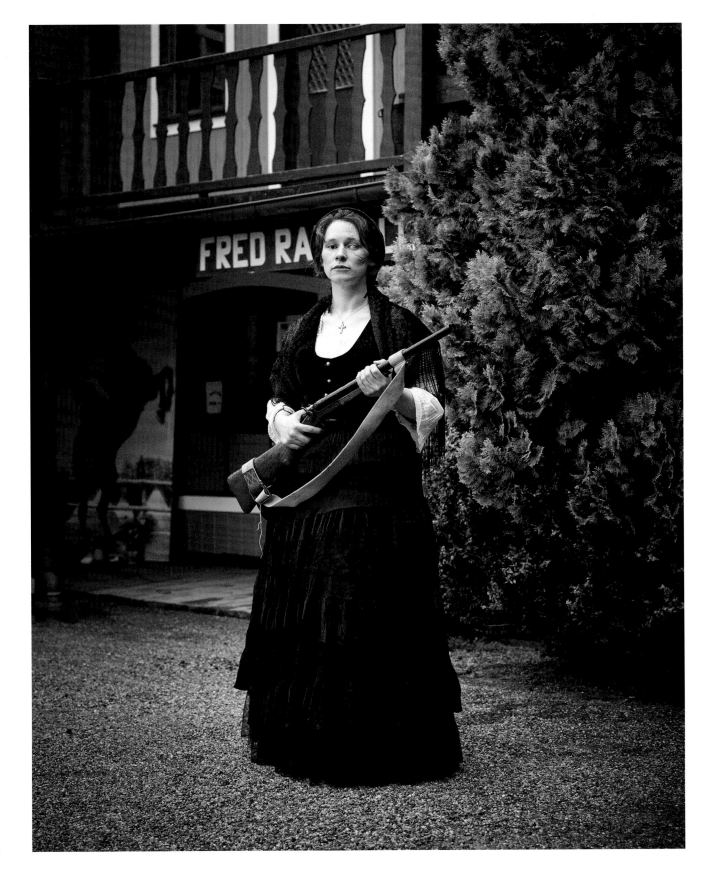

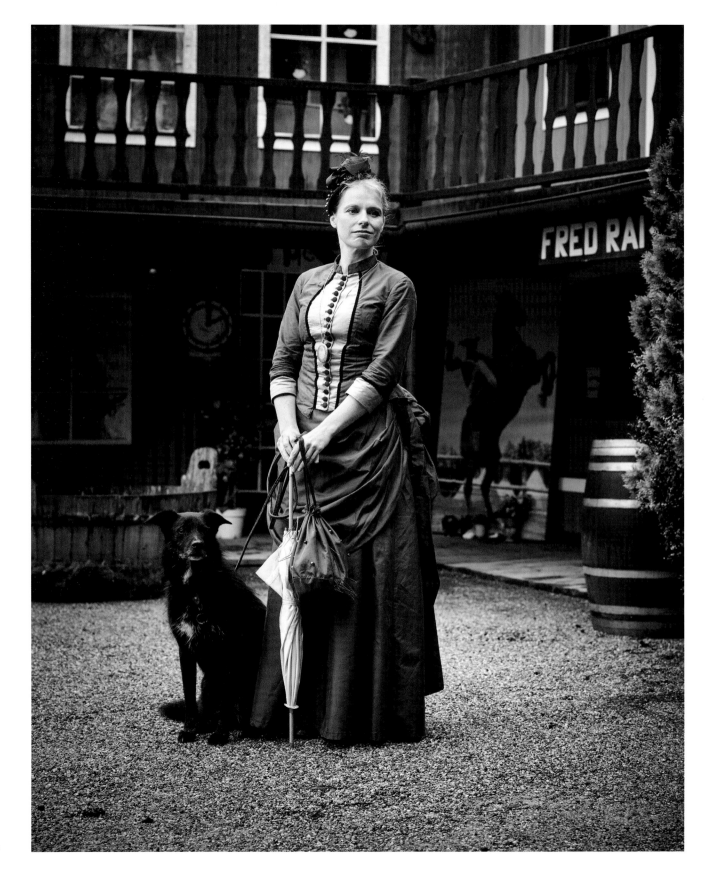

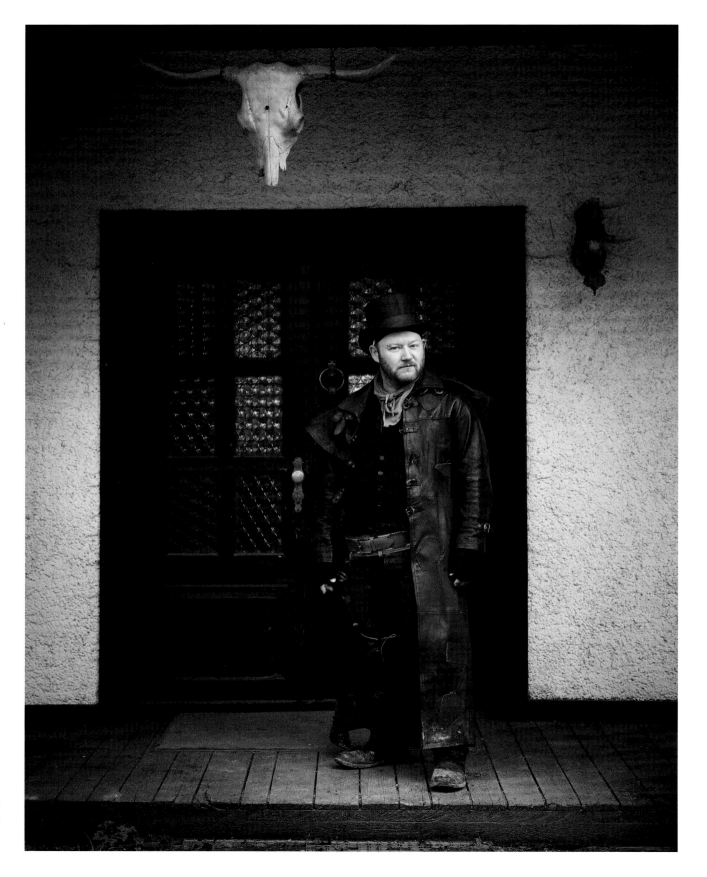

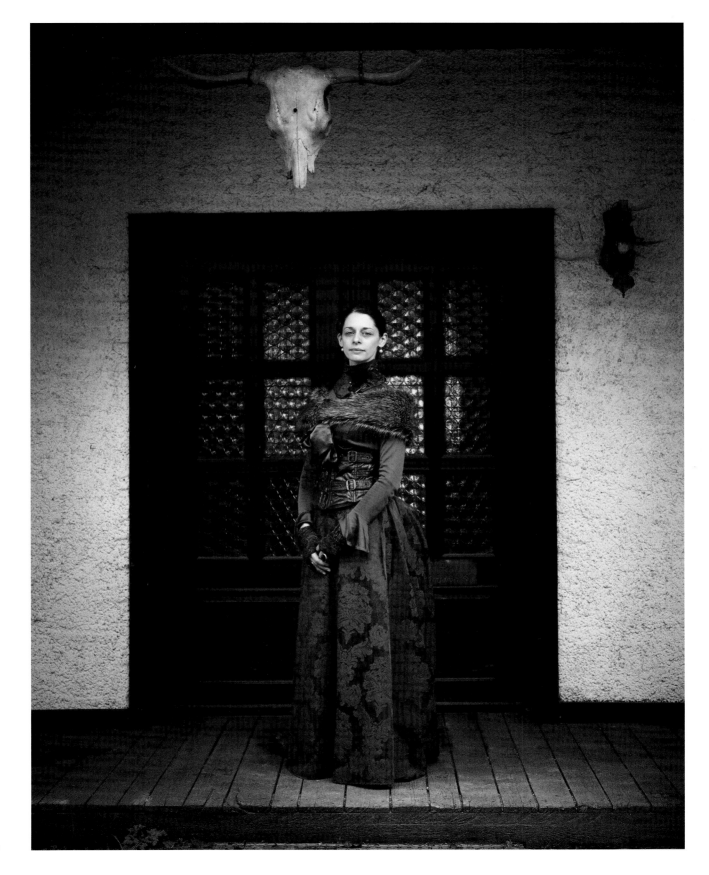

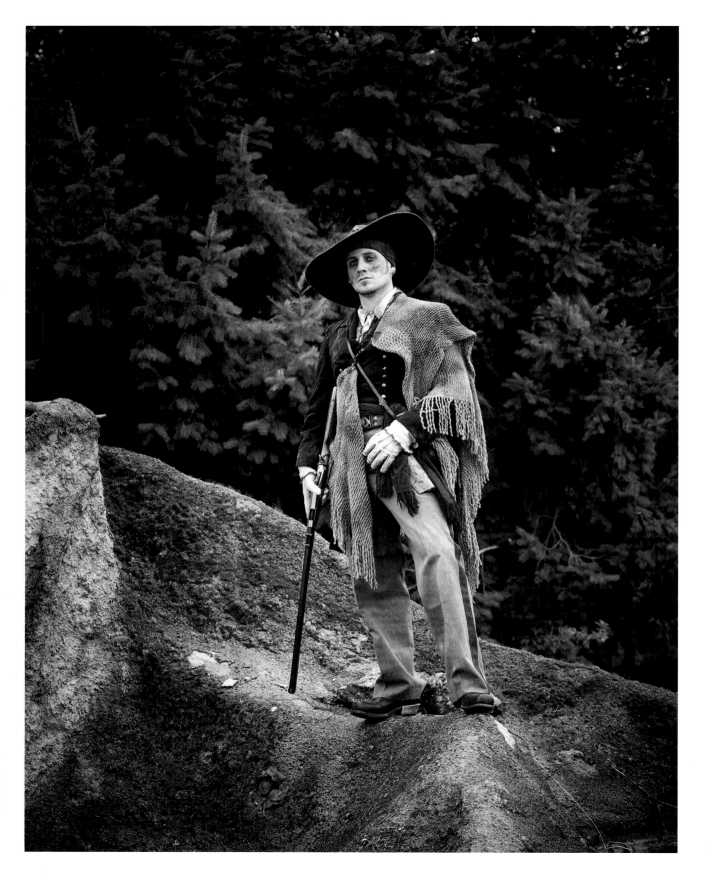

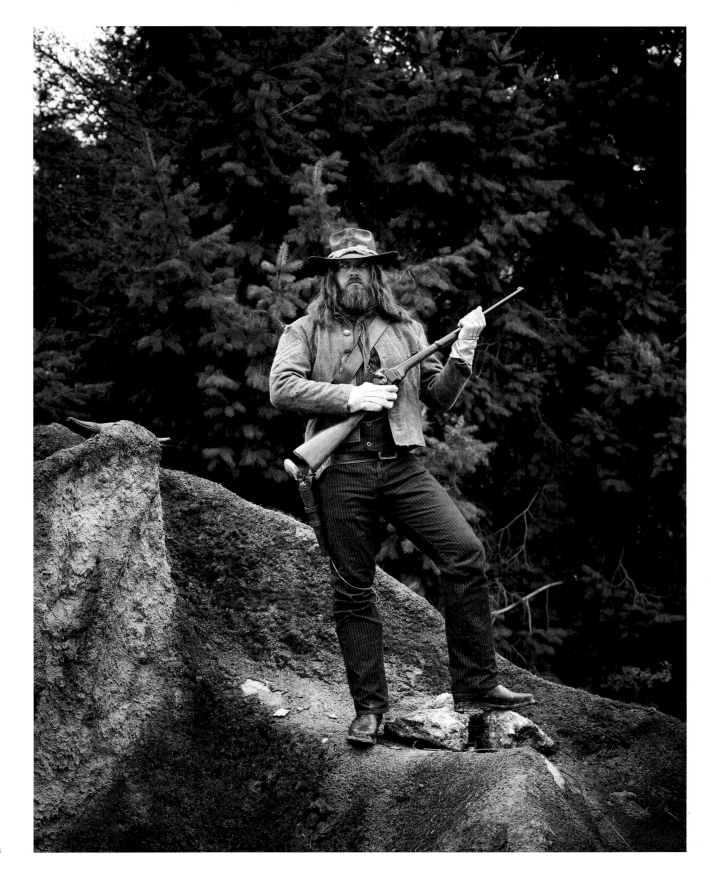

39
S./p.

Oskar Schaefer – Scarlet Mister, Manager der Scarlet Sisters, zuständig für Sicherheit und Geschäftliches.

Oskar Schaefer – Scarlet Mister, manager of the Scarlet Sisters, responsible for security and business-related matters.

40
S./p.

Shawn McFinnegans – Nachfahre irischer Einwanderer aus Boston und Gunman bei den Scarlet Sisters.

Shawn McFinnegans – Descendant of Irish immigrants from Boston and gunman with the Scarlet Sisters.

41
S./p.

Samuel Leroy Wheeler – Texas-Ranger, CSA-Veteran und Mitglied des Fred-Rai-City Gentlemen-Clubs.

Samuel Leroy Wheeler – Texas Ranger, CSA veteran, and member of the Fred Rai City Gentlemen's Club.

44
S./p.

Lou Crane – In Headley Corner, Texas, aufgewachsen. Später Deputy und danach sogar Sheriff. Zurzeit arbeitet er als Gunman für verschiedene Auftraggeber, er führt sein eigenes Unternehmen mit dem Namen „Crane's Transportation".

Lou Crane – Raised in Headley Corner, Texas. Later deputy and then even sheriff. Currently employed as a gunman for various clients, he runs his own business under the name "Crane's Transportation."

47
S./p.

Anthony McDowell – Jäger und Holzfäller und der Jüngste von den McDowell-Brüdern.

Anthony McDowell – Hunter and lumberjack, and the youngest of the McDowell brothers.

48
S./p.

Malcolm „Mumbly Mal" Hamby – Ehemaliger Anwaltsgehilfe, jetzt liebenswerter Säufer in Fred-Rai-City, verbringt seine Zeit meistens mit den Scarlet Sisters.

Malcolm "Mumbly Mal" Hamby – Former paralegal and now an amiable drunkard in Fred Rai City who spends most of his time with the Scarlet Sisters.

49
S./p.

Marten Redwood – Anwalt und Privatdetektiv.

Marten Redwood – Lawyer and private detective.

50
S./p.

Miss Kitty O'Malley – Tanzt und singt bei der Saloon-Showgirl-Truppe Scarlet Sisters.

Miss Kitty O'Malley – Dances and sings with the saloon girls show group known as the Scarlet Sisters.

51
S./p.

Henry White – Anwalt und stellvertretender Bankdirektor von Fred-Rai-City.

Henry White – Lawyer and associate bank director in Fred Rai City.

52
S./p.

Polly Mears – Arbeitet bei der Fred-Rai-City-Gazette, wuchs mit ihren Eltern und vier Brüdern auf einer Ranch im Südosten Amerikas auf (North Carolina).

Polly Mears – Works at the Fred Rai City Gazette; grew up with her parents and four brothers on a ranch in the American Southeast (North Carolina).

53
S./p.

„Lucky" Jack Smytho – Pokerspieler und Geschäftsmann.

"Lucky" Jack Smytho – Poker player and businessman.

54
S./p.

Karl-Johann Klingsporn – Landvermesser und Geologe, deutscher Einwanderer, gehört zu den Städtern in Fred-Rai-City.

Karl-Johann Klingsporn – Land surveyor and geologist; German immigrant; one of the townsmen of Fred Rai City.

55
S./p.

Witwe Ryan alias Emily – Rächte den Tod ihres Mannes, und nun lautet die Frage: Was macht sie als nächstes?

Widow Ryan alias Emily – Avenged the death of her husband; and now the question is: what's her next move?

57
S./p.

Caitlin Meagan Darcy – Gelernte Schneiderin, stammt aus einer streng katholischen, irischen Auswandererfamilie, lebt in Boston und ist mit Henry White verheiratet.

Caitlin Meagan Darcy – Trained seamstress; comes from a strict Irish Catholic immigrant family; lives in Boston and is married to Henry White.

58
S./p.

Matthew McGlory – Gitarrist und Sänger, Vertreter der Arbeitergewerkschaft, reist verdeckt als Musiker im Kampf für gerechtere Löhne und Arbeitsbedingungen durchs Land.

Matthew McGlory – Guitar player and singer; representative of the workers' union; travels across the country undercover as a musician in the struggle for fairer wages and better working conditions.

59
S./p.

Claire Voyance – Professorin für Parawissenschaften und Musikerin, hat sich Matthew McGlory angeschlossen und reist mit ihm und der Band durchs Land.

Claire Voyance – Professor for parasciences and musician; has joined up with Matthew McGlory and travels with him and the band across the country.

60
S./p.

Gerald Beauford – Ex-Konföderierter, setzte sich nach dem Krieg nach Mexiko ab, hat sich einer Bande angeschlossen, die vor allem im Grenzgebiet versucht, über die Runden zu kommen, wenn es sein muss, auch mit Gewalt.

Gerald Beauford – Ex-Confederate; after the war, he defected to Mexico, where he joined a gang that tries to make ends meet in the borderland; through violence, if necessary.

61
S./p.

Joe – Outlaw und Anführer der Gang, der sich auch Gerald Beauford verpflichtet hat und die sich ganz bescheiden und schlicht „Die Bande" nennt.

Joe – Outlaw and leader of the gang that Gerald Beauford joined and modestly calls itself simply "The Gang."

"I see the bad moon rising, I see trouble on the way," the song rasps out of the radio here in the bar in Angel Falls. The lunatics from the web and their humor.

Outside, everything's going to hell, and they're rubbing it in our faces, smirking all the while. Things had finally settled down a bit here in the area. It had finally become somewhat bearable to actually live here, and then this... Not only that, a new badlands gang, The Dusters, have made themselves at home here and terrorize anyone who crosses their path; no, to make matters worse, several Lost Ones turned up in the last few days to avenge the Blood Chips and the other nuts by stabbing and lacerating anyone they find still outside after sundown. What a shitty world...

"The cloud of dust has settled a bit... a gaze up at the sky reveals only dead, rusty moons that orbit the earth – a sign of our failure. They mockingly spit on mankind's delusions of grandeur." Stories are circulating again... The Dusters will move on soon – the beast no longer seems interested in the heap of garbage that it has exploited for several months now. Some had to be convinced with lead and steel that there is nothing to be gained here. For others, even this isn't enough to convince them. The hardest core of these bastards is still wreaking havoc out there and waiting for us to shoot a load of lead in their asses so that they finally get the hell out of here.

The nights are getting colder. The cartel has taken a lot of stick, and the protection we paid for has pretty much expired. What a fucking shitty idea... And it seems like not only the remaining dust guys are taking advantage of this. Lured by violence and death, worse things than these guys with their guns pass through the badlands. You hear about people and animals that simply disappear. Day or night, everyone carries their guns a bit more loosely right now. The forests should be avoided, and I have to admit that dark corners scare the shit of me. There's an uneasy feeling in the air – some nights, you can even make out lights in the forest, although nothing and no one should be living out there. Even the Zoners seem nervous, and if anyone's not supposed be nervous, for Christ's sake, it's these guys...

No matter what's going on out there, the walls of Angel Falls remain secure. I'm certainly not about to leave here. You want to park your ass outdoors, be my guest – but take good care of it, pal – because blood attracts far worse than Dusters. And in the last few years, the ground around this hole has been more or less painted with it.

F.A.T.E

"I see the bad moon rising, I see trouble on the way", schallt es kratzend aus dem Radio hier in der Bar in Angel Falls. Die Irren vom Web und ihr Humor.

Draußen geht alles den Bach runter, und die reiben es uns mit einem fetten Grinsen unter die Nase. Gerade war es mal ein bisschen ruhig geworden, hier im Umland. Gerade war es halbwegs erträglich, hier zu leben, und dann das… Nicht nur, dass eine neue Ödland-Gang, die „Duster", sich hier breit macht und jeden terrorisiert, der ihnen in die Quere kommt, nein, zu allem Überfluss sind in den letzten Tagen auch noch etliche der Verlorenen wieder aufgetaucht, um die „Blutchips" und andere Durchgeknallte zu rächen, indem sie jeden abstechen und zerfleischen, den sie nach Sonnenuntergang noch draußen antreffen. Was für eine beschissene Kackwelt…

„Die Staubwolke hat sich etwas gelegt… ein Blick in den Himmel offenbart nur tote, rostige Monde, die die Erde umkreisen – ein Zeichen unseres Scheiterns. Höhnisch spucken sie auf den Größenwahn der Menschheit." Und wieder kursieren Geschichten… Die „Duster" ziehen wohl bald weiter, die Bestie hat anscheinend kein Interesse mehr an dem Müllhaufen, den sie seit ein paar Monaten ausbeutet. Manche mussten mit Blei und Stahl überzeugt werden, dass es hier nichts zu holen gibt. Andere lassen sich nicht einmal damit überzeugen. Der härteste Kern dieser Bastarde treibt immer noch sein Unwesen da draußen und wartet darauf, dass wir ihnen eine Ladung Blei in den Arsch pusten, damit sie sich endlich verpissen.

Die Nächte werden kälter. Das Kartell hat ordentlich einstecken müssen, und der Schutz, für den wir gezahlt haben, ist inzwischen fast erloschen. Was für eine verdammte Scheißidee… Und das scheinen nicht nur die verbliebenen Staubtypen auszunutzen. Angelockt von Gewalt und Tod, durchqueren schlimmere Dinge als diese Kerle mit ihren Knarren das Ödland. Man hört von Menschen und Tieren, die einfach so verschwinden. Ob bei Tag oder Nacht, bei allen sitzt zurzeit die Knarre etwas lockerer. Wälder sollte man meiden, und dunkle Ecken jagen mir persönlich eine Scheißangst ein. Es liegt ein ungutes Gefühl in der Luft, und in manchen Nächten kann man sogar Lichter im Wald erkennen, wo eigentlich nichts und niemand leben sollte. Sogar die Zoner wirken nervös, und wenn es überhaupt jemanden gibt, der nicht nervös sein sollte, dann sind es verdammt noch mal diese Jungs…

Was auch immer da draußen vor sich geht, die Mauern von Angel Falls bleiben sicher. Ich geh' hier ganz bestimmt nicht weg. Wenn du deinen Arsch lieber unter freiem Himmel parkst, bitte sehr, aber pass gut auf ihn auf, Kumpel, denn Blut zieht Schlimmeres an als die „Duster". Und in den letzten Jahren wurde der Boden um dieses Loch herum quasi damit getränkt.

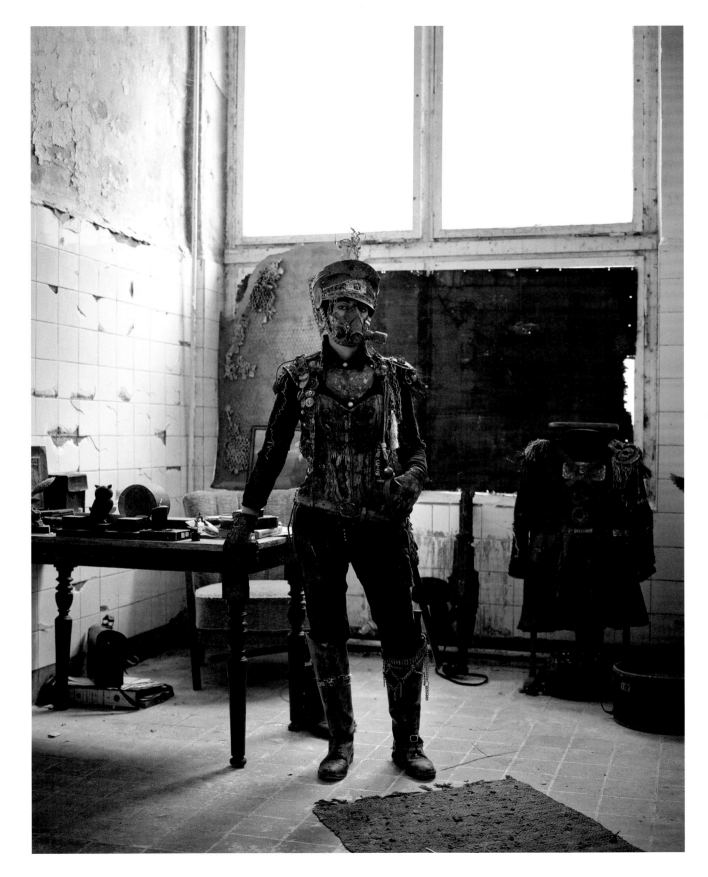

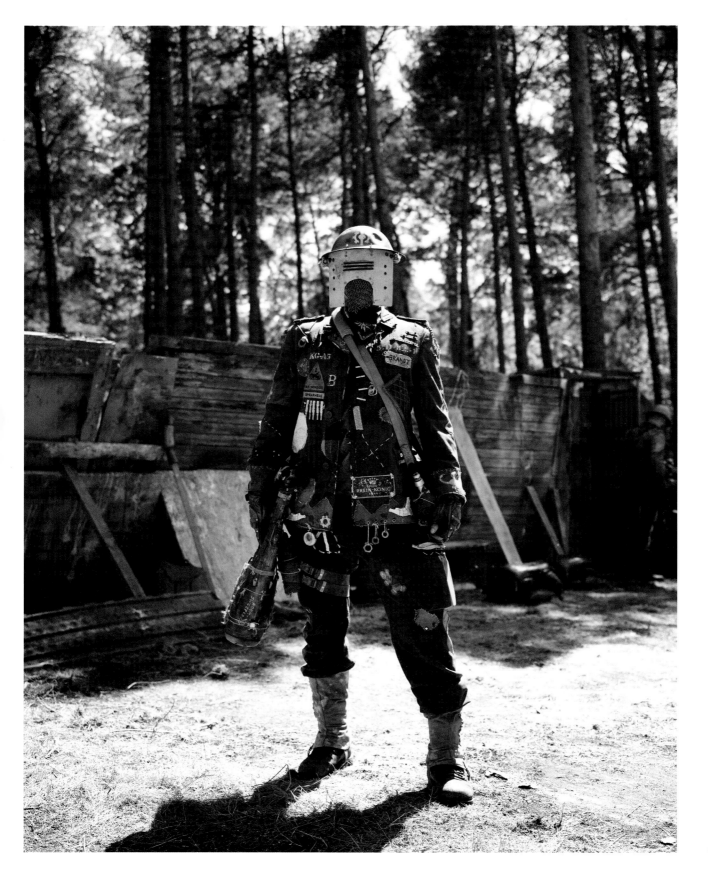

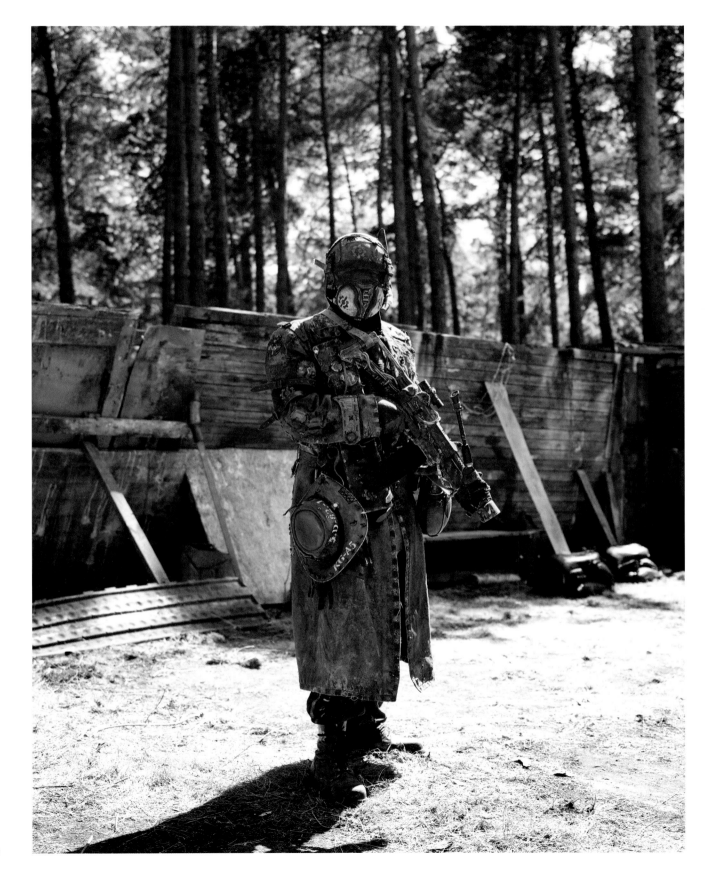

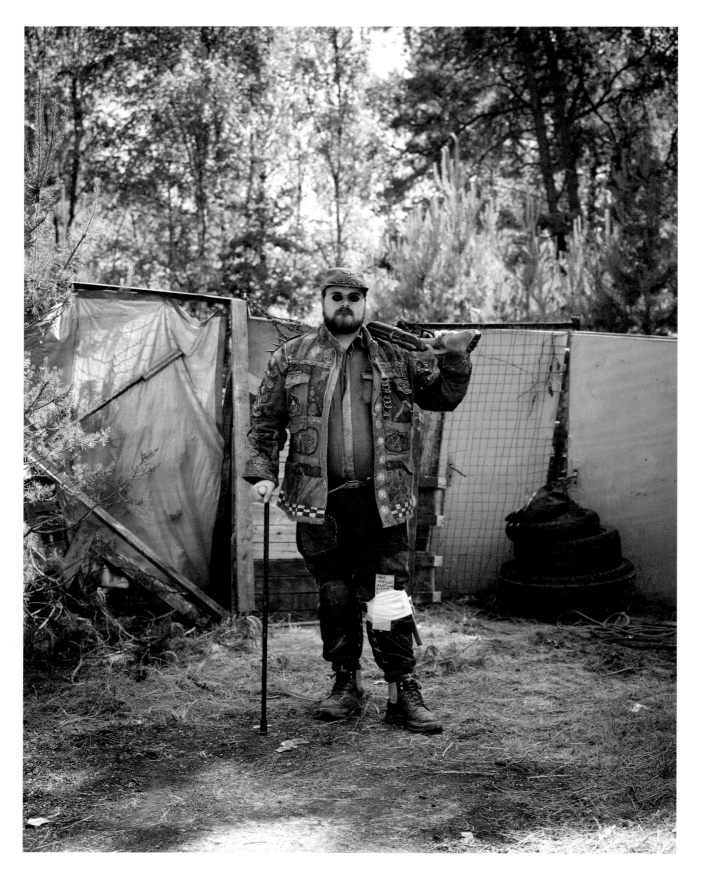

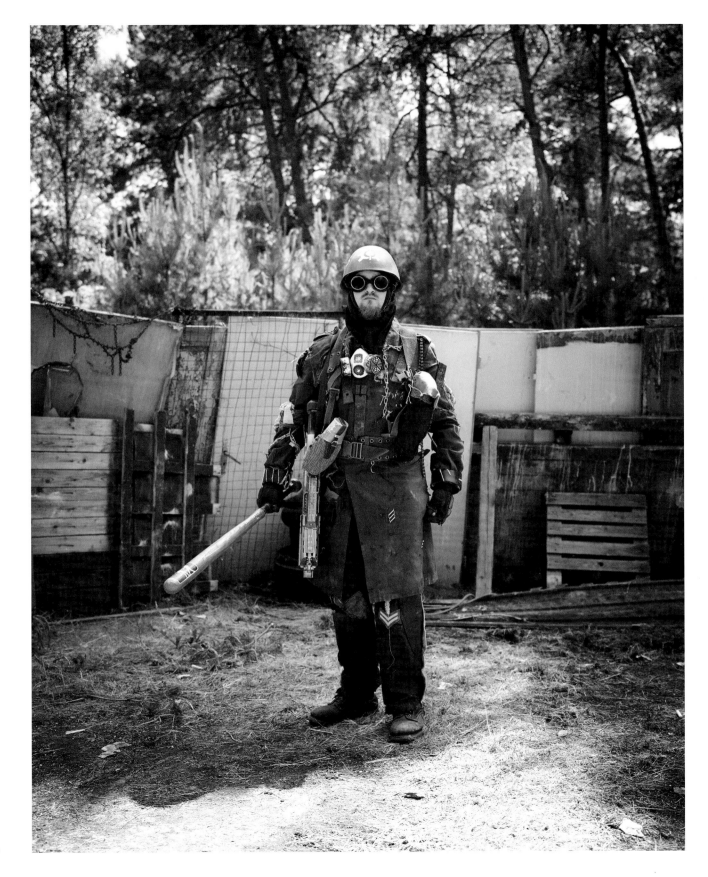

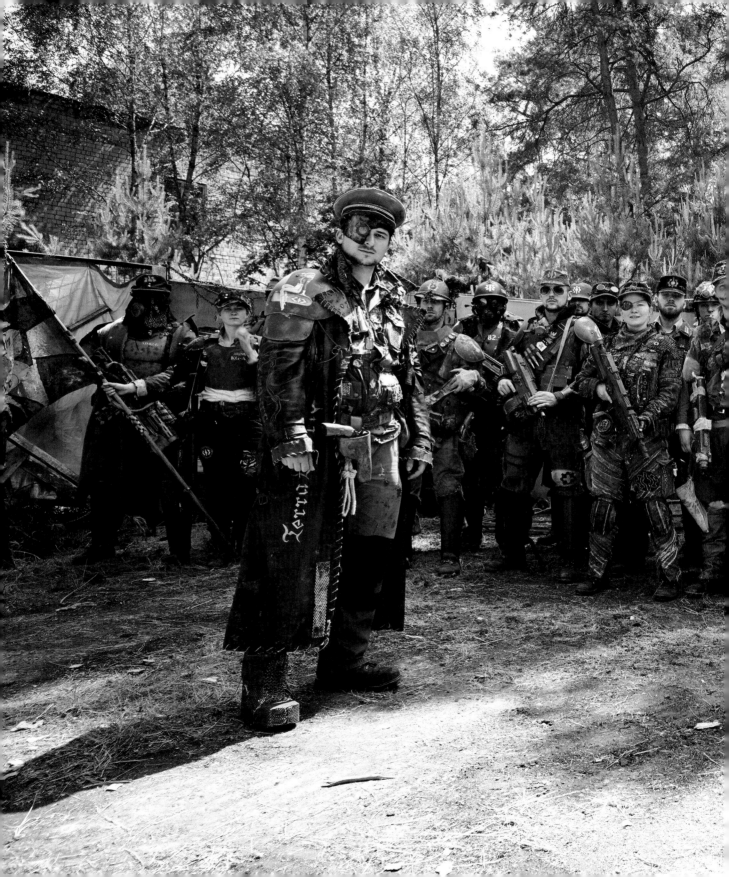

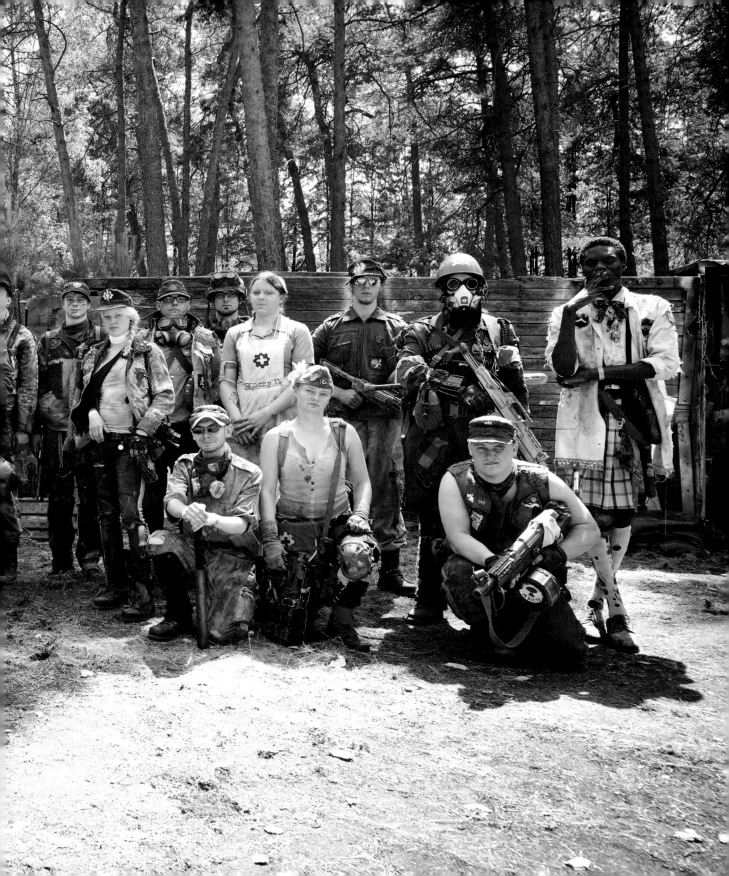

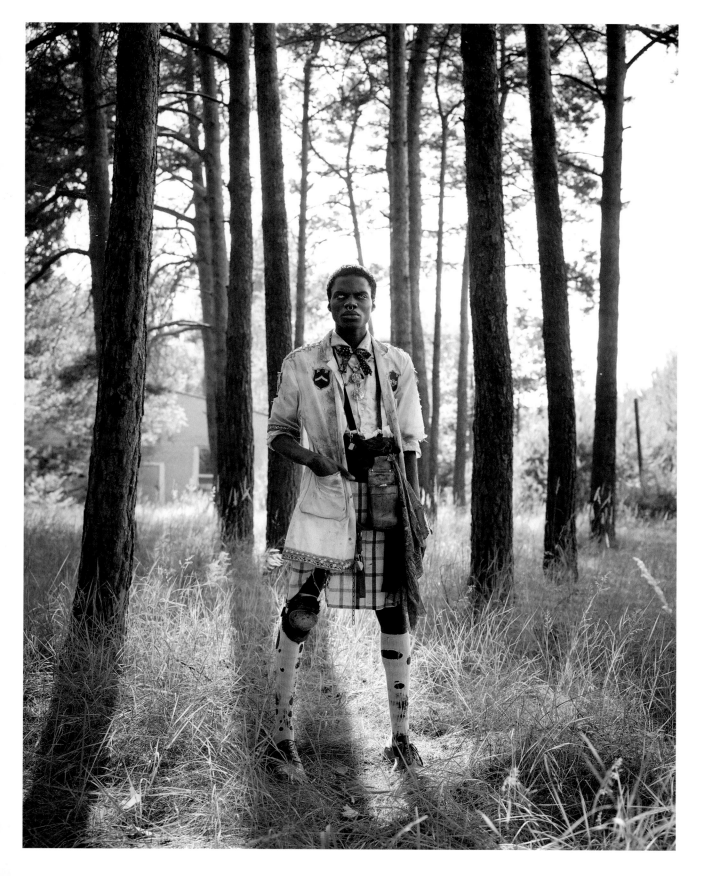

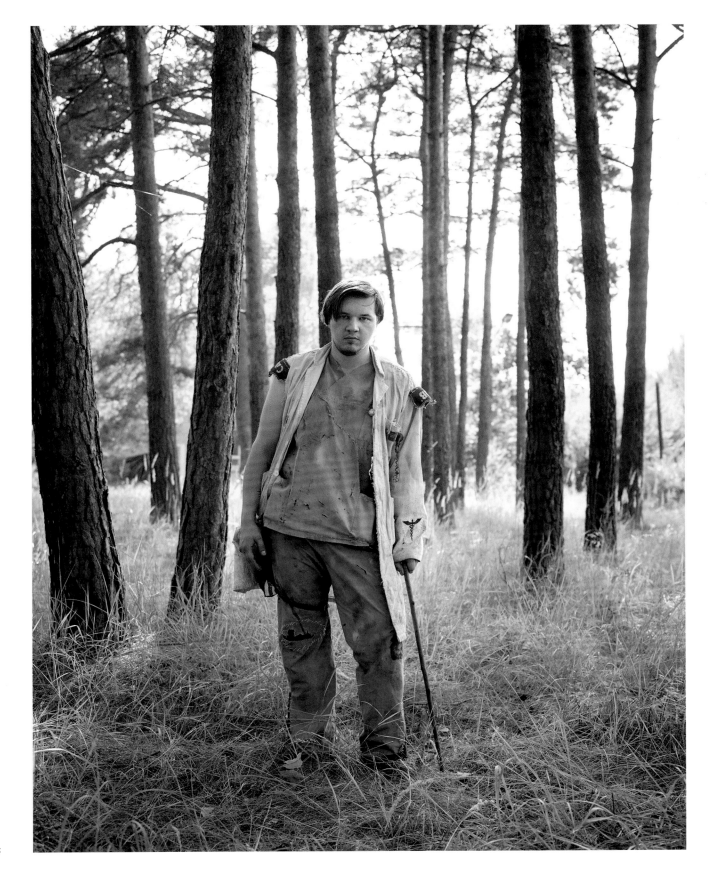

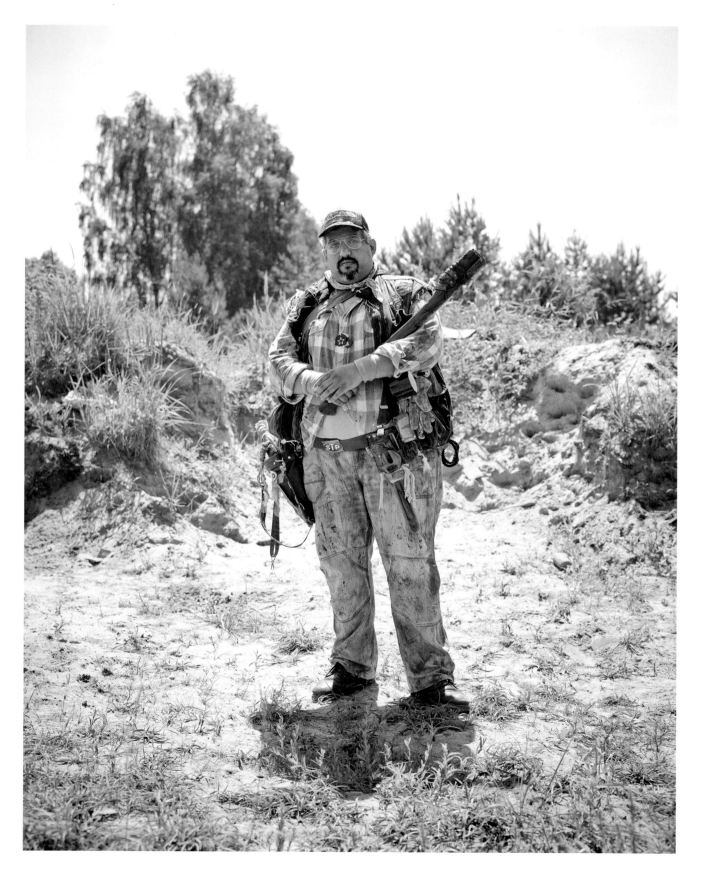

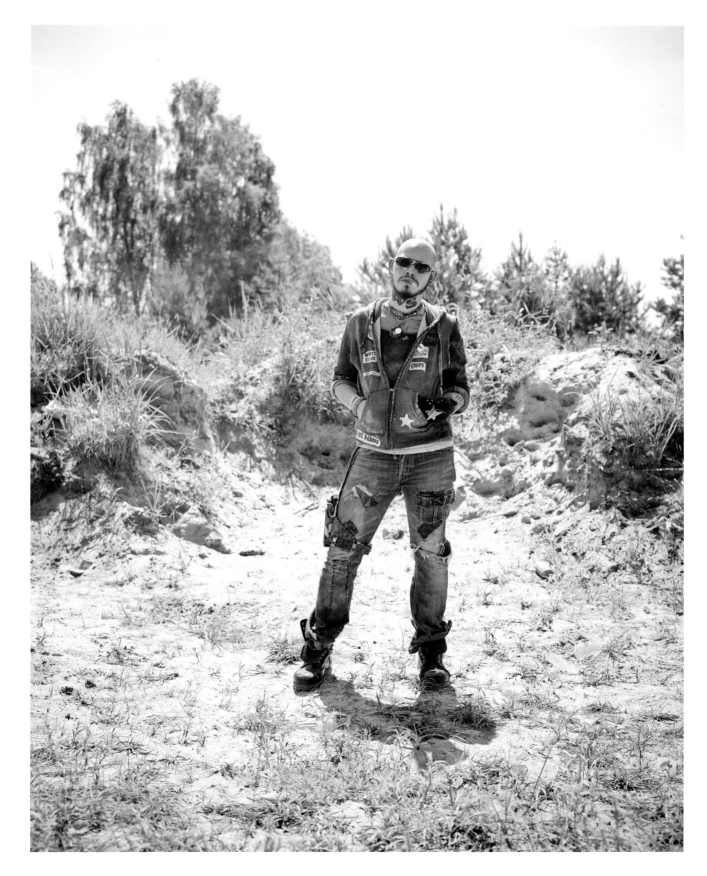

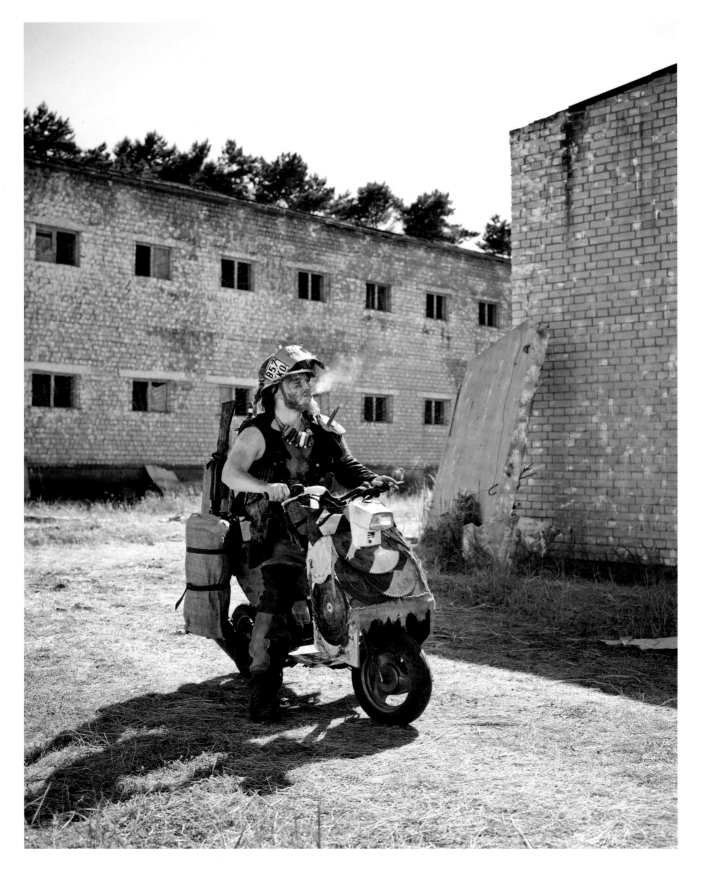

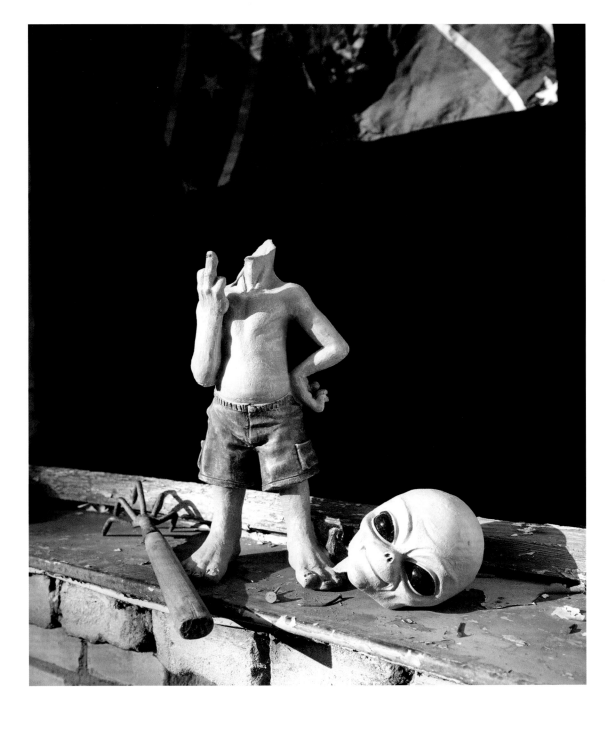

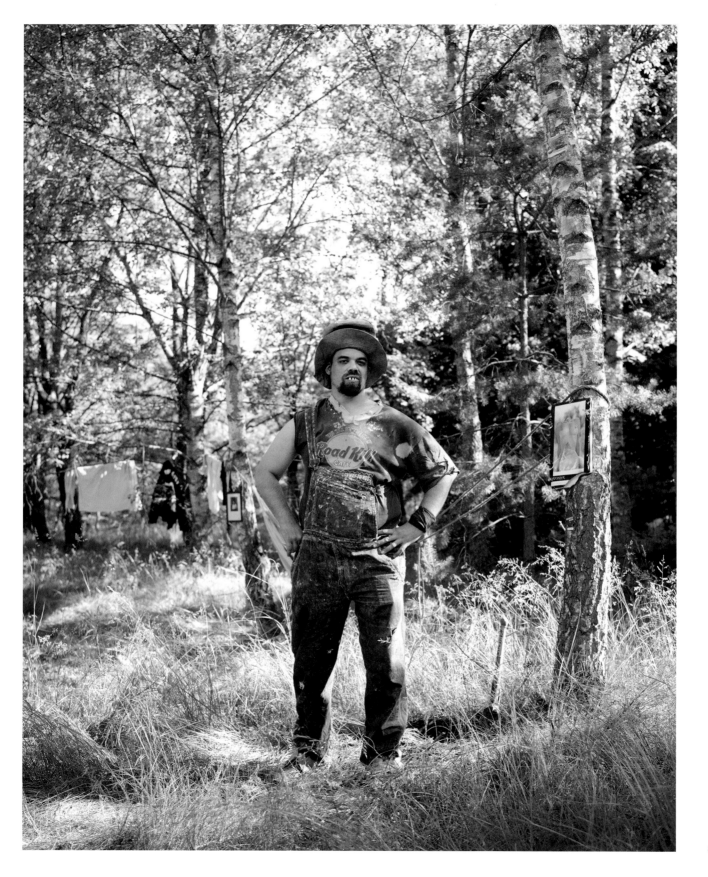

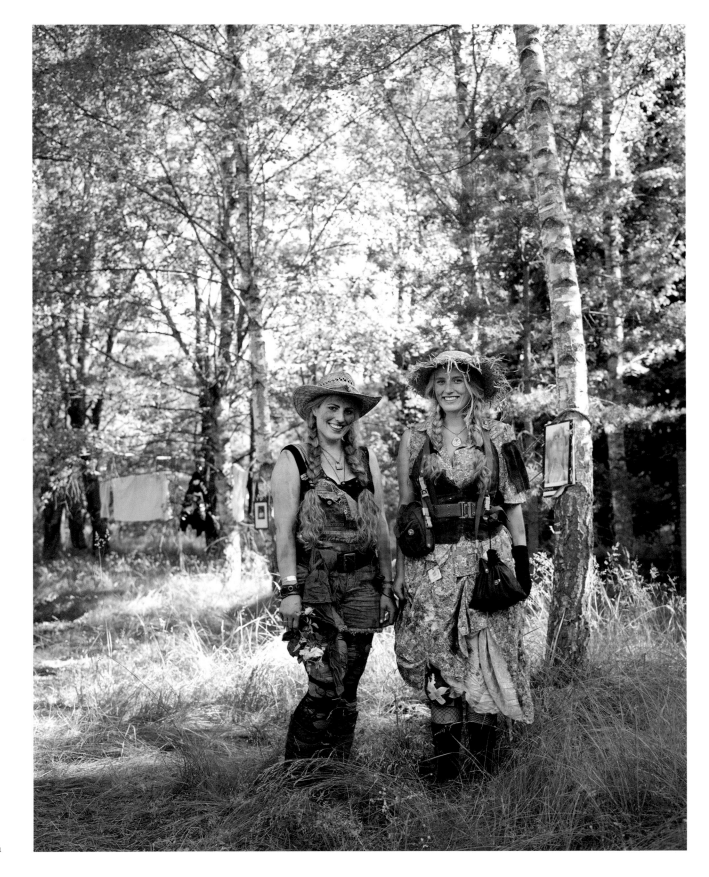

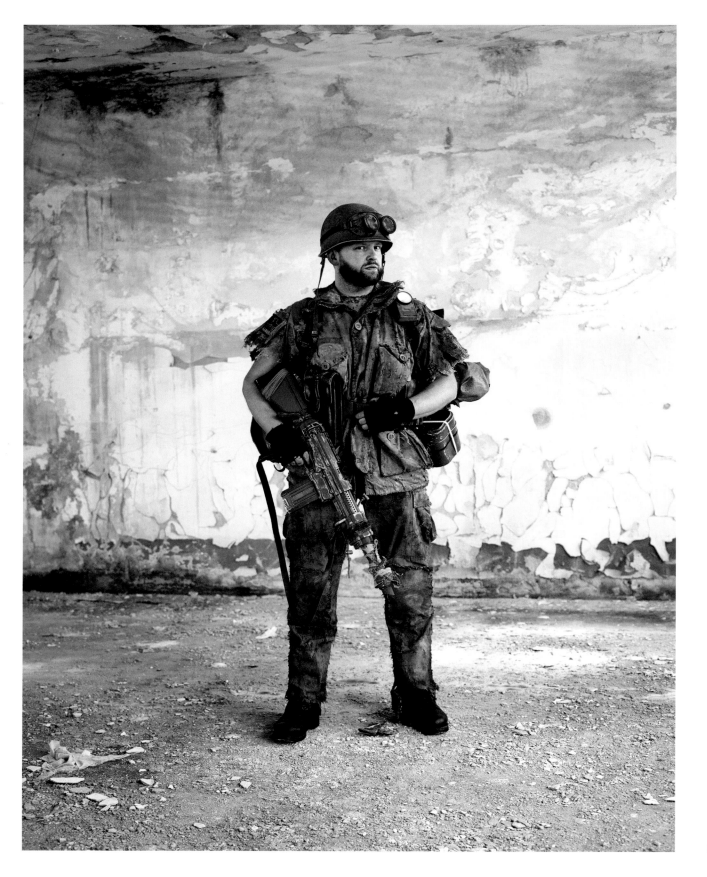

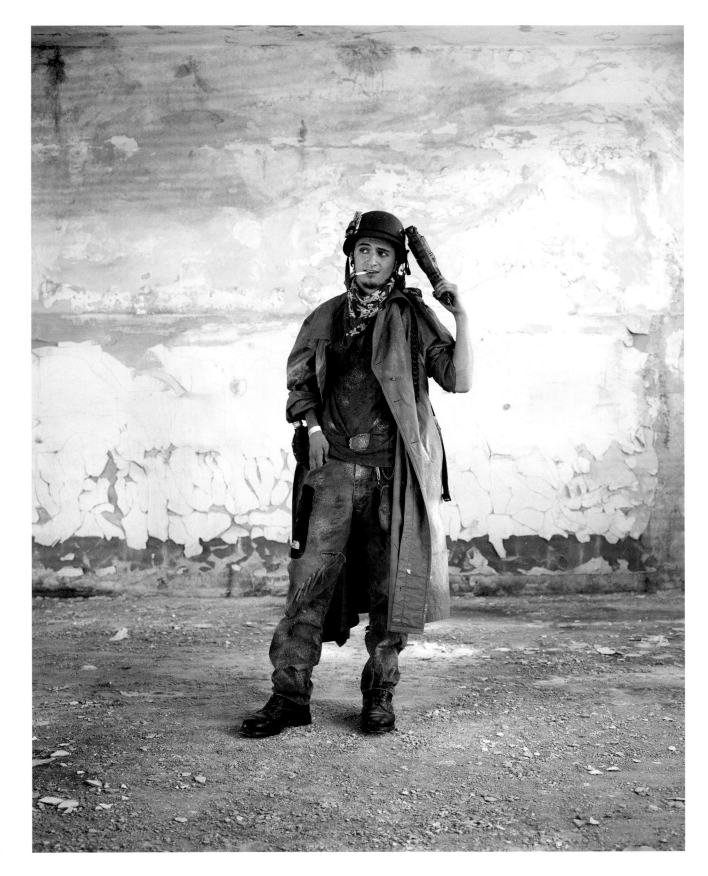

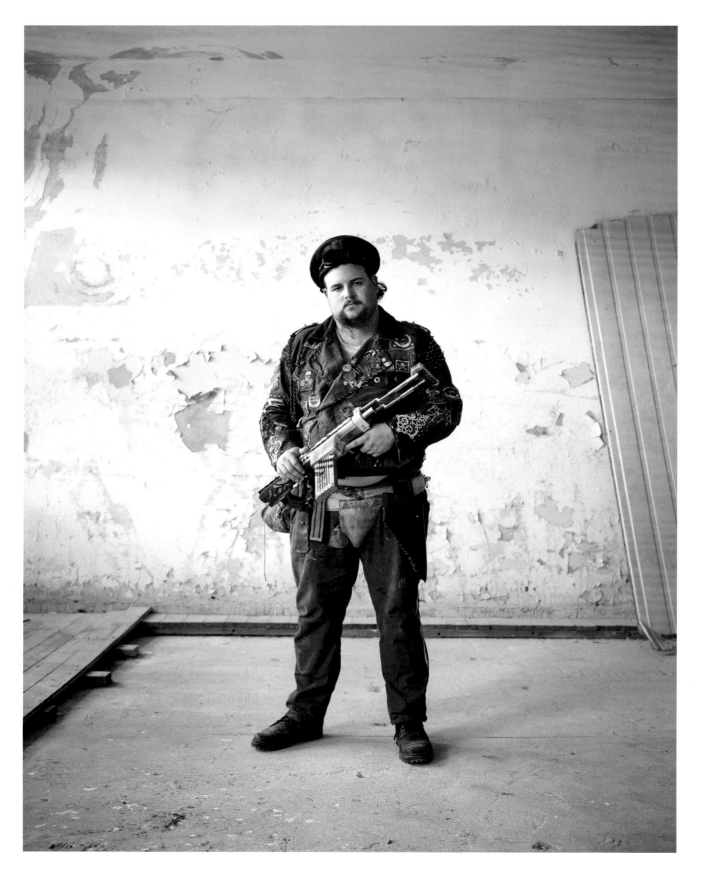

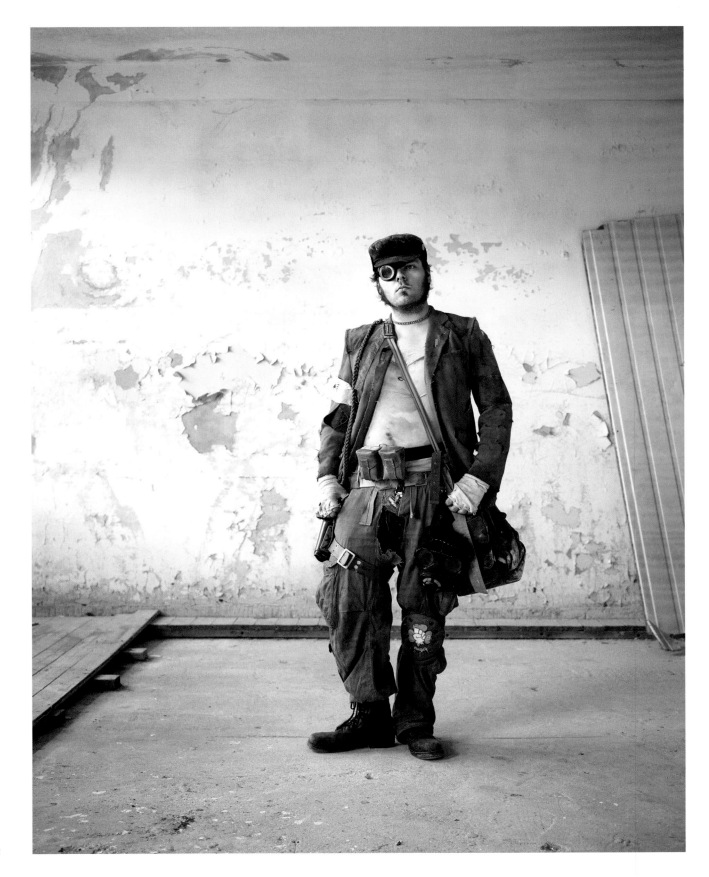

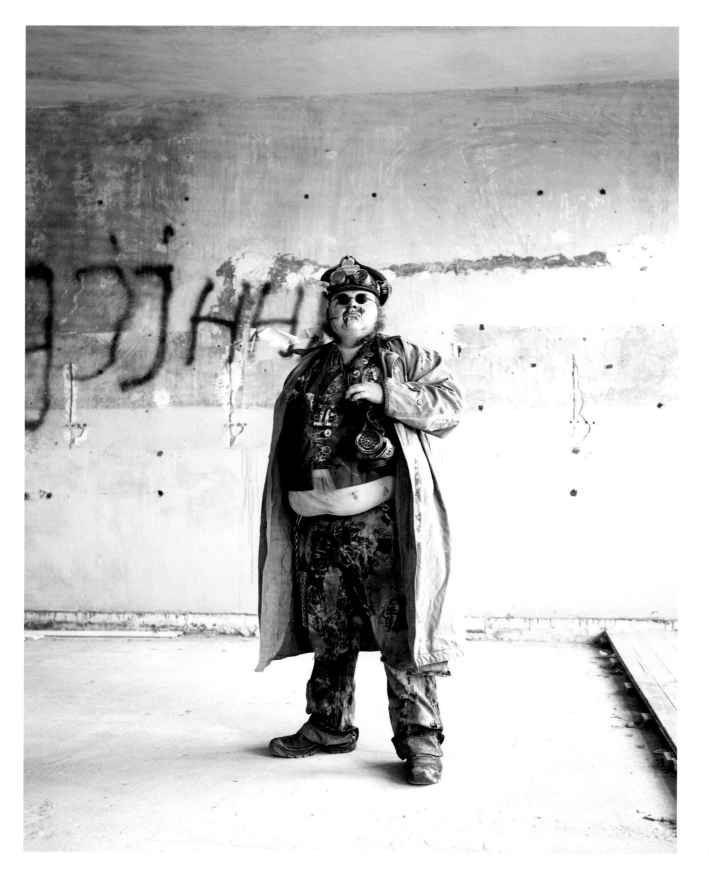

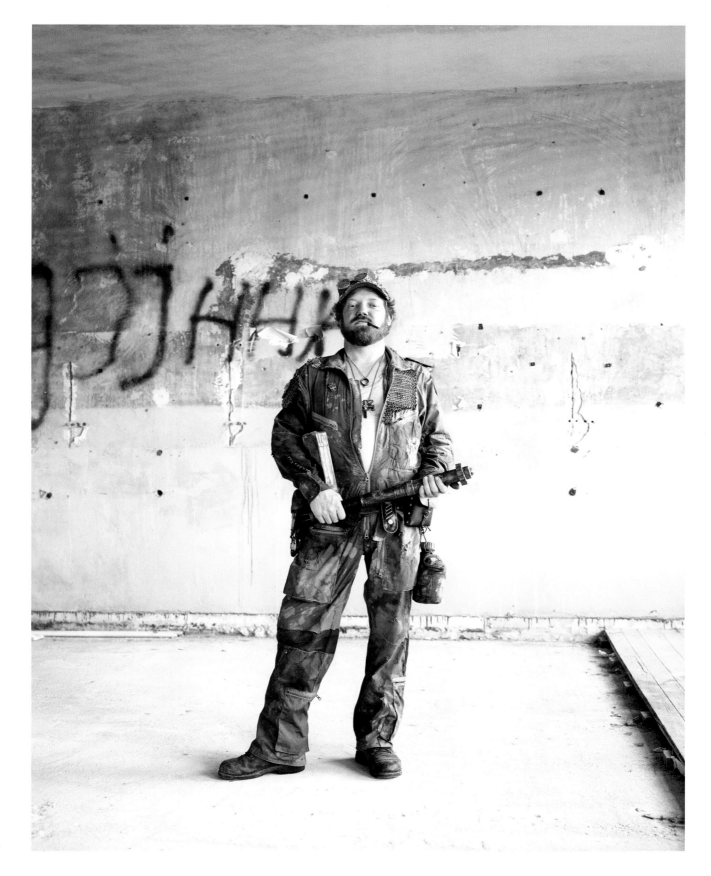

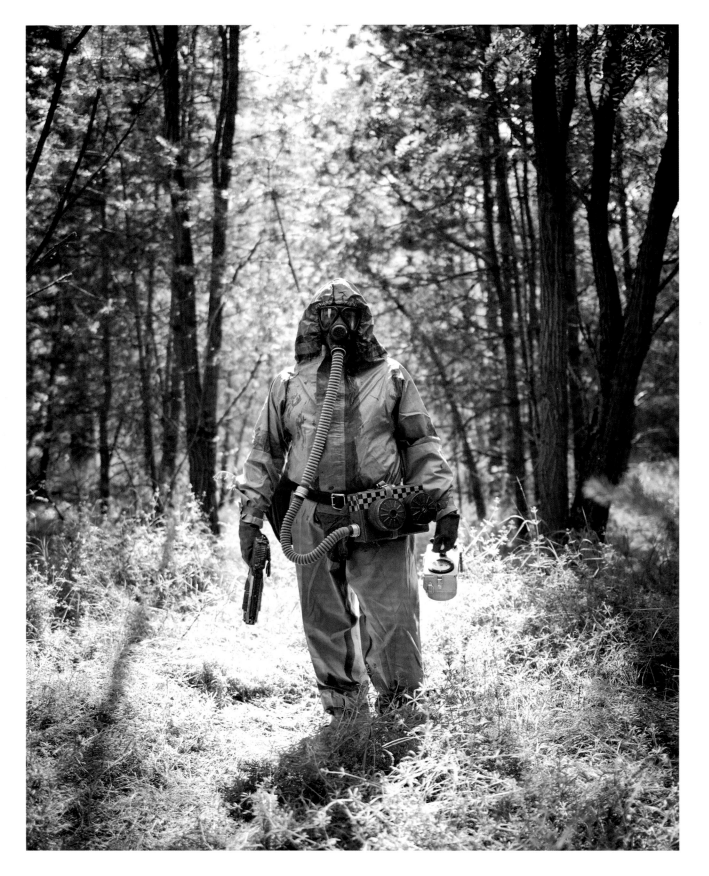

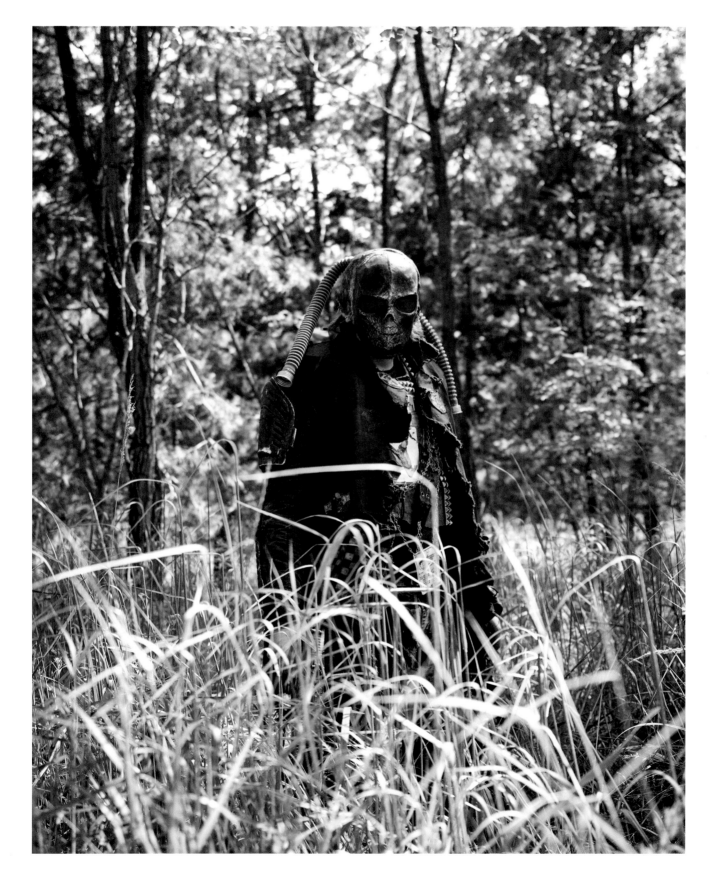

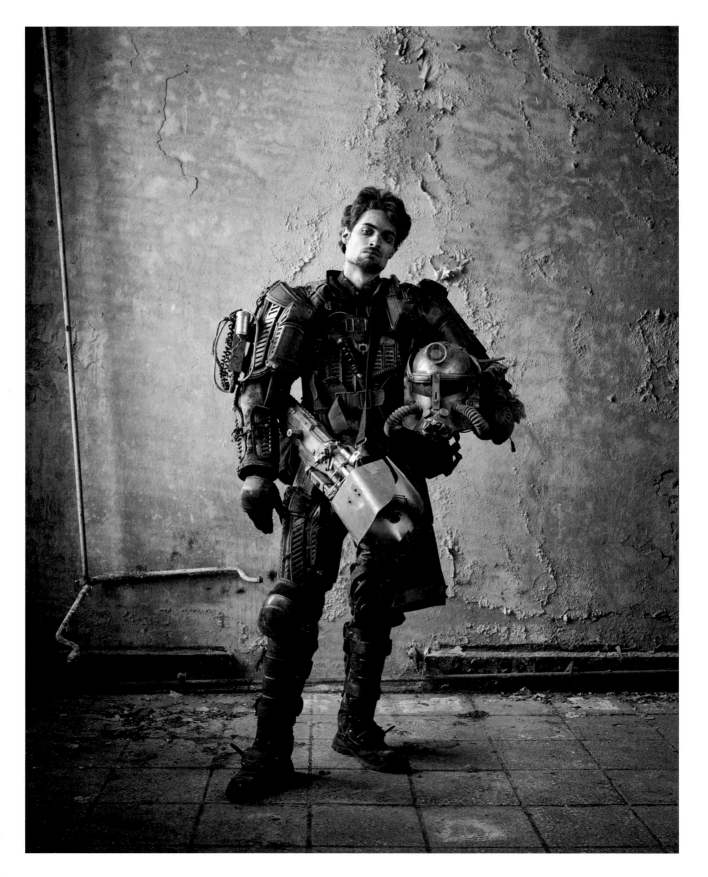

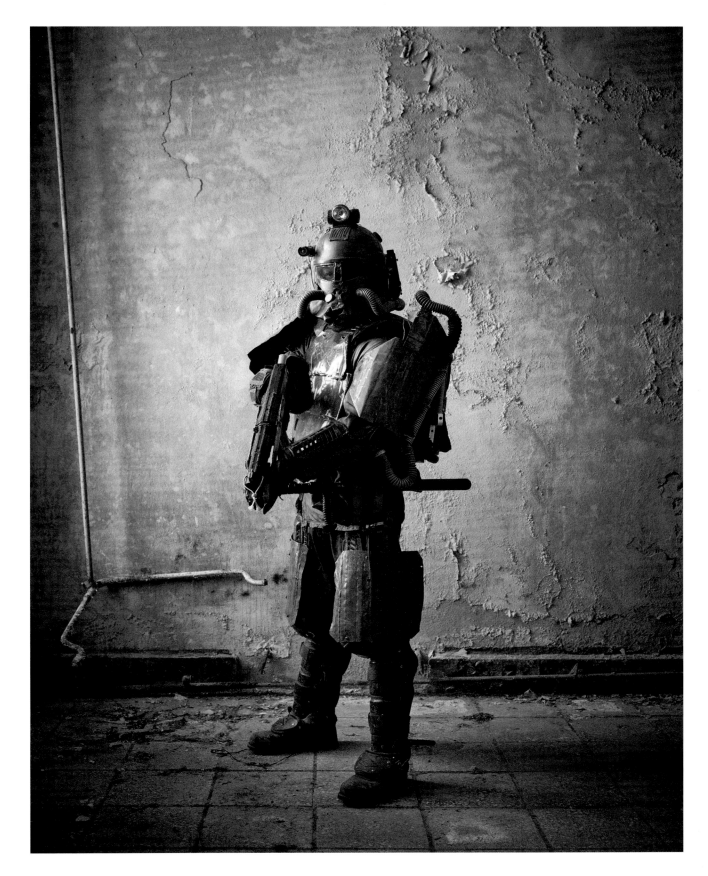

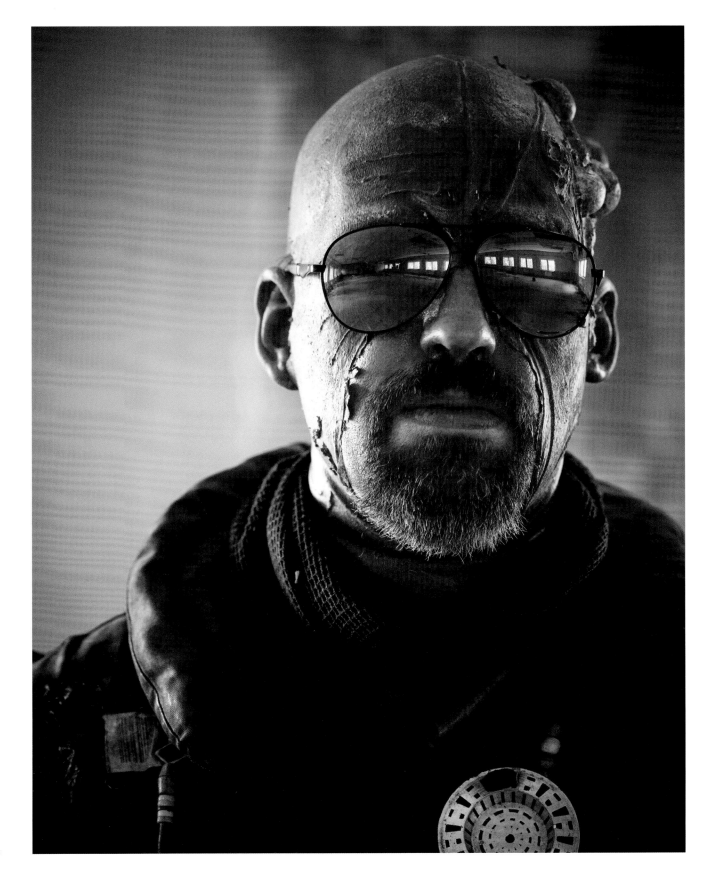

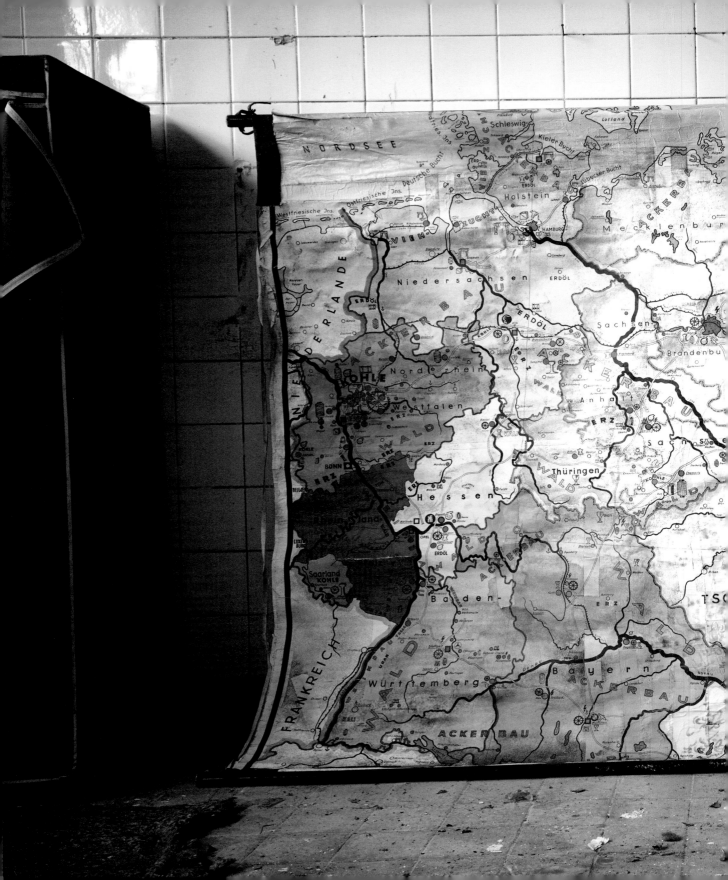

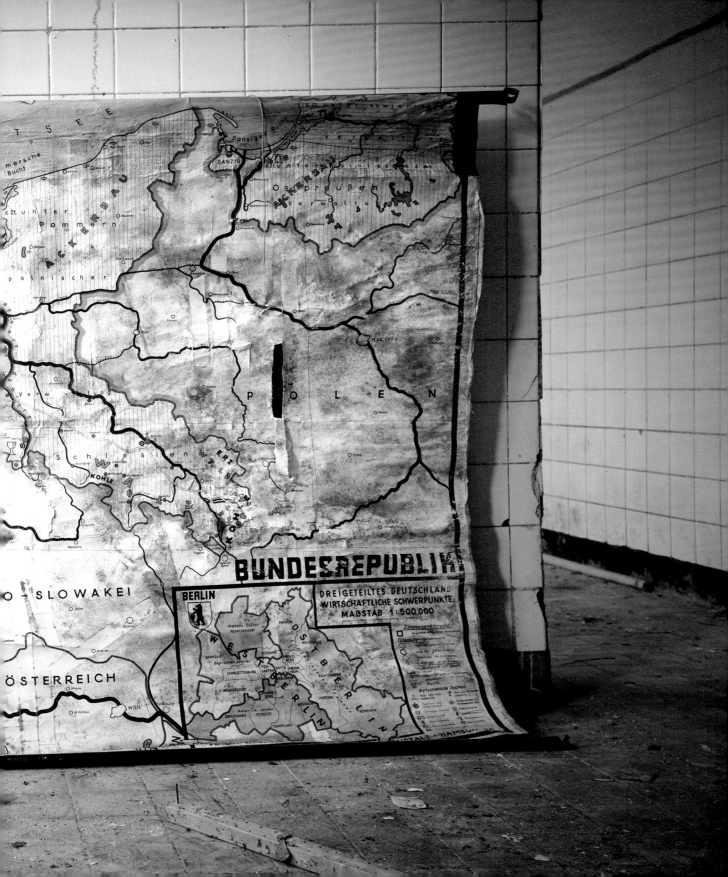

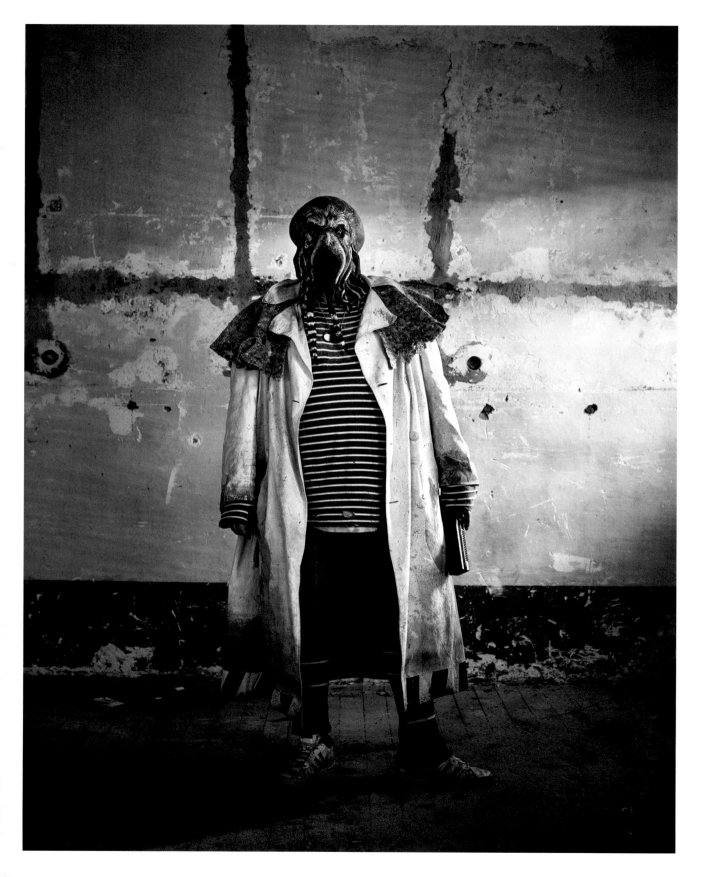

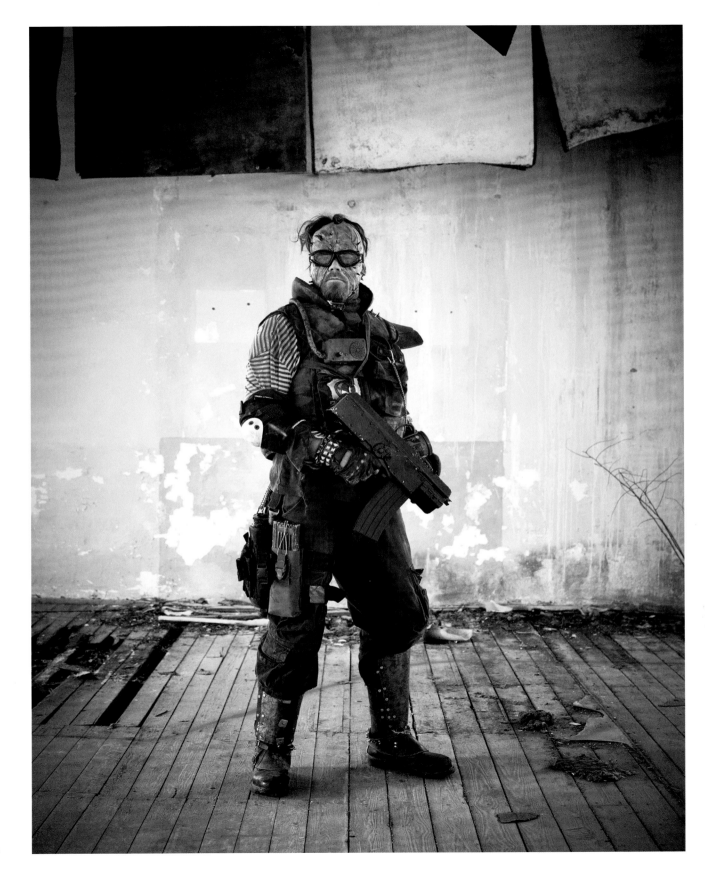

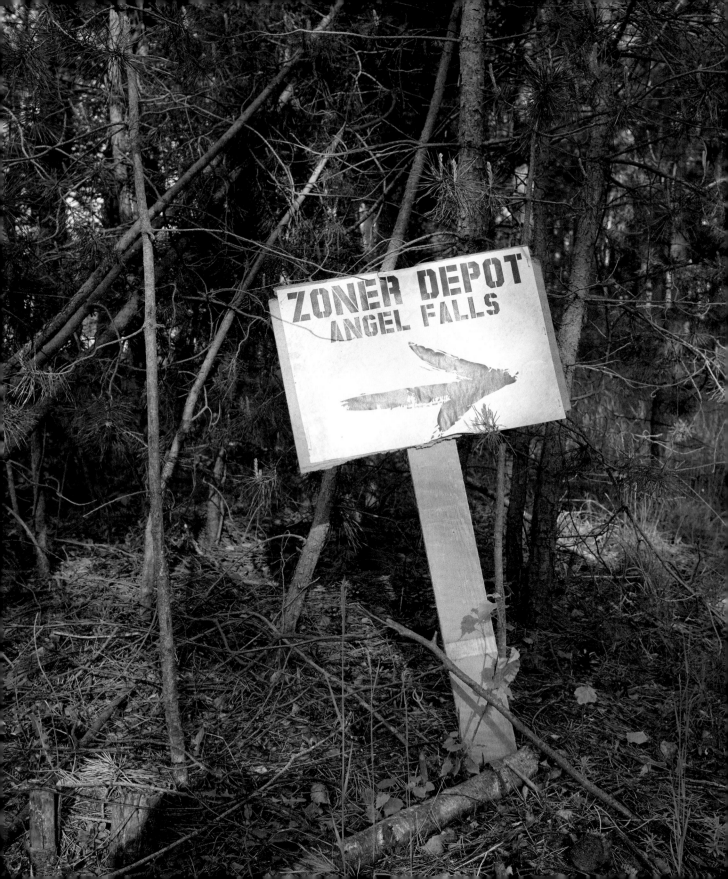

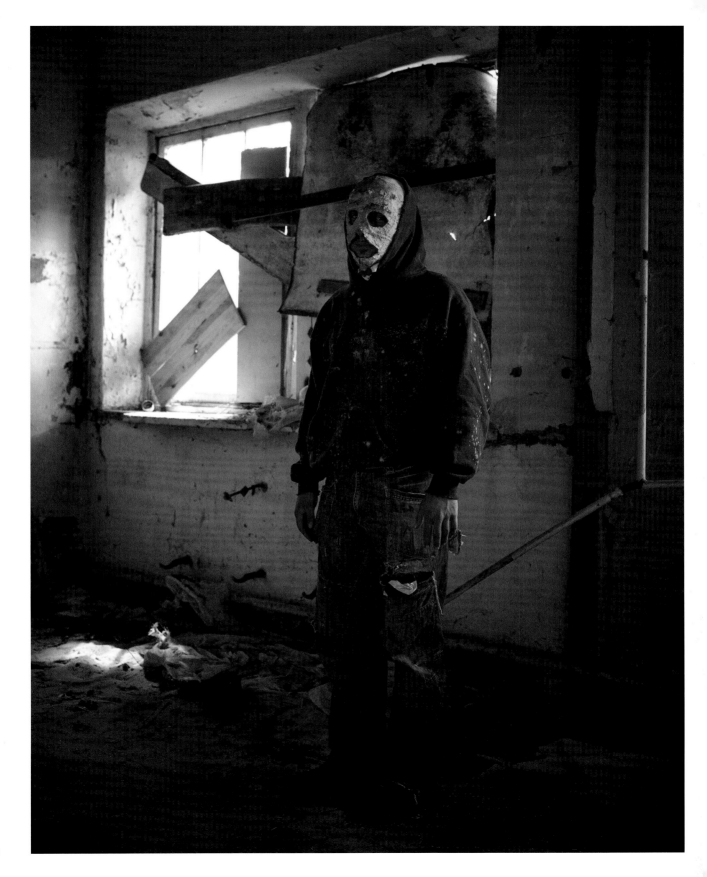

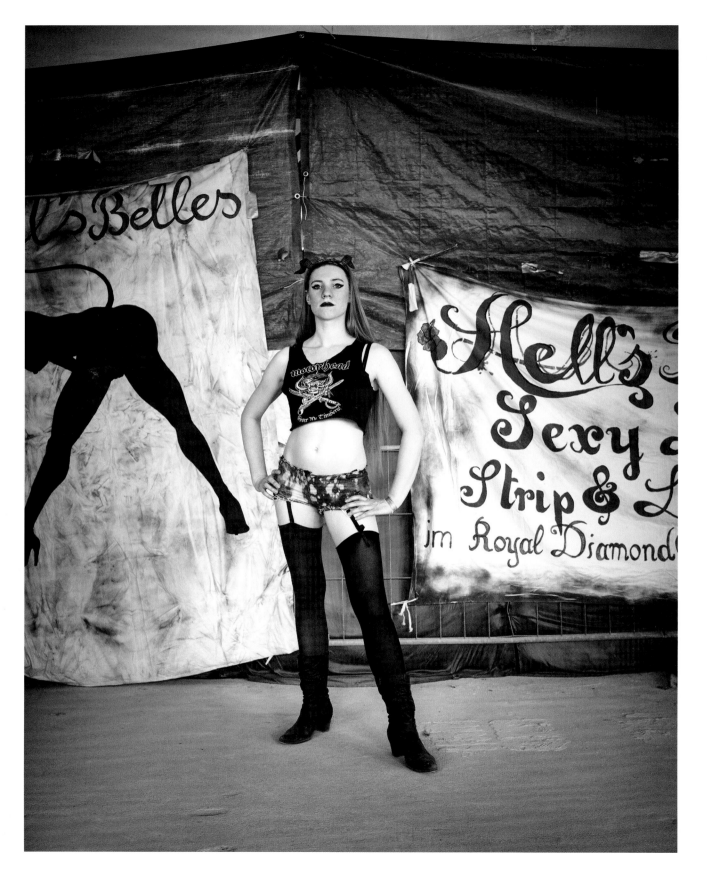

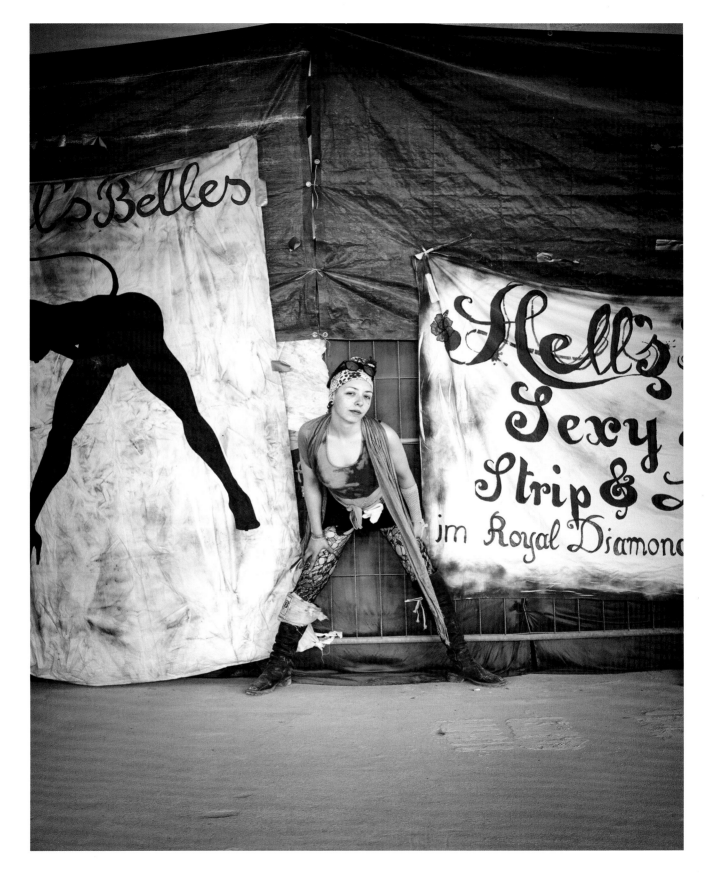

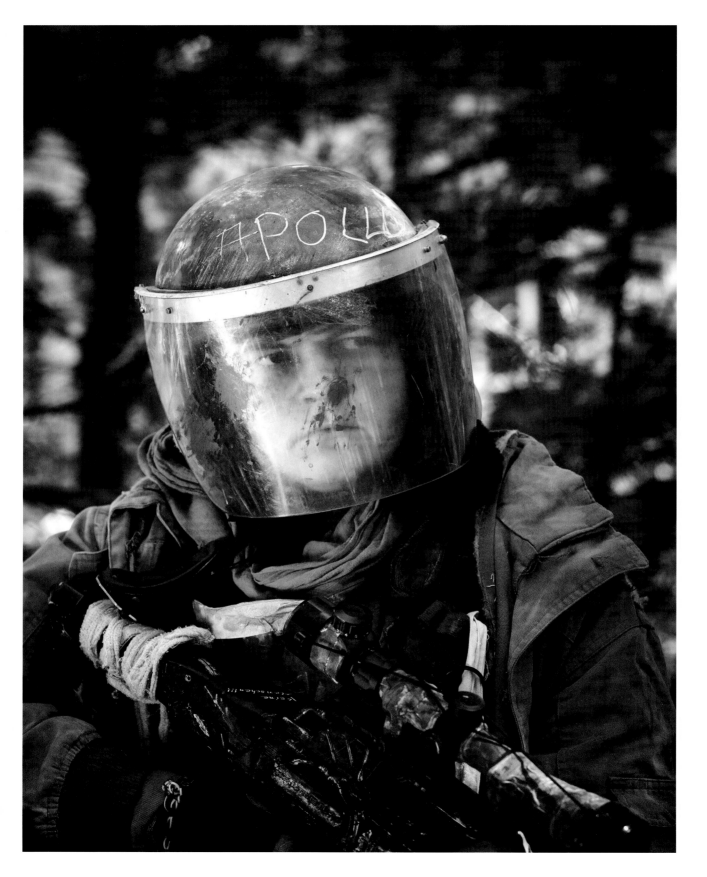

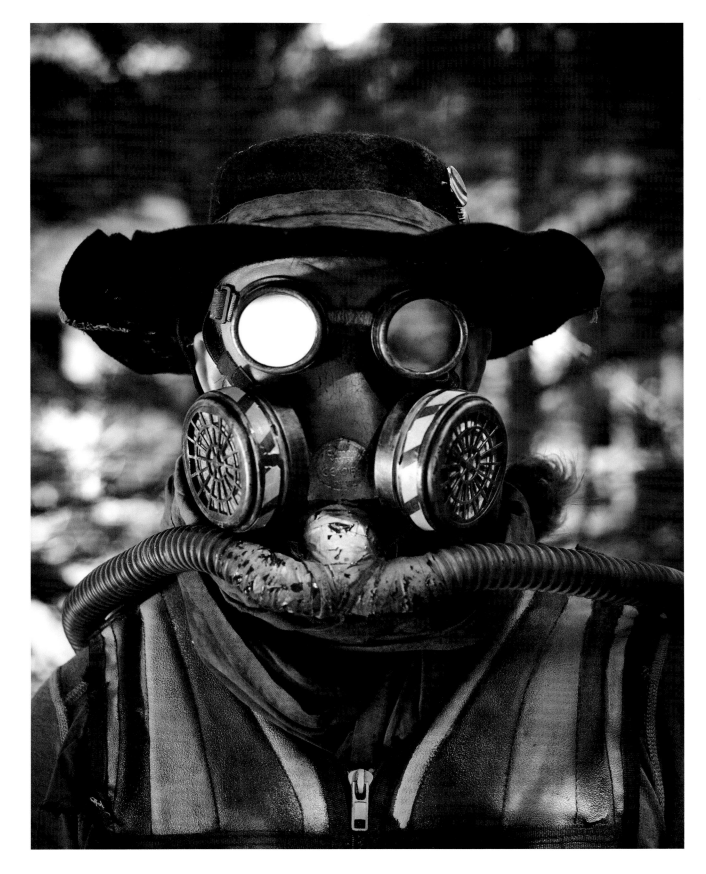

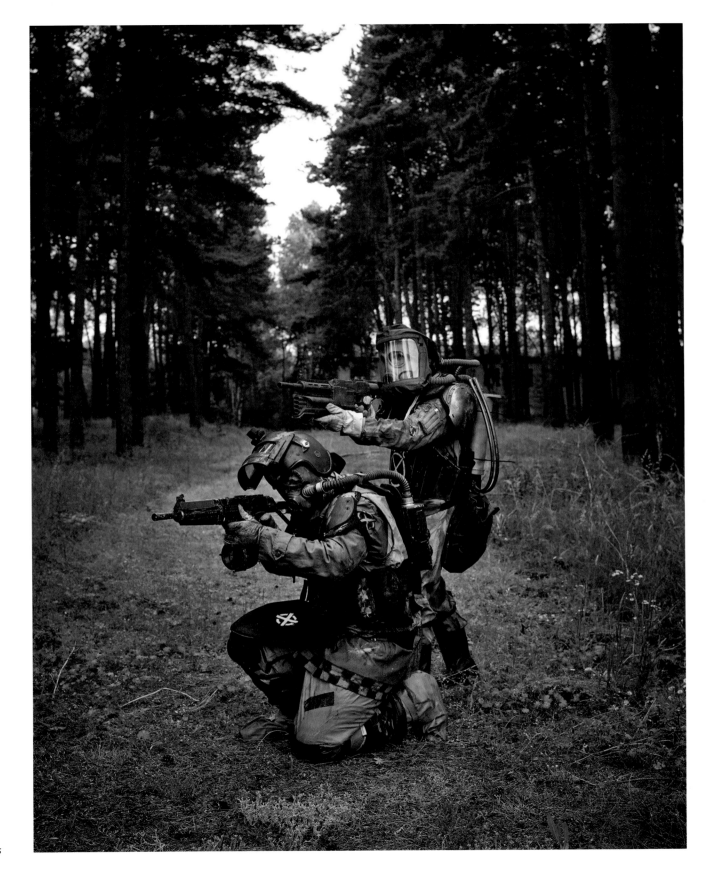

67
S./p.

Elsa von Thalhofen – Ehemalige Kommandantin der Armee des Stahls, in jüngster Zeit Feldmarschallin bei der 5. Division.

Elsa von Thalhofen – Former Commander of the Army of Steel, most recently Field Marshall in the 5th Division.

68
S./p.

Werner Brandt – Pionier und Schütze 2. Klasse, Armee des Stahls, im Kampf gefallen.

Werner Brandt – Pioneer and Rifleman 2nd Class, Army of Steel, killed in action.

69
S./p.

Mark Korn – Gardist 3. Klasse bei der Armee des Stahls.

Mark Korn – Guardsman 3rd Class in the Army of Steel.

70
S./p.

Sarge Schmidt – Pionier, Armee des Stahls.

Sarge Schmidt – Pioneer, Army of Steel.

71
S./p.

Albrecht Lichtenfels – Schütze 1. Klasse, 3. Zug und dienstältester Infanterist, Armee des Stahls.

Albrecht Lichtenfels – Rifleman 1st Class, 3rd Reserve, and longest-serving infantryman, Army of Steel.

72
S./p.

Die Armee des Stahls, im Vordergrund: **Lordnant Jürgen von Brechersgaden** – Infanterieoffizier, 5. Division, ehemals Armee des Stahls.

The Army of Steel, in the foreground: Lordnant Jürgen von Brechersgaden – Officer for the infantry, 5th Division, formerly Army of Steel.

74
S./p.

Dr. Henry-Pierre de Sard – Mutantenforscher und persönlicher Assistent von Stabsarzt Dr. Herzberger, Armee des Stahls.

Dr. Henry-Pierre de Sard – Mutant researcher and personal assistant to Surgeon Major Dr. Herzberger, Army of Steel.

75
S./p.

Dr. Robert Nolan alias „Doc Nolan" – Freier Wasteland-Arzt, kurzzeitig bei der Armee des Stahls und an der Leitung des Lazaretts KGA-5 beteiligt, stammt aus Chemstädt.

Dr. Robert Nolan alias "Doc Nolan" – Free Wasteland physician, briefly with the Army of Steel and involved in the supervision of the sickbay of the KGA-5; born and raised in Chemstädt.

76
S./p.

James „Big Block" Cooper – Anwärter und Türsteher bei den White Stars.

James "Big Block" Cooper – Aspirant and doorman with the White Stars.

77
S./p.

Chips – Vollmitglied bei den White Stars.

Chips – Full member of the White Stars.

78 S./p. „Kotze" – HOGS Mutant Motorcycle Club.

"Kotze" ("Barf") – HOGS Mutant Motorcycle Club.

80 S./p. **Cletus** – Gesang, Teekisten-Bass und Banjo bei den Radi Yokels, ist sein eigener Großvater.

Cletus – Singer, tea-chest bass, and banjo with the Radi Yokels; is his own grandfather.

81 S./p. **Die Schwestern** – Leben zusammen mit den Radi Yokels auf einer Farm irgendwo westlich der Spree und östlich des Mississippi.

The Sisters – Live together with the Radi Yokels on a farm somewhere west of the Spree and east of the Mississippi.

82 S./p. **Gustav alias Der „dreckige" Gustav** – Kundschafter aus Noricum, Anführer des Noricum. Ist unfehlbarer „Demokrator". Im Umland von Angel Falls hat Gustav Anschluss beim „Roten Pakt" gefunden.

Gustav alias "Dirty" Gustav – Scout from Noricum, Leader of the Noricum. The infallible "Democrator." In the area around Angel Falls, Gustav got connected with the "Red Pact."

83 S./p. **Jack Beam** – Verbrachte die meiste Zeit seines Lebens im Bunker, bis er und seine Brüder rausgeschmissen wurden. Der Grund war schlichtweg : Männerüberschuss. Danach waren die Brüder zeitweise bei den „Hetzern", konnten sich aber lossagen. Jack ist nun bei den Söldnern, ehrliches Geld für ehrliche Arbeit… mehr oder minder.

Jack Beam – Spent most of his life in the bunker, until he and his brothers were thrown out. The reason was simply a surplus of males. After that, the brothers occasionally spent time with the agitators, but were eventually able to break away again. Jack is now with the mercenaries: honest money for honest work… more or less.

84 S./p. **Franz Stein** – Man-at-Arms beim Kartell, ehemaliger Sergeant der Armee des Stahls.

Franz Stein – Man-at-Arms with the Cartel; former Sergeant in the Army of Steel.

85 S./p. **Alan O'Leary** – Maler, Mechaniker und Sprengstoffexperte, Irish Brotherhood.

Alan O'Leary – Painter, mechanic, and explosives expert; Irish Brotherhood.

86 S./p. **Ian „The Chief" McFlannigan** – Anführer der Irish Brotherhood.

Ian "The Chief" McFlannigan – Leader of the Irish Brotherhood.

87
S./p.

Red O'Mally – Big Brother (Offizier) und Geldeintreiber bei der Irish Brotherhood, Clan-Chef der O'Mallys South-East für den Bezirk Deutschland. Geboren in Birmingham.

Red O'Mally – Big Brother (Officer) and bill collector with the Irish Brotherhood; Clan Chief of the O'Mallys South-East, district Germany. Born in Birmingham.

88
S./p.

Wassily Churkow – Freier Zoner, arbeitet mit den Zonern der Sewastopolskaja zusammen.

Wassily Churkow – Free Zoner, works together with the Zoners of Sevastopolskaja.

89
S./p.

Unbekannt – Einer der vielen Unbekannten, die um Angel Falls herum durchs Ödland ziehen...

Unknown – One of the many unknowns who wander about the wastelands around Angel Falls...

90
S./p.

Priest – Sergeant, befehlshabender Offizier über den Squat, Schwingen des Stahls (Splittergruppe aus ehemaligen Mitgliedern der Armee des Stahls).

Priest – Sergeant; commanding officer over the Squat, Wings of Steel (splinter group of former members of the Army of Steel).

91
S./p.

Burghardt Gössel alias „Bug" – Normaler Schwingensoldat, unter anderem zuständig für die technische Wartung der Fahrzeuge (Schwingenschleifer), Schwingen des Stahls.

Burghardt Gössel alias "Bug" – Normal Wings soldier, responsible for, among other things, the technical maintenance of vehicles (swing grinder), Wings of Steel.

93
S./p.

Joker – Rotmutant, Mitglied der MFF (Mutierte Folxs Front).

Joker – Red mutant, member of the MFF (Mutated Folxs Front).

96
S./p.

Takelage – Vom Tier zum Sepia-Mutanten mutiert. Ist angeblich aus dem Reich der Toten zurückgekehrt, um eine Botschaft zu überbringen und glaubt, dass der „große Knall" (die Apokalypse) durch das Erwachen alter Götter ausgelöst wurde. Mutationen sind für ihn Geschenke der „Großen Alten", um würdige Kreaturen zu verbessern. Er sieht sich und andere Mutanten demnach als auserwählte und verbesserte Lebewesen.

Takelage (Rigging) – Mutated from an animal to a sepia mutant. He is said to have returned from the land of the dead to convey a message and believes that the "big bang" (the Apocalypse) was triggered by the awakening of ancient gods. For him, mutations are gifts of the "great ancients" to improve worthy creatures; he thus sees himself and other mutants as chosen and improved living beings.

97 S./p. **Dunkel** – Stachelmutant in Blau, sehr selten, Freiheitskämpfer bei der MFF.

Dunkel (Dark) – Spiked mutant in blue, very rare; freedom fighter with the MFF.

99 S./p. **Name: Nr. 12** – Mutant, Art: Frogger, sein Volk wurde bei einer harten langen Schlacht ausgerottet, lebt seitdem in der Mutake.

Name: No. 12 – Mutant, type: Frogger. His people had been wiped out during a long, hard battle; lived since then in the Mutake.

100 S./p. **Vanity Fair** – Ehemals Tänzerin bei den Hell's Belles, sie tanzte Poledance, mit dem Vertikaltuch in der Luft und Tribal Style. Zur Zeit arbeitet sie im Casino von Angel Falls.

Vanity Fair – A former Hell's Belles pole dancer, specializing in aerial silk and tribal style. She is currently working in the casino in Angel Falls.

101 S./p. **Little Lilith** – Tänzerin bei den Hell's Belles.

Little Lilith – Dancer with Hell's Belles.

102 S./p. **Käsus Krustus** – Söldner/Tagelöhner bei der Königlich Bayerischen Landwehr.

Käsus Krustus – Mercenary/day laborer with the Royal Bavarian State Army.

103 S./p. **Alois Schmied** – Übersetzer für Bayerisch und Ödländisch, Königlich Bayerische Landwehr.

Alois Schmied – Translator Bavarian – Wastelandish, Royal Bavarian State Army.

105 S./p. **Kostja und Burns** – Zwei Zoner vom „Zoner-Depot Angel Falls".

Kostja and Burns – Zoners from the "Zoner-Depot Angel Falls."

It is the year 2015, and the Apocalypse continues. For more than two years now, the virus has been spreading into ever more corners of our known world.

In the initial phase of the outbreak, total chaos reigned everywhere, since no one knew what was happening, who the bloodthirsty lunatics were, if zombies were indeed overrunning the world or if it was only a matter of overblown newspaper hoaxes. This lack of knowledge was quickly dispelled when they attacked the survivors in masses. Everyone against everyone, total communication breakdown, no one knew anything.

Six months after the outbreak, the Azura virus has been more or less decoded by various private companies simultaneously, and the N.O.A. antidote is somewhat "more easily available" than in the initial phase of the outbreak, but still extremely expensive. In the meantime, the virus has altered its hosts to such an extent that the zombies have developed a noticeable sensitivity to light. During the daytime (at least in strong sunlight), they retreat into buildings, under bridges, and into natural shelters. Only in great masses do they still move freely in the sunshine in so-called "zergs."

The worldwide zombie war has reached a climax. Aware of the hour upon them, everyone is armed and ready... or already infected and dead.

The cities are virtually inaccessible, and most of the detention and refugee camps are overrun or infected from within. The governments of several countries in Central Europe have recovered from the paralyzing initial shock and now attempt to save whatever can be saved, particularly themselves.

Due to the relatively small number of safe zones, the majority of survivors continue to fight alone and are forced to depend on their own resources.

The so-called "hide-and-run" tactic and "private" safe houses secure their daily survival. Small tracks of randomly thrown together civilians are repeatedly formed, who, together with their families, try to find a safe zone that is still open.

Others, in turn, have switched to the "survival mode" – regardless of consequences, they roam about as plunderers and take whatever they need.

Zombie

Apokalypse

Wir schreiben das Jahr 2015 und die Apokalypse hält an. Seit mehr als zwei Jahren verbreitet sich das Virus und erschließt immer mehr Winkel unserer bekannten Welt.

Am Anfang des Ausbruchs herrschte überall totales Chaos, weil niemand genau wusste, was vor sich ging, wer diese blutrünstigen Irren waren, ob wirklich Zombies die Welt überrannten oder ob es nur aufgebauschte Falschmeldungen waren. Dieses Unwissen zerstreute sich sehr schnell, als sie in Massen über die Überlebenden herfielen. Jeder gegen jeden, totaler Kommunikationsausfall, niemand wusste irgendetwas.

Sechs Monate nach dem Ausbruch wurde das Azura-Virus von verschiedenen Privatfirmen gleichzeitig fast vollständig entschlüsselt, und das N.O.A.-Gegenmittel ist etwas „leichter verfügbar" als am Anfang des Ausbruchs, aber immer noch extrem teuer. Inzwischen hat das Virus seine Wirte so weit modifiziert, dass die Zombies eine deutliche Lichtempfindlichkeit entwickelt haben. Tagsüber (zumindest bei starkem Sonnenlicht) ziehen sie sich in Gebäude zurück, hocken unter Brücken und in natürlichen Unterständen. Nur in großen Massen bewegen sie sich bei Sonnenschein noch frei in sogenannten „Zergs".

Der weltweite Zombie-Krieg hat einen Höhepunkt erreicht. Inzwischen weiß jeder, was die Stunde geschlagen hat, ist bewaffnet und bereit... oder bereits infiziert und tot. Die Städte sind praktisch unzugänglich, die meisten Internierungs- und Flüchtlingslager sind überlaufen oder von innen heraus infiziert. Die Regierungen etlicher Länder Mitteleuropas haben sich von dem lähmenden ersten Schock erholt und versuchen nun zu retten, was zu retten ist, ganz besonders sich selbst.

Aufgrund der vergleichsweise geringen Anzahl von Sicherheitszonen kämpft die Mehrheit der Überlebenden weiterhin allein und auf sich gestellt dort draußen.

Die sogenannte „hide-and-run"-Taktik sowie „private" Safe-Häuser sichern das tägliche Überleben. Immer wieder bilden sich kleine Trupps aus wahllos zusammengewürfelten Zivilisten, die mit ihren Familien versuchen, doch noch eine offene Safe-Zone zu finden.

Andere Überlebende wiederum haben inzwischen auf „Überlebensmodus" geschaltet. Ohne Rücksicht auf Verluste ziehen sie als Plünderer durch die Lande und nehmen sich, was sie brauchen.

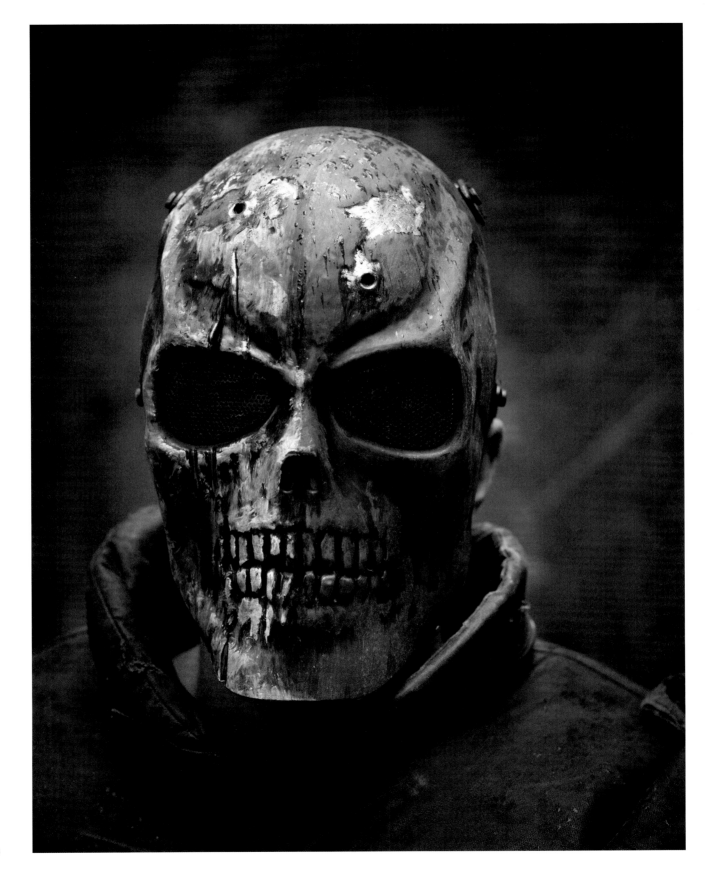

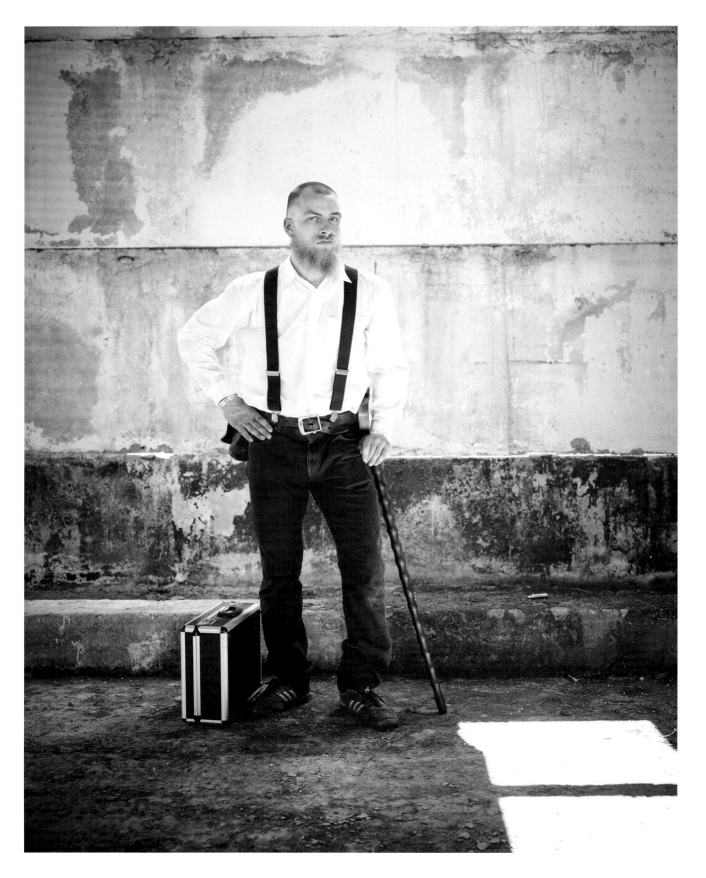

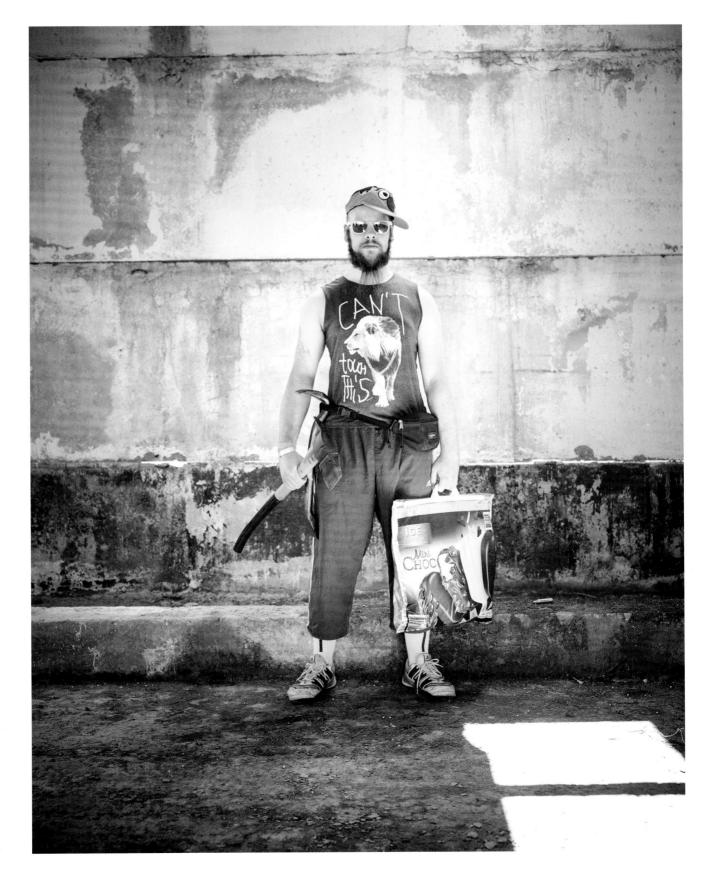

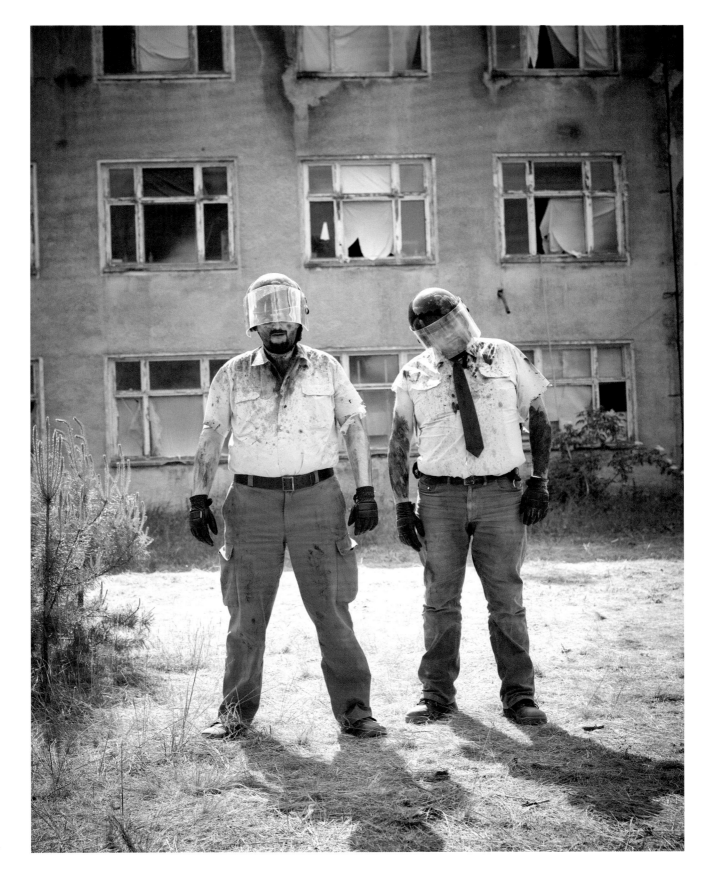

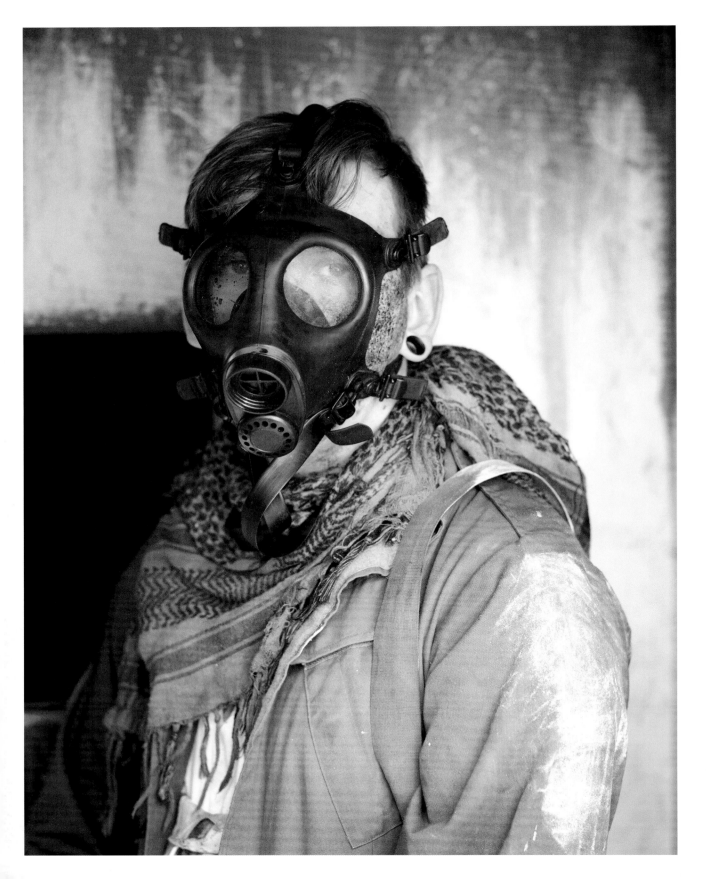

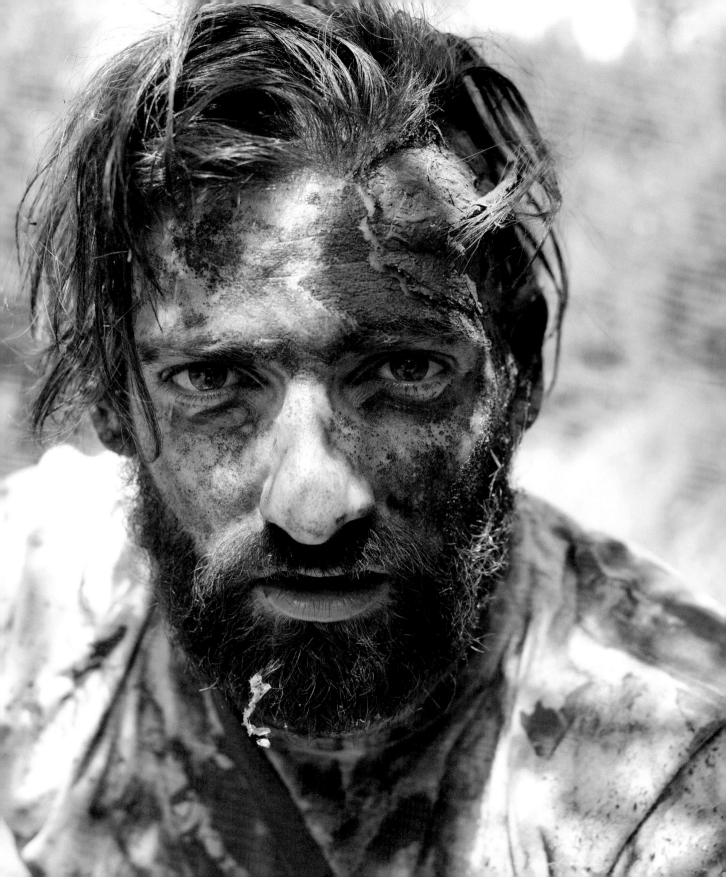

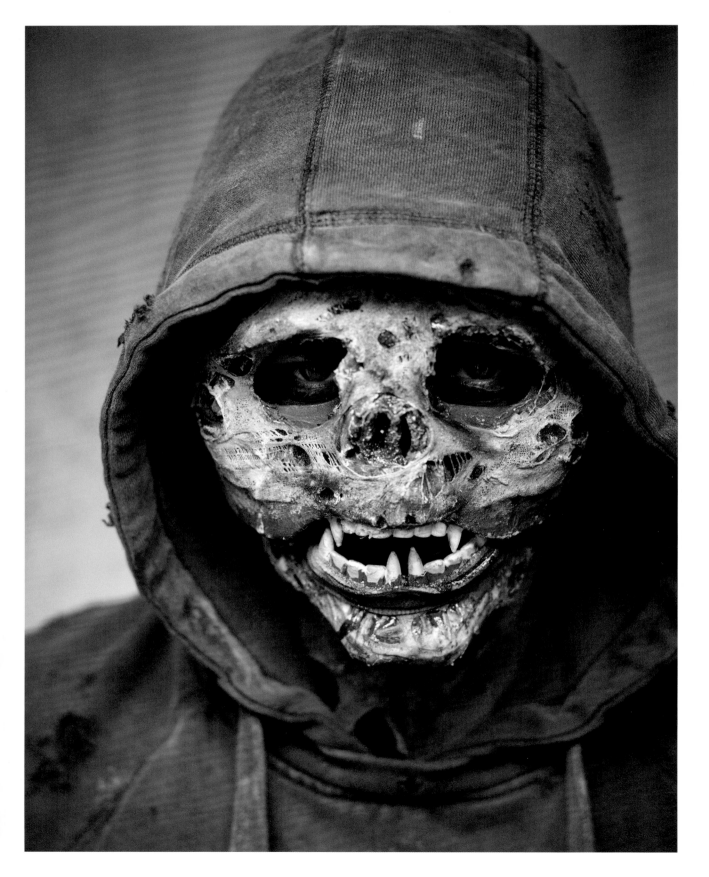

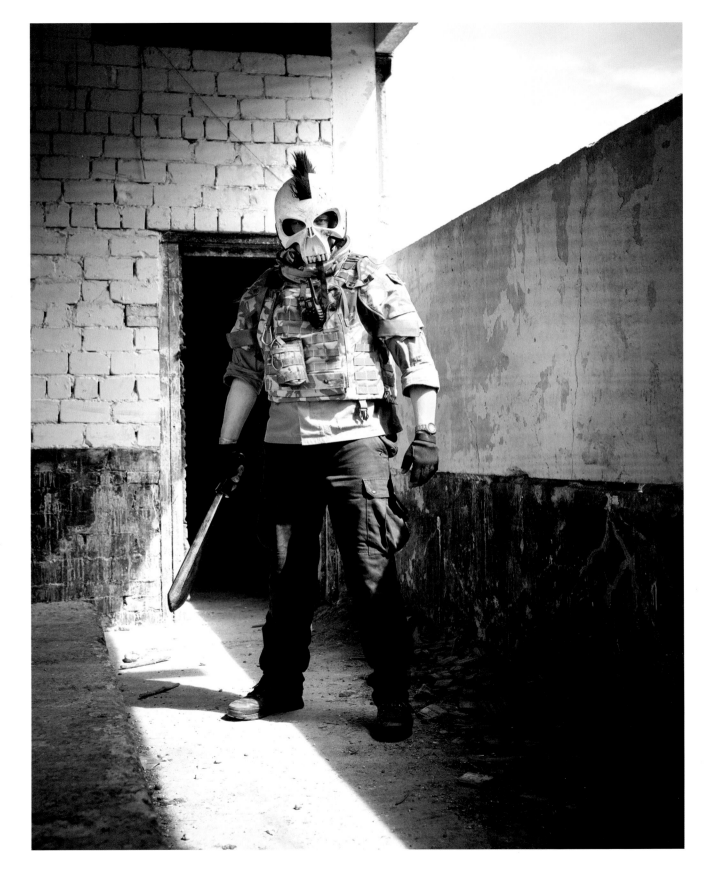

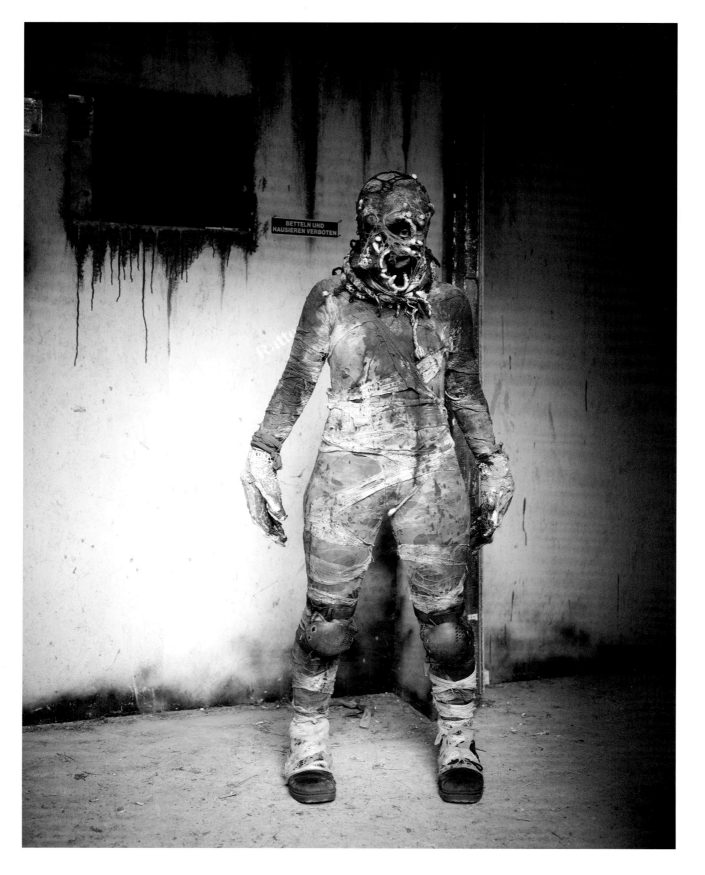

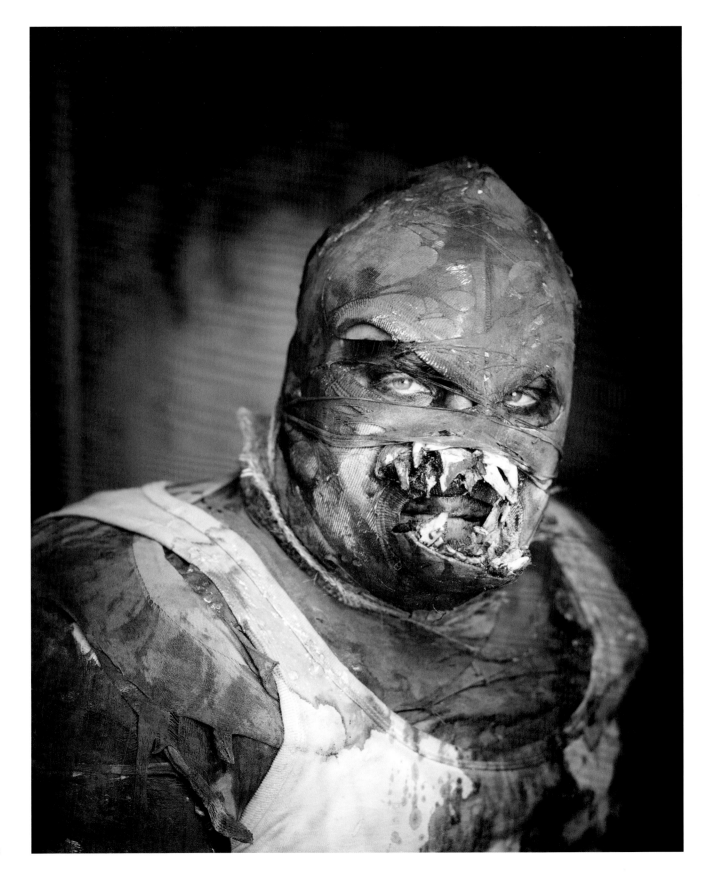

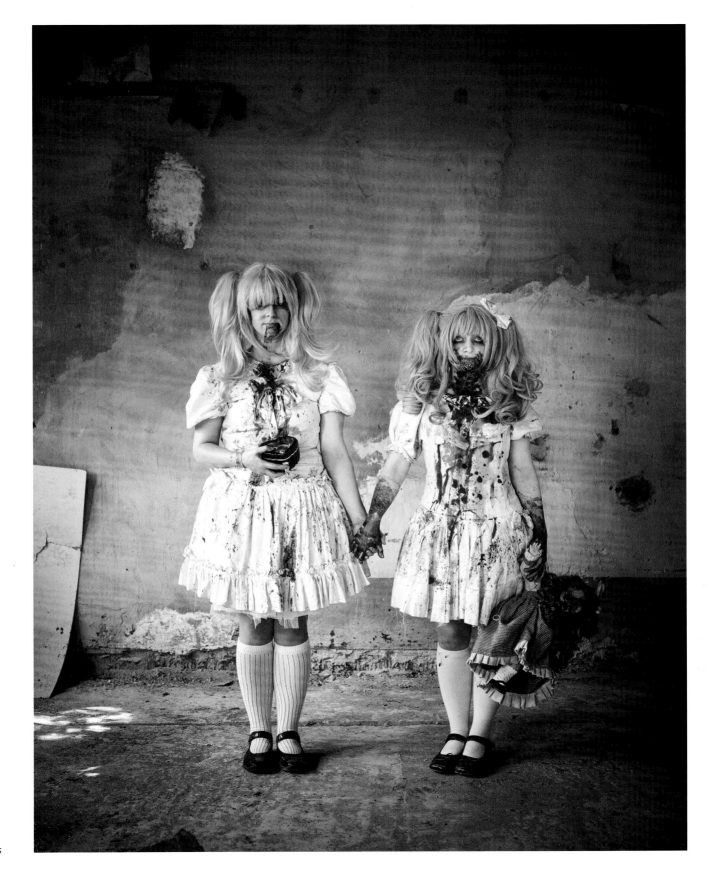

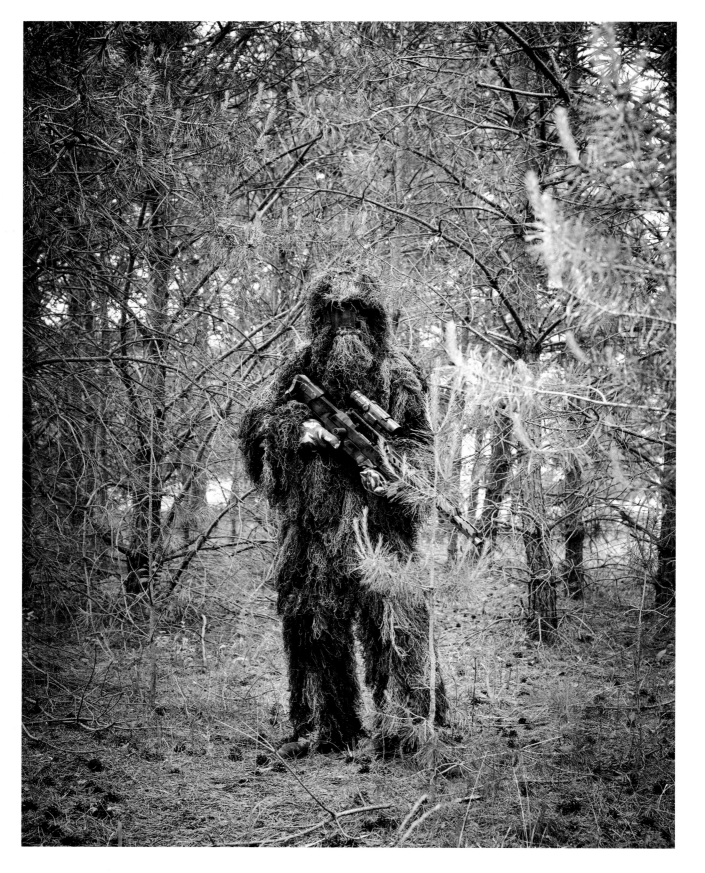

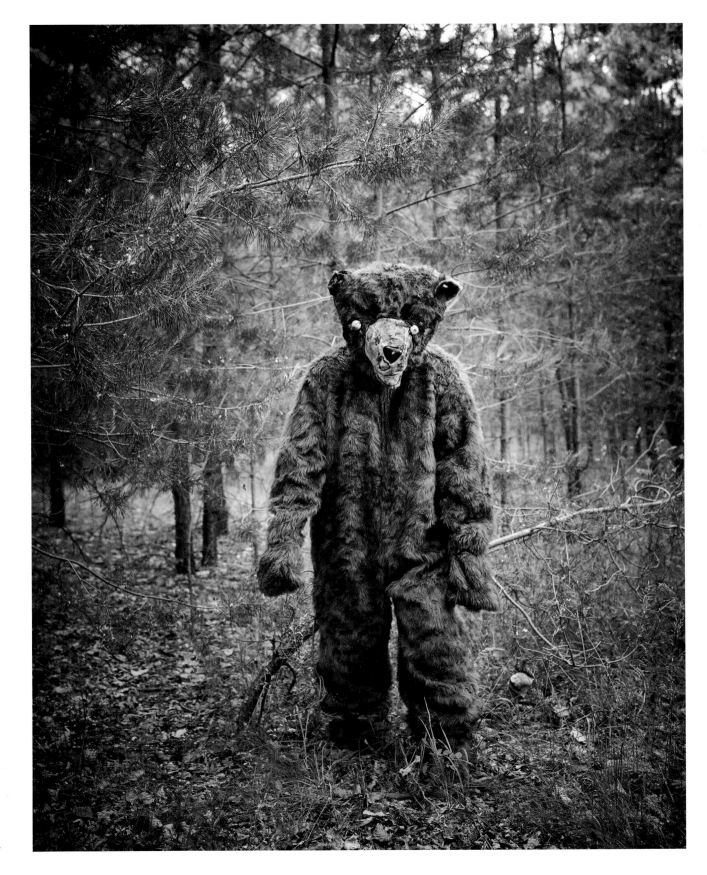

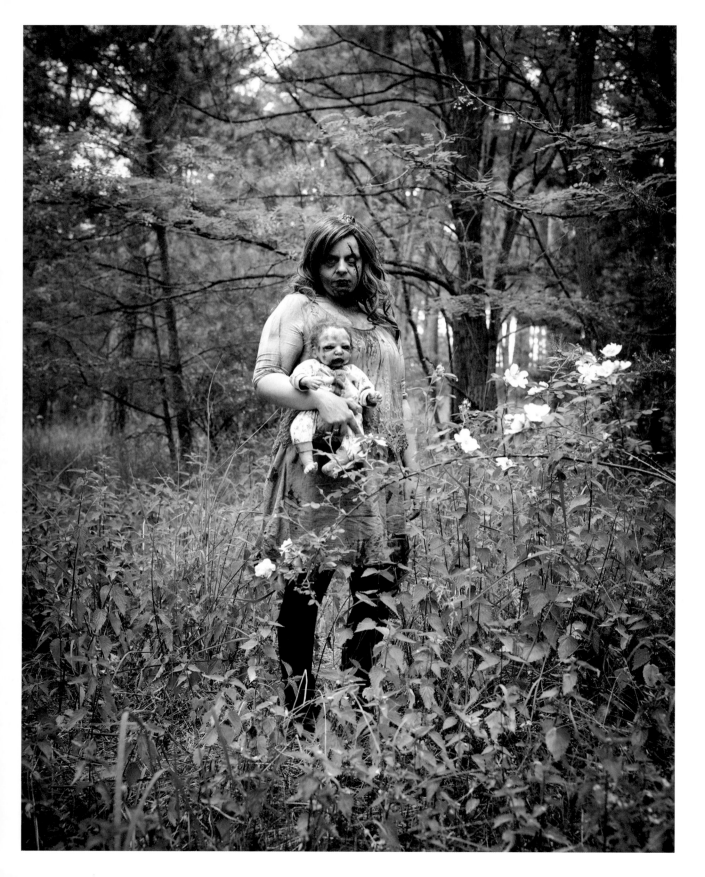

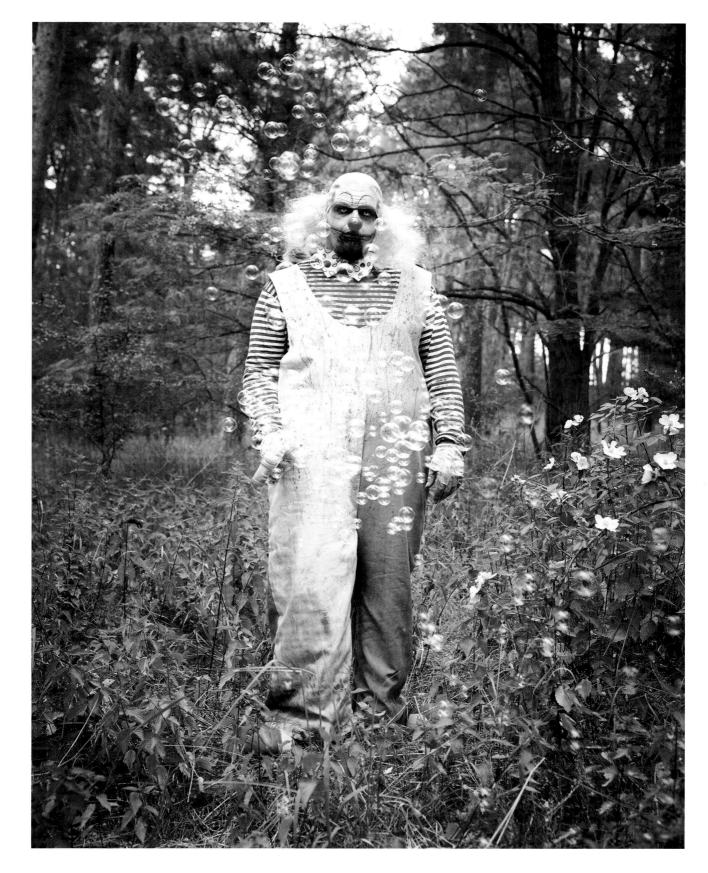

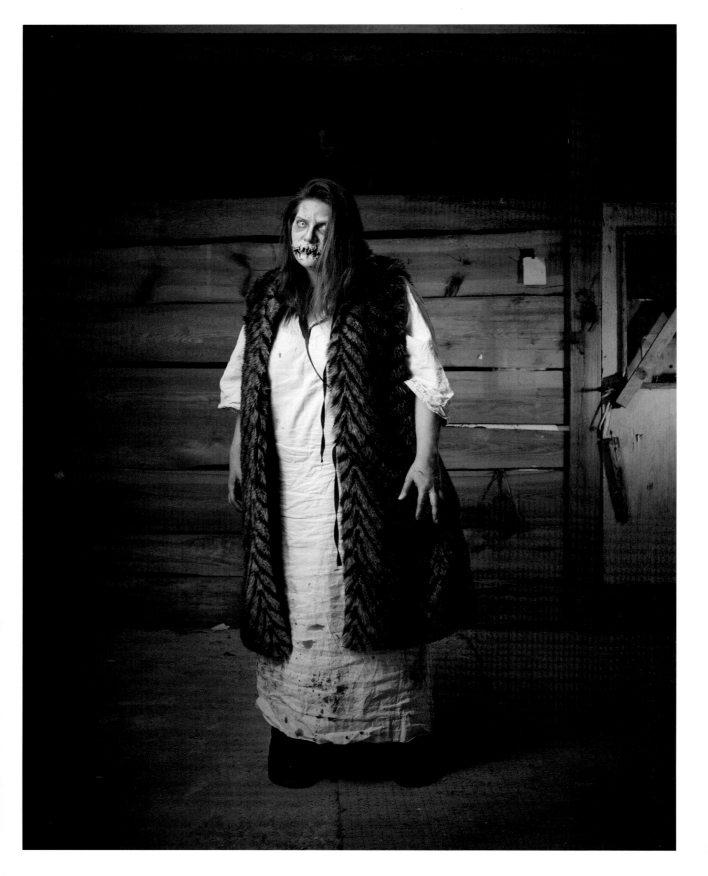

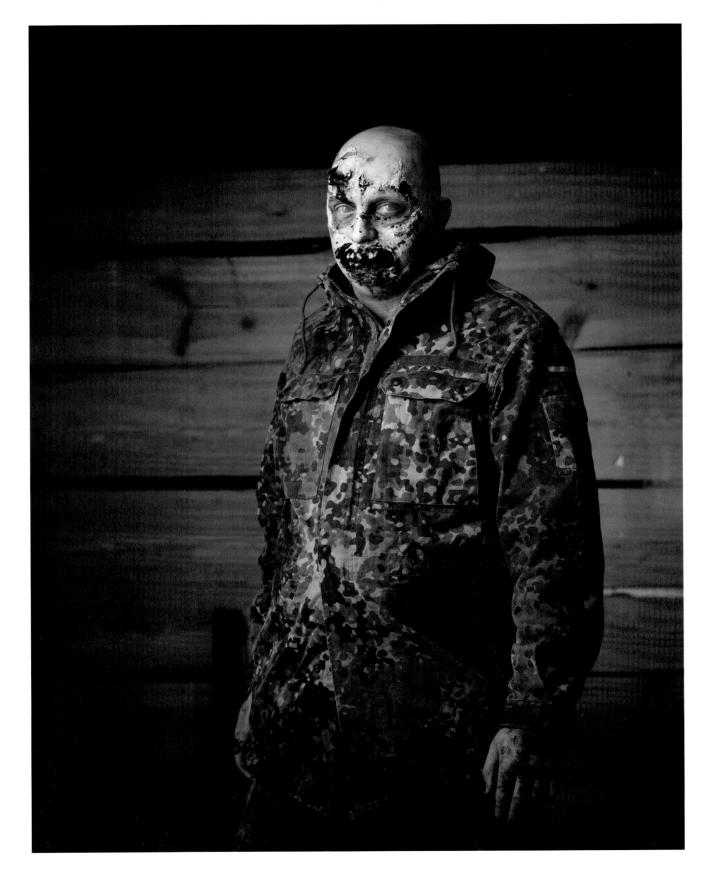

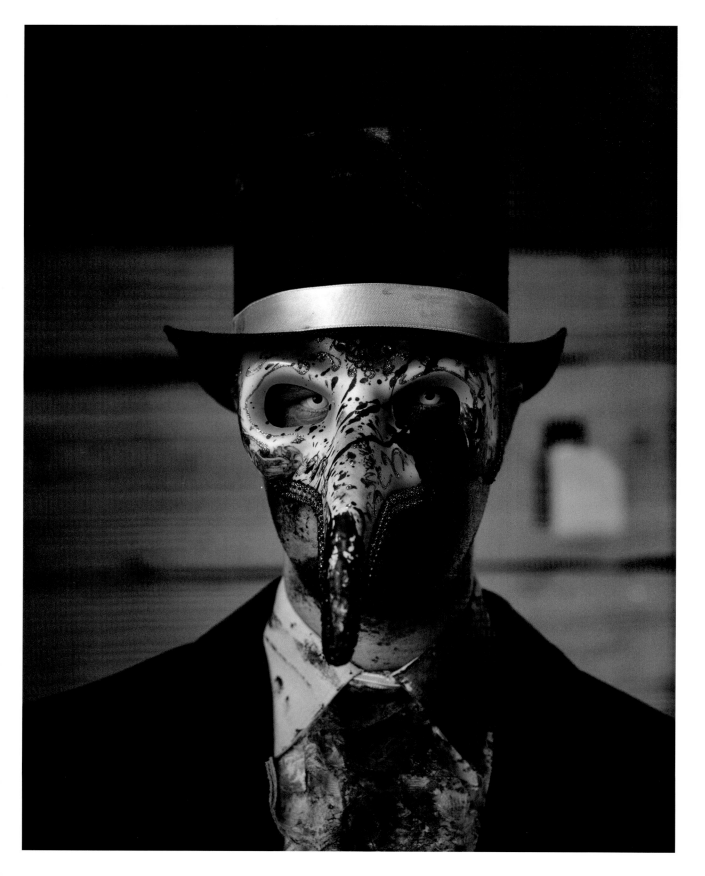

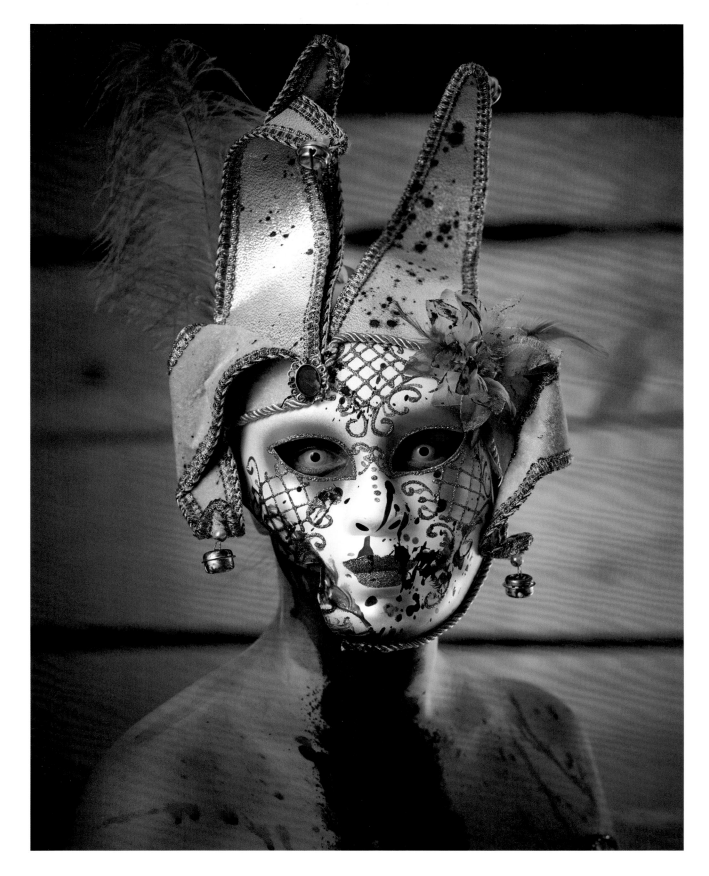

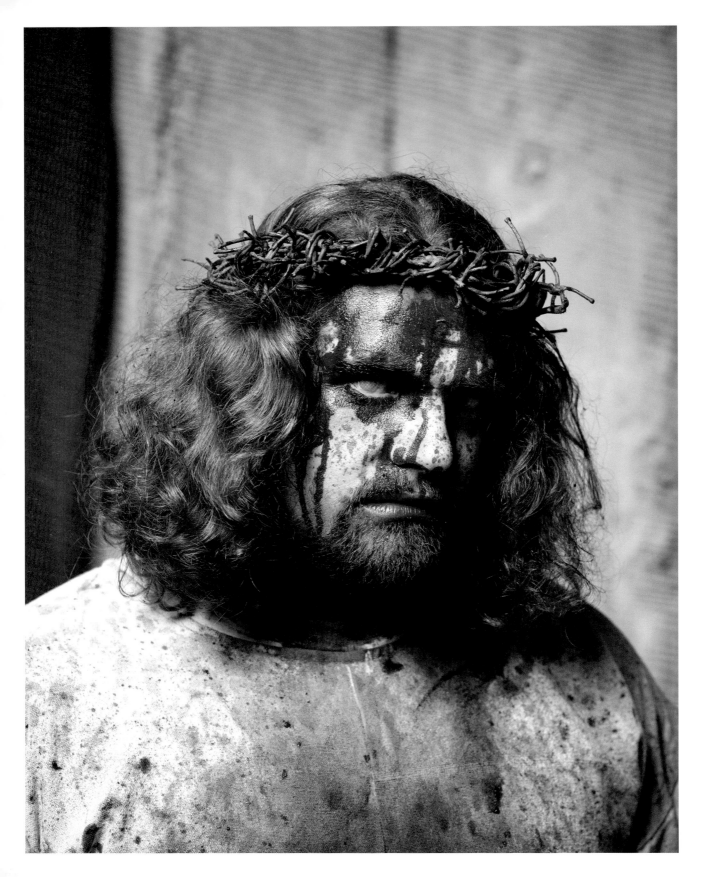

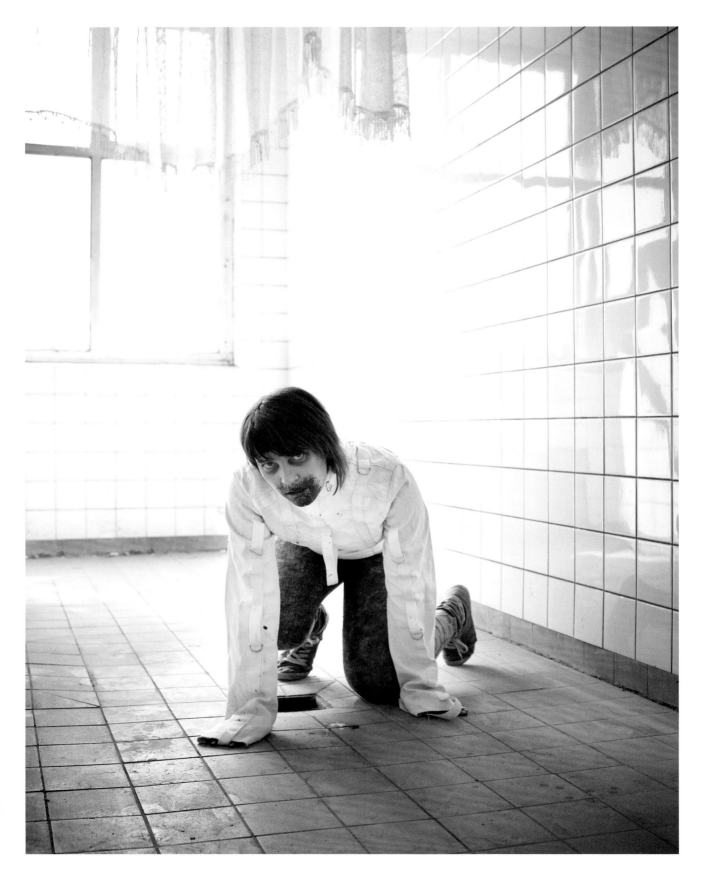

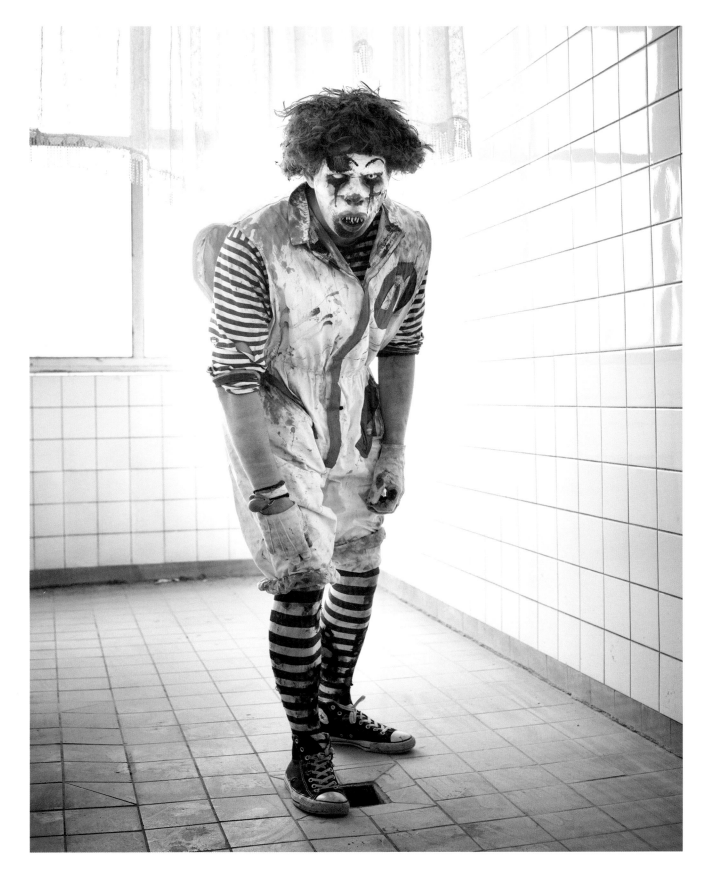

113
S./p.

Corporal Gustav Kramer alias „Sweety" – Söldner im Kampf gegen die Untoten; im Kampf immer in der ersten Reihe; hat eine Schwäche für Süßigkeiten, (NSC).

Corporal Gustav Kramer alias "Sweety" – Mercenary, fighting the undead; in the fight always in the first row; has a weakness for sweets, (NSC).

114
S./p.

Manfred von Eberschwengel – Gentleman und Bewährungshelfer, Überlebender der Zombie Apokalypse.

Manfred von Eberschwengel – Gentleman and probation officer, survivor of the Zombie Apocalypse.

115
S./p.

Jeremy-Pascal – Junger Kleinkrimineller, ebenfalls Überlebender der ZA.

Jeremy-Pascal – Young small-time criminal, also a survivor of the ZA.

117
S./p.

Zombie Polizisten – Früher Justizvollzugsbeamte in Sachsen.

Zombie Police – Former prison officers in Saxony.

118
S./p.

Nick Custer alias „Neph" – Widerstandskämpfer.

Nick Custer alias "Neph" – Resistance fighter.

119
S./p.

Die Verwandlung eines frisch Infizierten.

The transformation of a recently infected.

120
S./p.

Crawler – Identifizierung nicht möglich.

Crawler – Identification is not possible.

121
S./p.

Lt. Felix Schwarzwand – 2. Division „Titan" des Ugandan Mercenary Corps (UMERC).

Lt. Felix Schwarzwand – 2nd Division "Titan" of the Ugandan Mercenary Corps (UMERC).

122 / 123
S./p.

Crawler – Identifizierung nicht möglich.

Crawler – Identification is not possible.

125
S./p.

Die Twins – Marie und Louise (von rechts nach links), geschätztes Alter um die 12 Jahre.

The Twins – Marie and Louise (from right to left); estimated age: roughly twelve years old.

126
S./p.

Identität unbekannt – Scharfschütze, gehört einer Gruppe von ehemaligen Bundeswehrsoldaten an.

Identity unknown – Sniper, belongs to a group of former Bundeswehr soldiers.

127
S./p.

„Teddy" – Ehemaliges Kindermädchen der Twins, wurde beim Spielen von den Twins gebissen.

"Teddy" – The twins' former nanny, who was bitten by them while playing.

130
S./p.

Molly MacNeck – Frau eines Moonshiners, sie war schwanger, als sie im Streit von einem Familienmitglied in eine Zombiehorde gestoßen wurde, während ihrer Verwandlung gebar sie ihren Sohn Lazarus.

Molly MacNeck – Wife of a moonshiner; she was pregnant when, during a fight, she was shoved by a member of her family into a horde of zombies; during her transformation, she gave birth to her son Lazarus.

131
S./p.

Gonko – Ehemaliger Varieté-Künstler im Zirkus Harlekin, Russland.

Gonko – Former vaudeville artist in the Circus Harlequin, Russia.

132
S./p.

Testobjekt 247 – Name, Alter und Herkunft unbekannt, Geschlecht: weiblich.

Test Object 247 – Name, age, and family background unknown; sex: female.

133
S./p.

Nico – Ehemaliger Soldat, im Kampf infiziert worden, floh zusammen mit Testobjekt 247 aus militärischer Gefangenschaft.

Nico – Former soldier, infected in battle, fled from military internment together with Test Object 247.

134 / 135
S./p.

Venezianisches Paar – Sorgten für Aufsehen, als sie eines Abends zusammen einen Walzer tanzten, normalerweise tanzen Zombies nicht, ihre Hintergrundgeschichte ist unbekannt.

Venetian Couple – Attracted attention when they danced a waltz together one evening – zombies do not normally dance. Their background story is unknown.

136
S./p.

Harald Töpfer – Ehemals großer Harry Potter Fan, wurde auf einer „Hogwarts-Party" überrascht und gebissen, wie auch vier seiner Freunde.

Harald Töpfer – Was once a great fan of Harry Potter; he and four of his friends were surprised and bitten at a "Hogwarts Party."

138

S./p.

Zombie Jesus – Wird von seiner Anhängerschaft, den Jüngern der Sieben Siegel, als der wahre Erlöser gesehen.

Zombie Jesus – He is seen by his followers, the Disciples of the Seven Seals, as the true savior.

140

S./p.

Elenor – Ehemalige Patientin der Psychiatrie, Diagnose: Schizophrenie mit suizidalen Tendenzen, sie wurde eingeliefert, da sie Stimmen hörte, die ihr befahlen, sich selbst zu verletzen. Flüchtete mit ihrer Schwester Vanessa, einer ehemaligen Soldatin, bis sie eines Tages infiziert wurde und kurz danach ihre eigene Schwester anfiel und ebenfalls infizierte.

Elenor – Former psychiatric patient; diagnosis: schizophrenia with suicidal tendencies. She was admitted because she had heard voices which commanded her to hurt herself. She fled with her sister Vanessa, a former soldier, until she was infected one day and shortly thereafter attacked and infected Vanessa.

141

S./p.

Ronald McDonald – Arbeitete ehemals als Maskottchen für eine bekannte Fastfood-Restaurantkette.

Ronald McDonald – Formerly employed as the mascot of a well-known chain of fast food restaurants.

Aké – it is a world outside of space and time, ruled by the mysterious Lesath people. Some ten years ago, after eons of neglect, the custom of the Battle of the Nations was revived. Those invited to participate founded their own camps in the land of the Lesath. Often – and not always with the conscious knowledge of the newcomers – this took place on the same sites where their ancestors had set up camp in primeval times. In contrast to the worlds beyond the sphere of the Lesath, one did not actually die here; one reappeared after death in the sanctum of one's own camp. The camps were only inhabited in the days immediately before, during, and after the games. Only then was access to the world of the Lesath possible. So it was in the past and so shall it be once again.

For the Lesath it is their world, and the games are played according to their rules, as it has been since the beginning of time. Nevertheless, the other worlds and peoples out there have changed over time, and the world of the Lesath no longer seemed to be as it once was. After only several cycles of the revived games, it became clear that an ancient adversary of the Lesath had manifested itself in the shadows: Theki, the dark goddess! But not only that! In the form of the high priestess Inan Amun, who had been struck down the year before, the evil myrmidons attacked the Lesath themselves and overthrew the given order. It was even rumored in the meantime that several inhabitants could stay throughout the year in the world of the Lesath, and that dark cults of a new, as of yet unknown divine power had gained access...

Today, in the tenth year after the revival of the games, there are once again twelve camps: those of the free city of New Ostringen, the Empire, the Convention, the Green Comets, the Pilgrims, the King, the Elves, and the Ancients, as well as the Norrelag, the Ork Legion, the Hordes of Chaos, and – participating this year for the first time – the Old Way.

The goal of the Lesath competition, with its many battles and challenges, was to determine the strongest camp. The mode of the games was changed by the Lesath for mysterious reasons. The large competitions were replaced by a great battle, in which the camps measure themselves. The Lesath sense that their power is threatened, not only by the dark powers, which, unobserved, have gained new strength, but by the increasing influence of the camps and of the free city of New Ostringen with its ever-expanding urban neighborhoods. The future is uncertain: a battle has broken out in the world and the victor...

⚔ EPIC ⚔ EMPIRES

Aké — eine Welt außerhalb von Raum und Zeit, beherrscht von dem geheimnisvollen Volk der Lesath. Vor inzwischen zehn Jahren wurde nach Äonen die Sitte des Wettkampfes der Völker wiederbelebt. Die Eingeladenen gründeten im Land der Lesath eigene Lager. Oft — und nicht immer mit dem Wissen der Neuankömmlinge — geschah dies an denselben Plätzen, an denen ihre Vorfahren bereits vor Urzeiten gelagert hatten. Im Gegensatz zu den Welten außerhalb der Sphäre der Lesath konnte man in der Welt der Lesath nicht sterben, sondern erschien nach dem Tod wieder am Heiligtum des eigenen Lagers. Bewohnt wurden die Lager nur in den Tagen vor, während und nach den Spielen. Nur dann war der Zutritt zu der Welt der Lesath möglich. So war es früher und so sollte es wieder sein.

Die Lesath — es ist ihre Welt und gespielt wurde nach ihren Regeln, wie schon seit dem Beginn der Zeit. Jedoch haben sich die anderen Welten und die Völker da draußen verändert und auch die Welt der Lesath schien nicht mehr ganz dieselbe zu sein. Schon nach einigen Zyklen der neu aufgelegten Wettkämpfe erwies sich, dass sich eine alte Widersacherin der Lesath in den Schatten manifestierte: Theki, die dunkle Göttin! Aber nicht nur das! In Gestalt der im letzten Jahr niedergestreckten Hohepriesterin Inan Amun attackierten die Schergen des Bösen auch die Lesath selbst und brachten die vorgegebene Ordnung ins Wanken. Man munkelte inzwischen sogar, dass einige Bewohner nun ganzjährig in der Welt der Lesath verbleiben können und dass dunkle Kulte einer neuen, noch unbekannten göttlichen Macht sich Zutritt verschafft haben...

Heute, im zehnten Jahr nach der Wiederaufnahme der Spiele gibt es wieder zwölf Lager: die Freistadt Neu-Ostringen, das Lager des Imperiums, der Zusammenkunft, des Grünen Kometen, der Pilger, des Königs, der Elben, das der Antike sowie das Norrelag, das Orkheer-Lager, die Horden des Chaos und — erst in diesem Jahr dazugekommen — das Lager des Alten Wegs.

Es galt bei dem Wettstreit der Lesath, mit zahlreichen Kämpfen und Herausforderungen das stärkste Lager zu küren. Der Modus der Spiele wurde durch die Lesath aus geheimnisvollen Gründen geändert. Die großen Wettkämpfe wurden durch eine große Schlacht ersetzt, in der sich die Lager messen. Die Lesath spüren, dass ihre Macht bedroht ist, nicht nur von den dunklen Mächten, die unbeachtet zu neuer Stärke gekommen sind, auch der Einfluss der Lager und der Freistadt Neu-Ostringen mit ihren stetig wachsenden Stadtvierteln nimmt zu.

well, it appears as though there may perhaps never be one. And is not the battle for this new world what draws all the invited peoples here? Sure, they come to win, but the joy of victory in battle is brief, intoxicating, and ecstatically celebrated. The eternal battle keeps them there, keeps them alive.

Die Zukunft ist ungewiss: Es ist ein Kampf in der Welt entstanden und der Sieger… Nun, es scheint eher so, als würde es vielleicht niemals einen geben. Und ist es nicht auch der Kampf um diese neue Welt, der alle geladenen Völker hierher treibt? Sicher, sie kommen, um zu siegen, doch das Glück des Sieges einer Schlacht ist kurzweilig, berauschend – ausgelassen und ekstatisch wird er gefeiert, doch der ewige Kampf hält sie dort und am Leben.

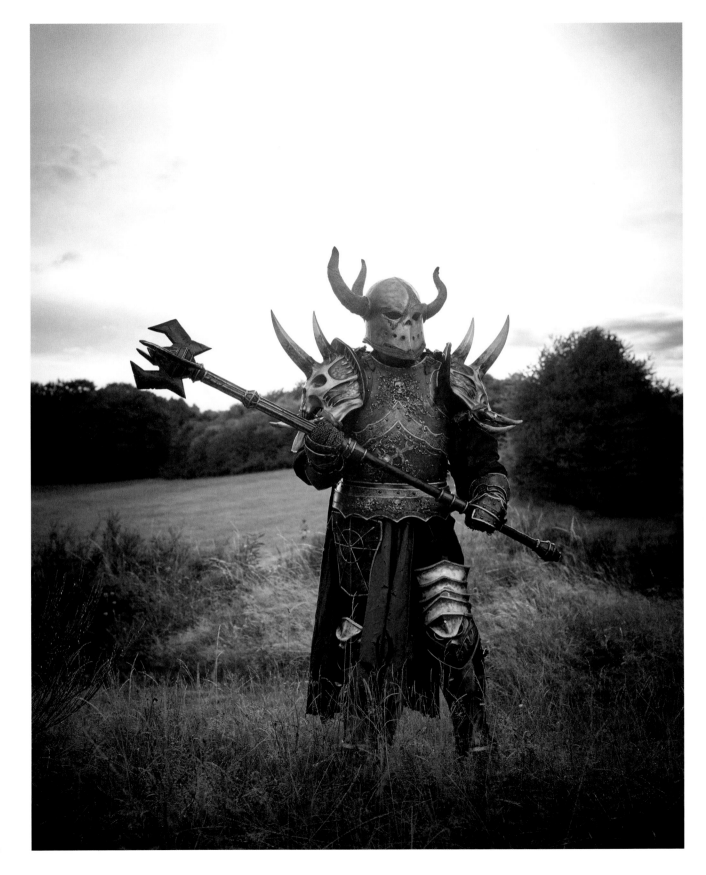

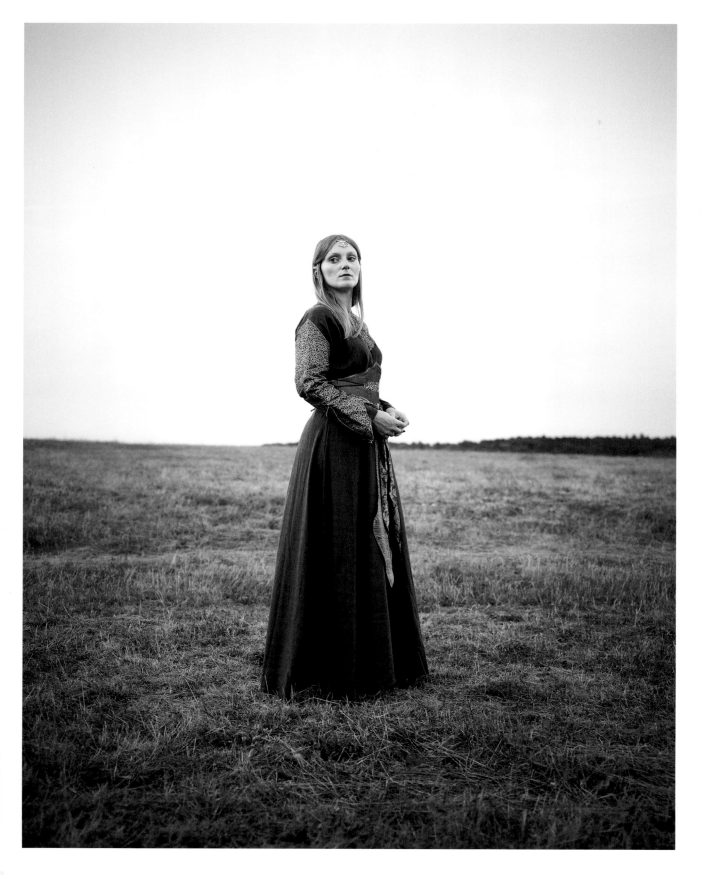

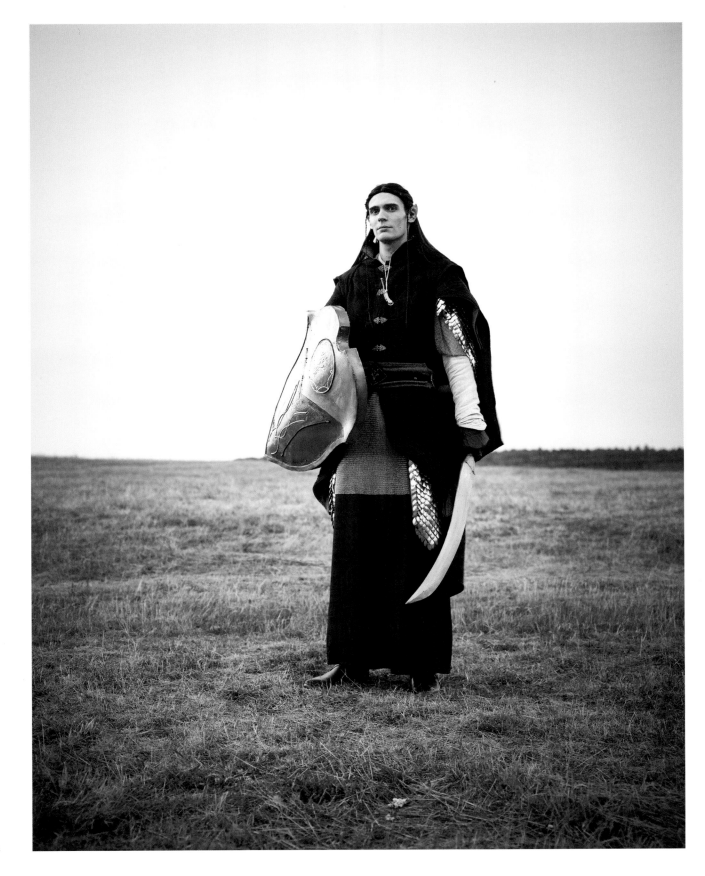

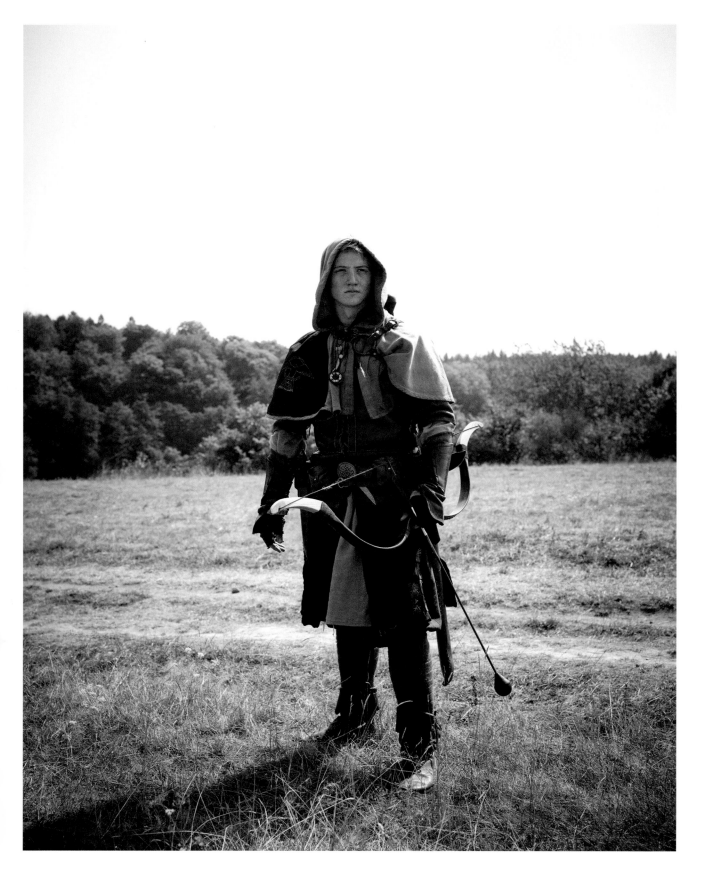

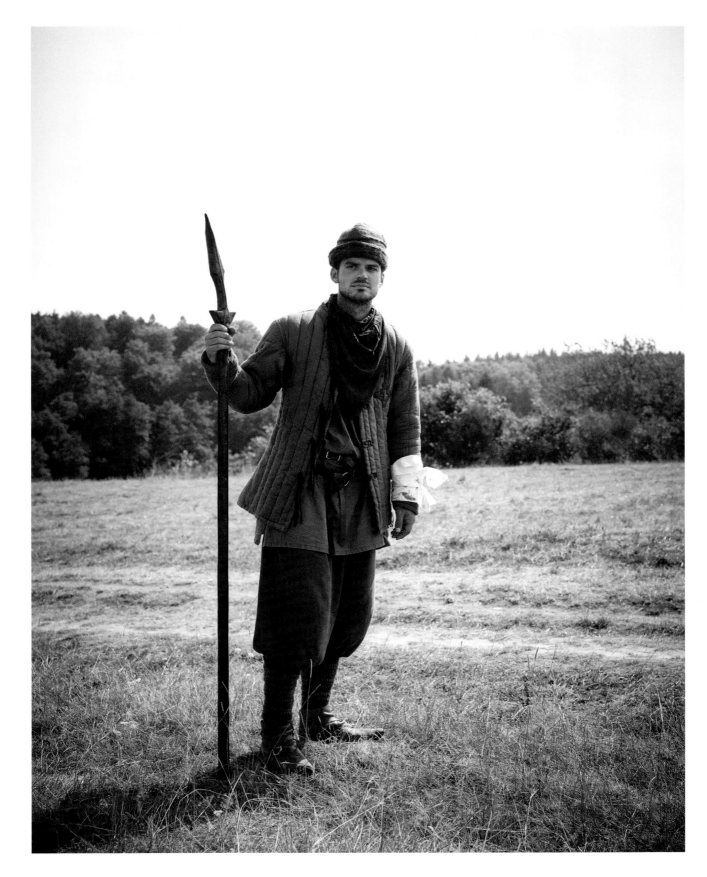

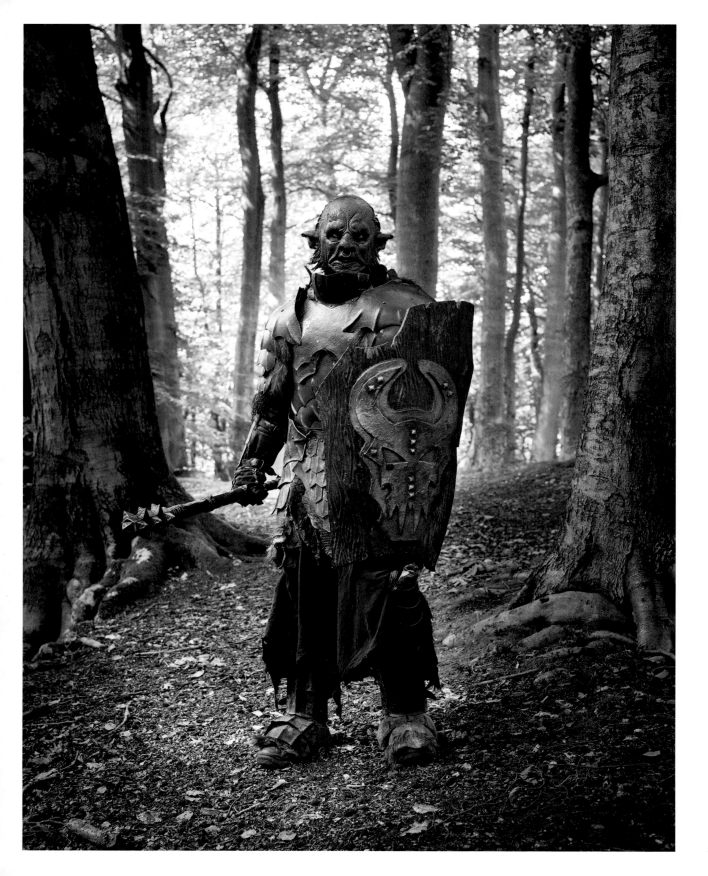

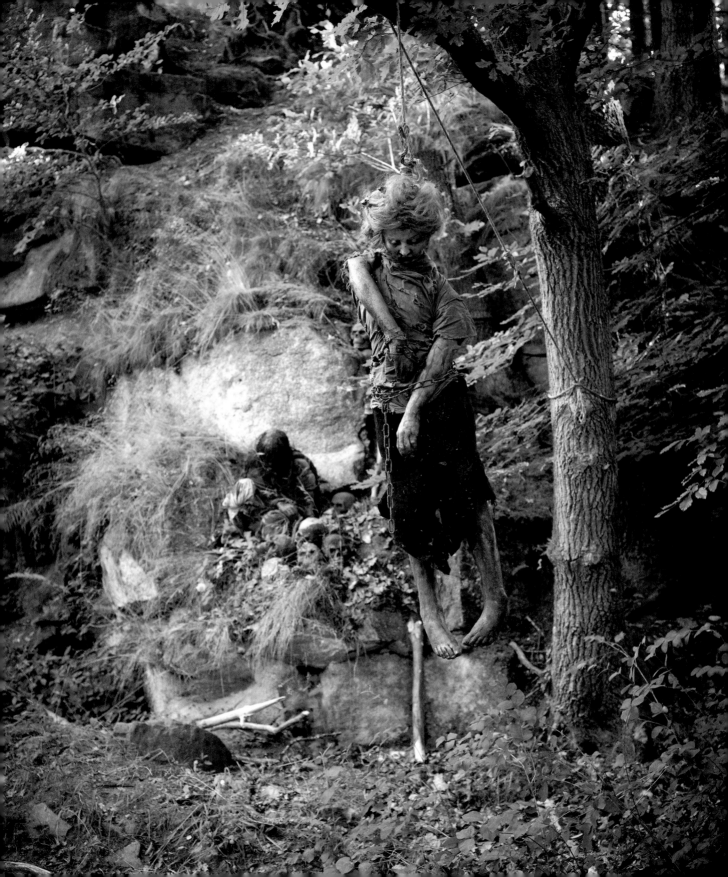

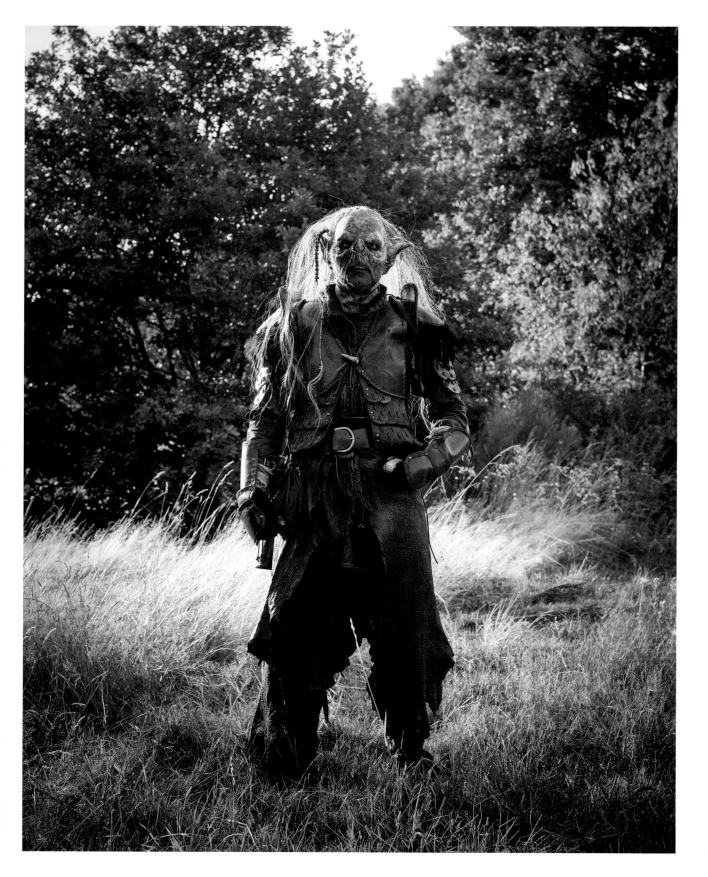

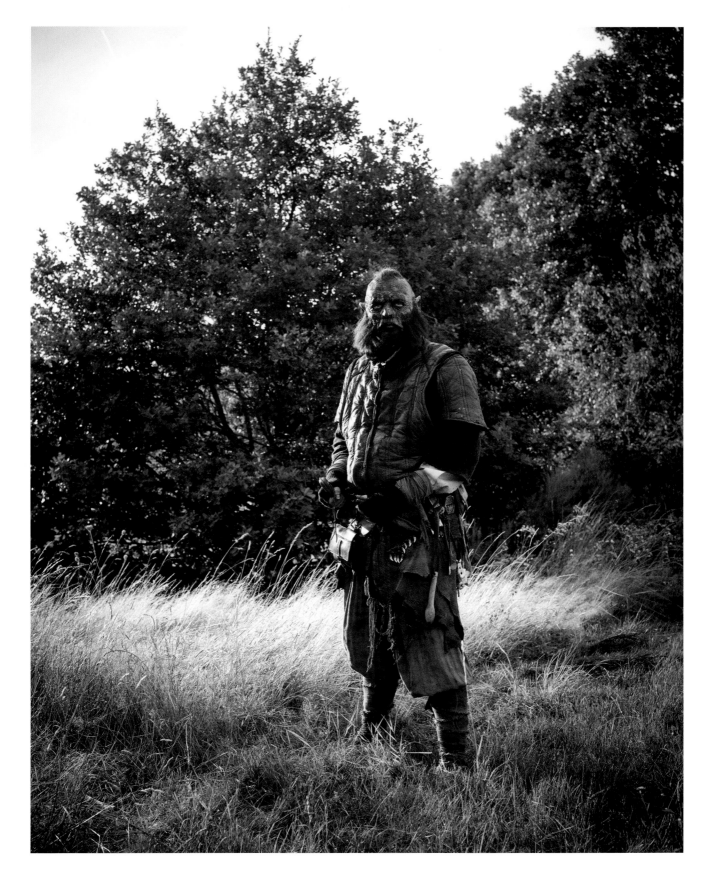

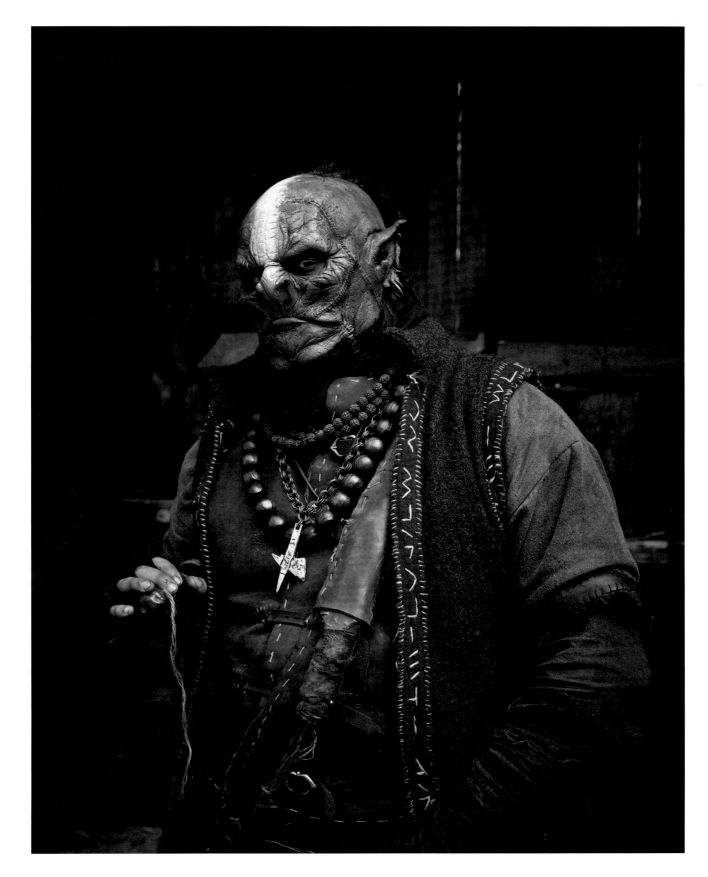

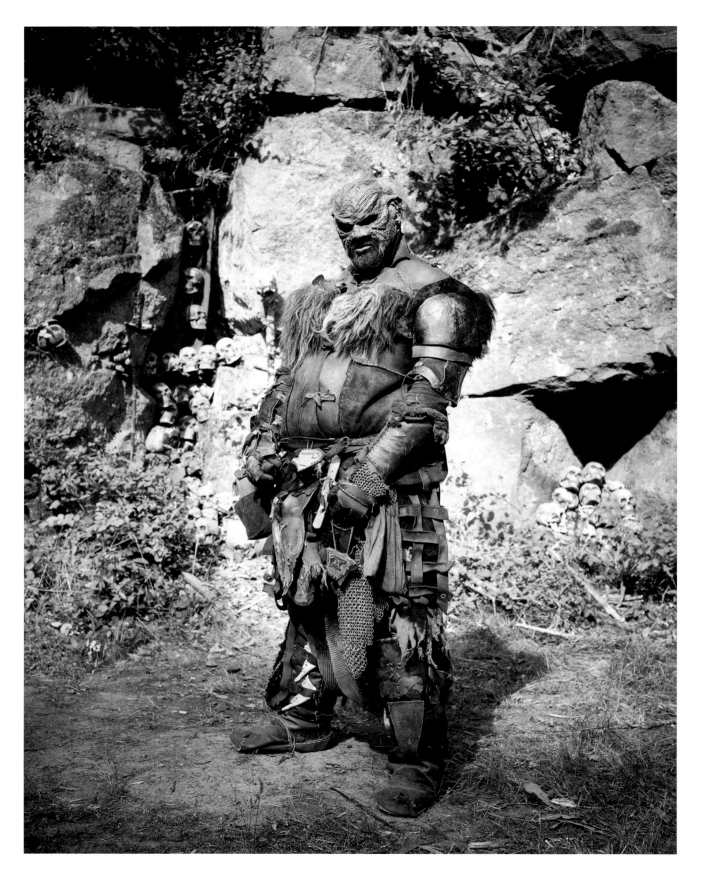

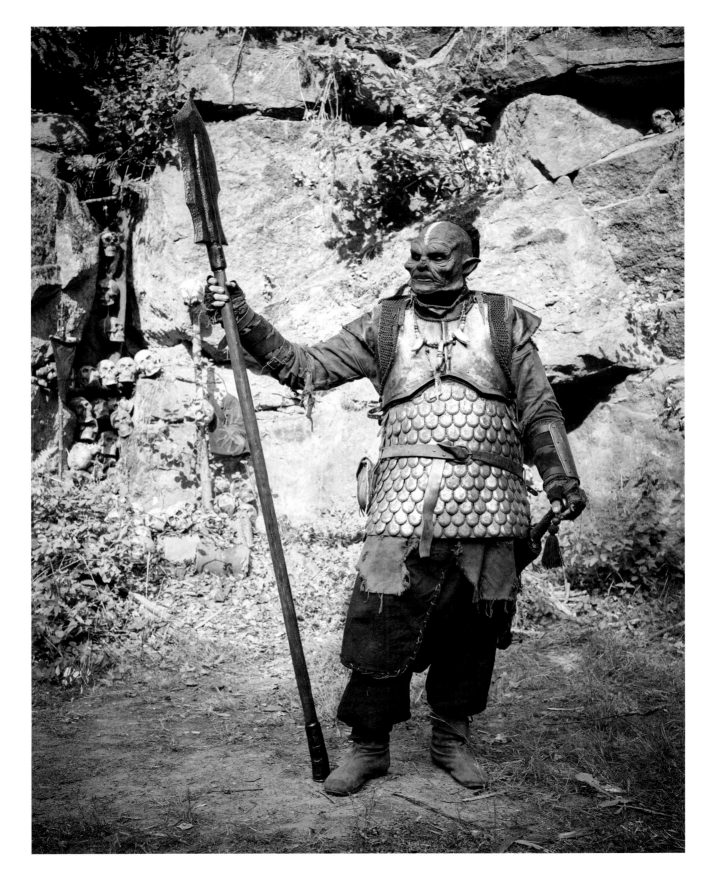

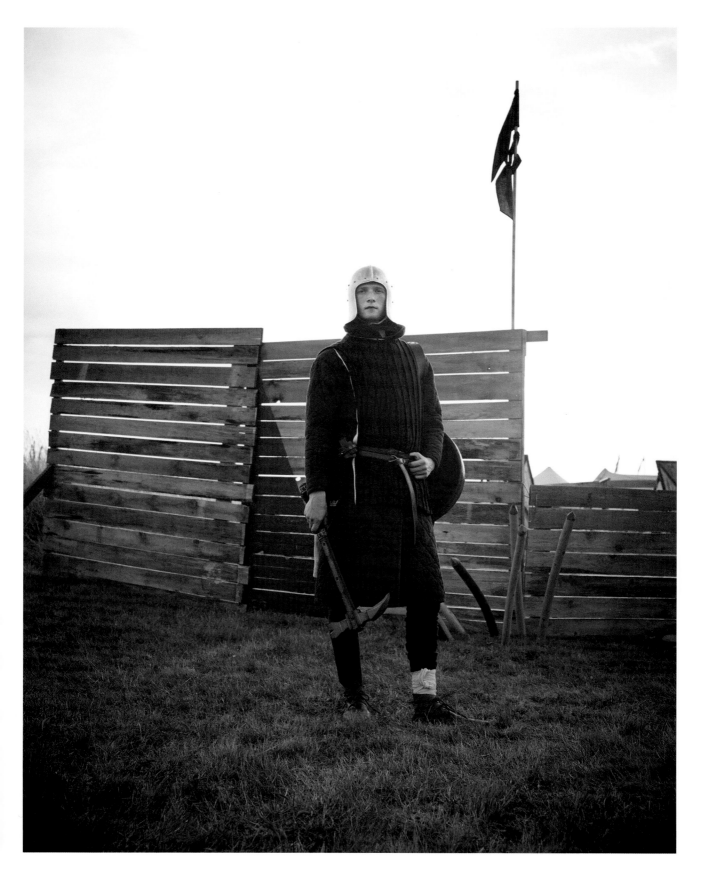

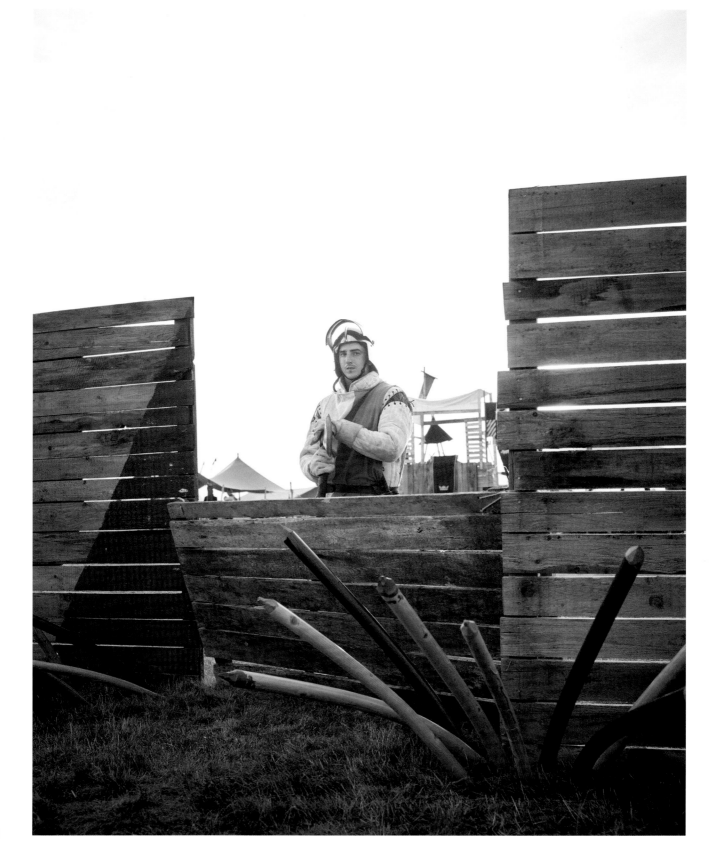

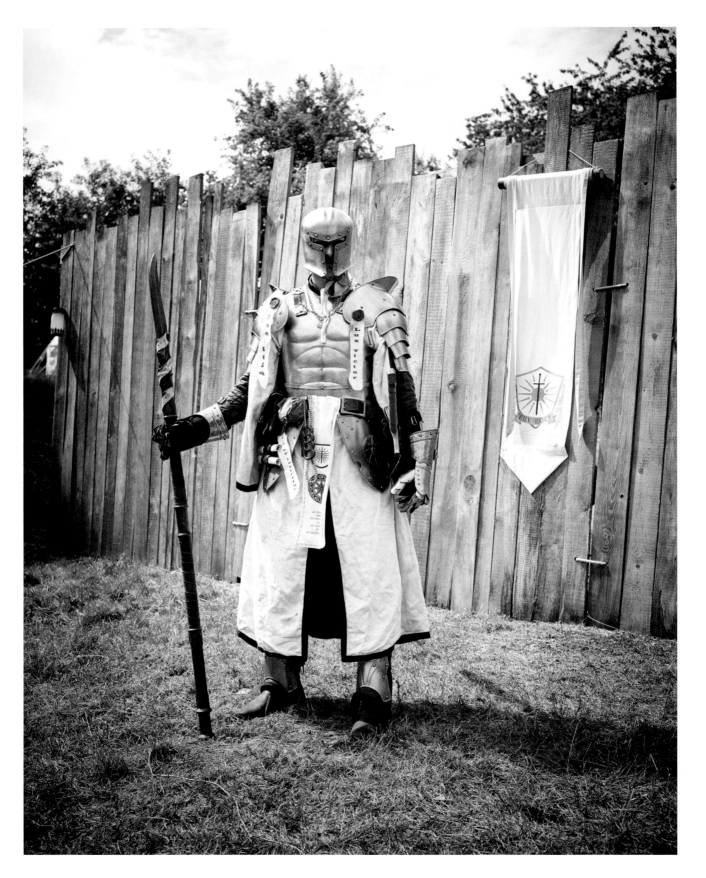

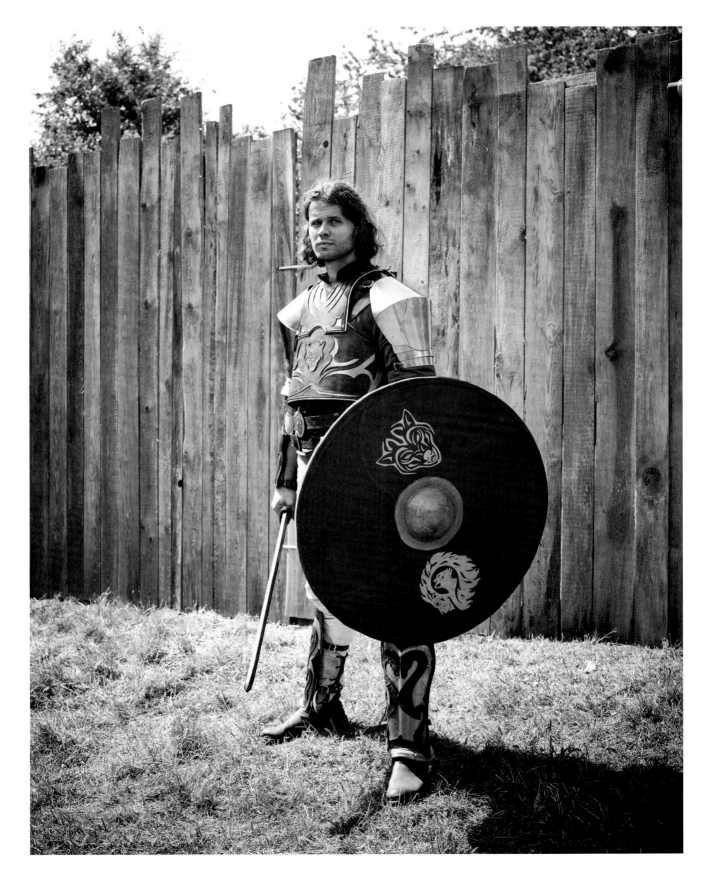

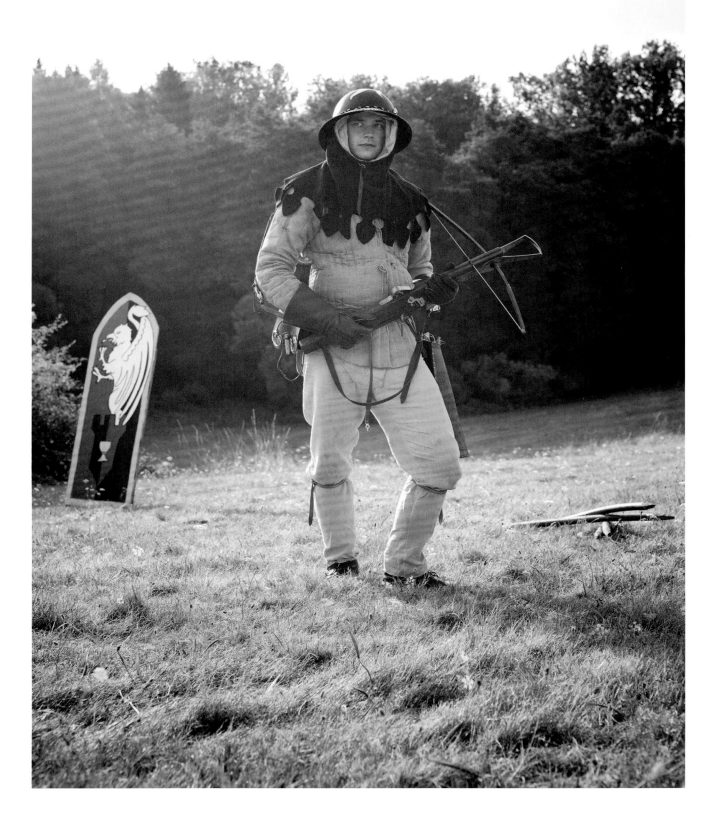

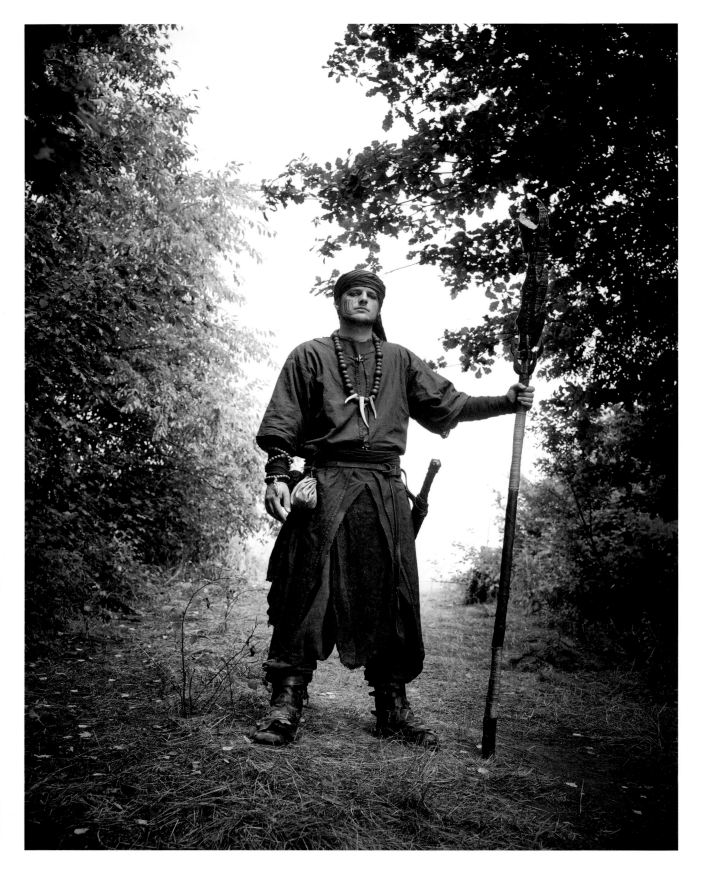

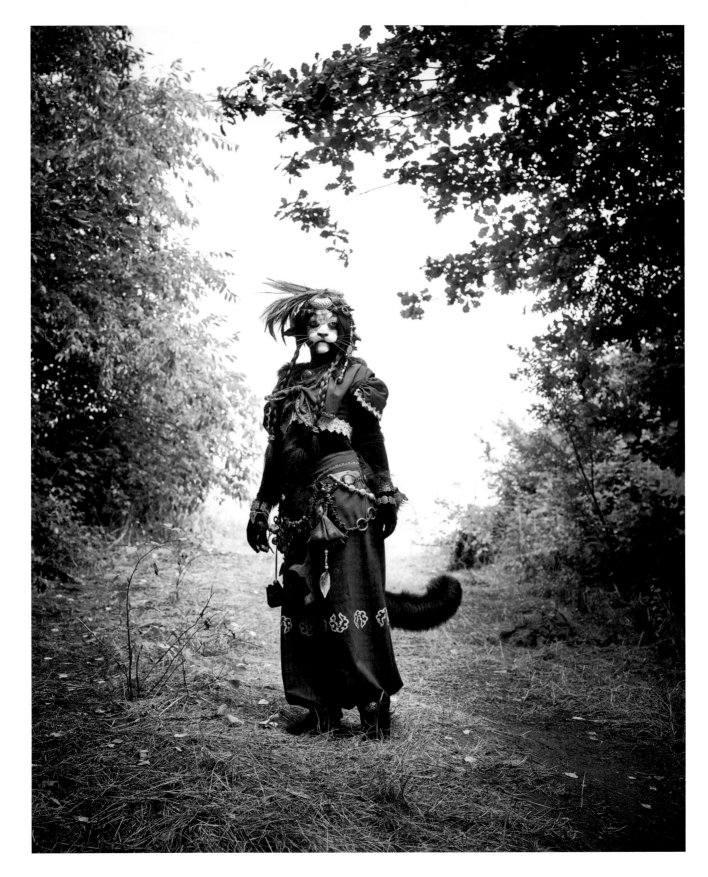

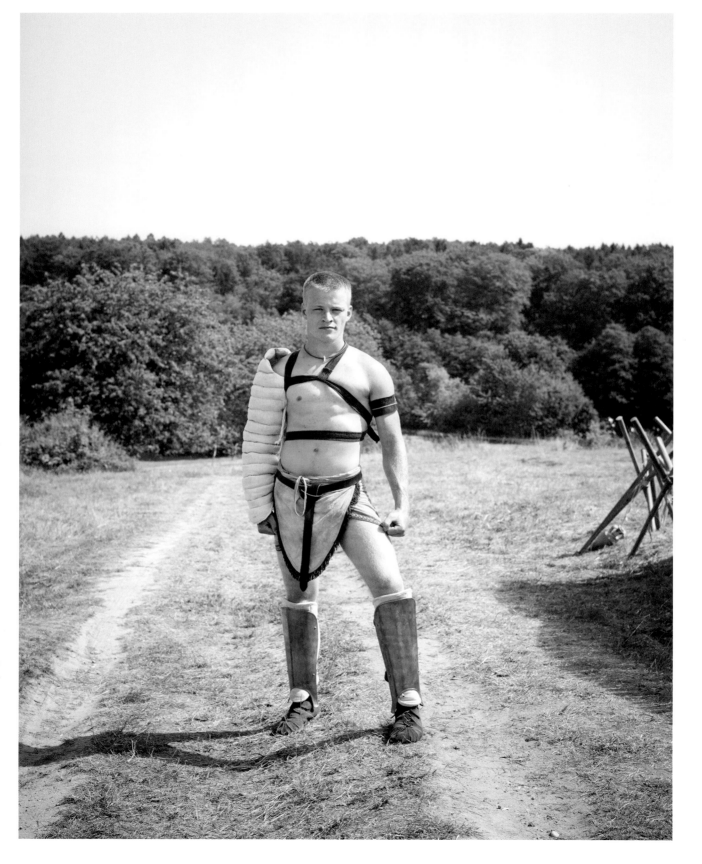

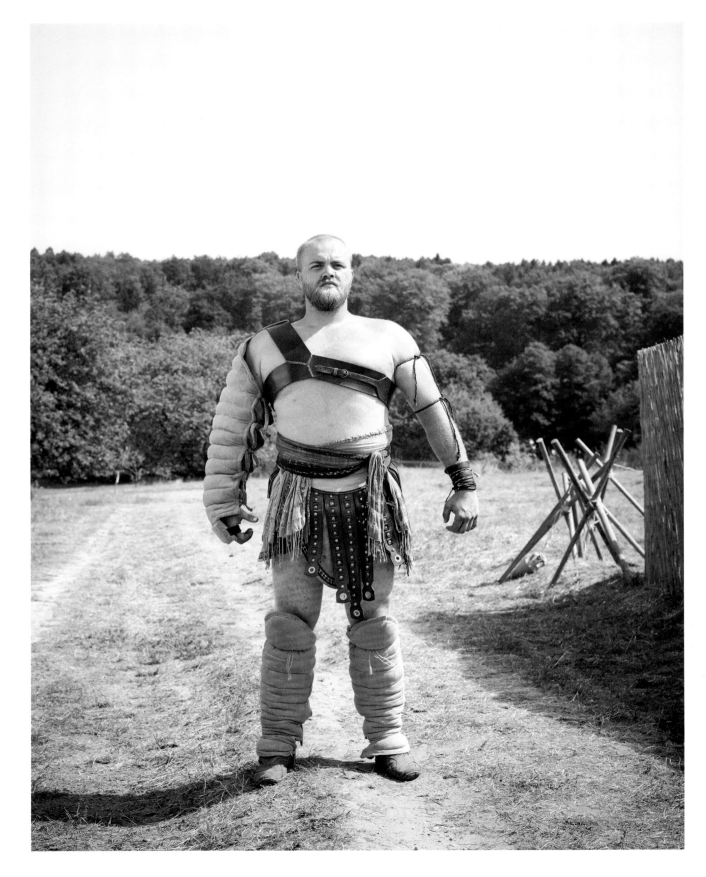

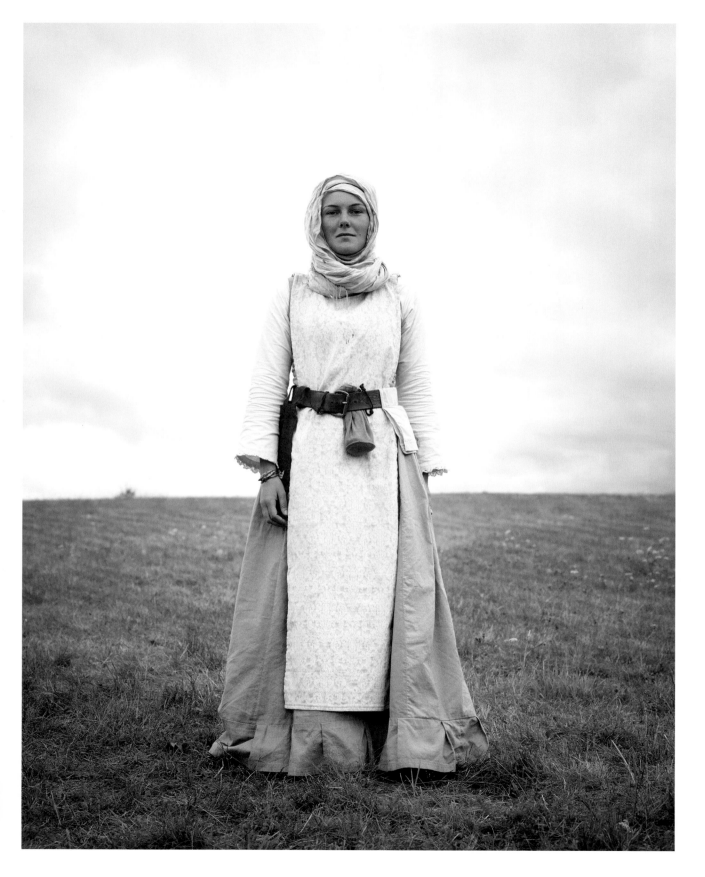

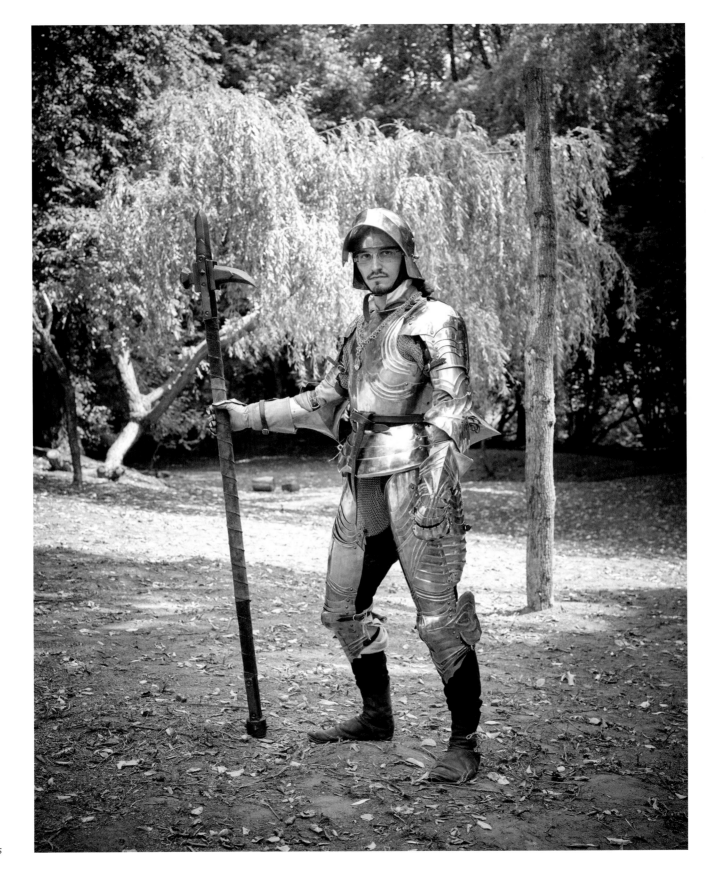

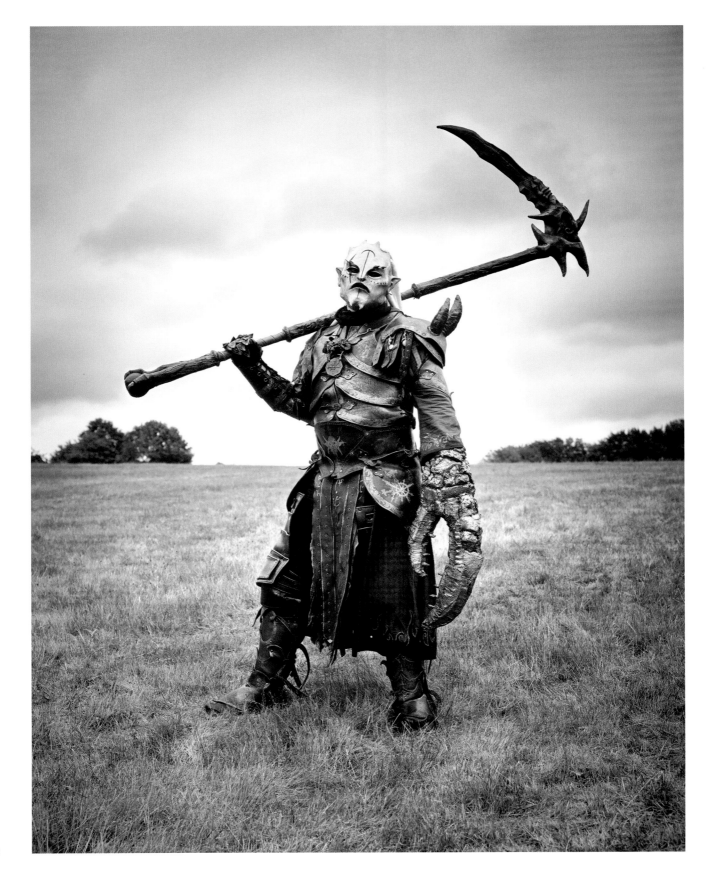

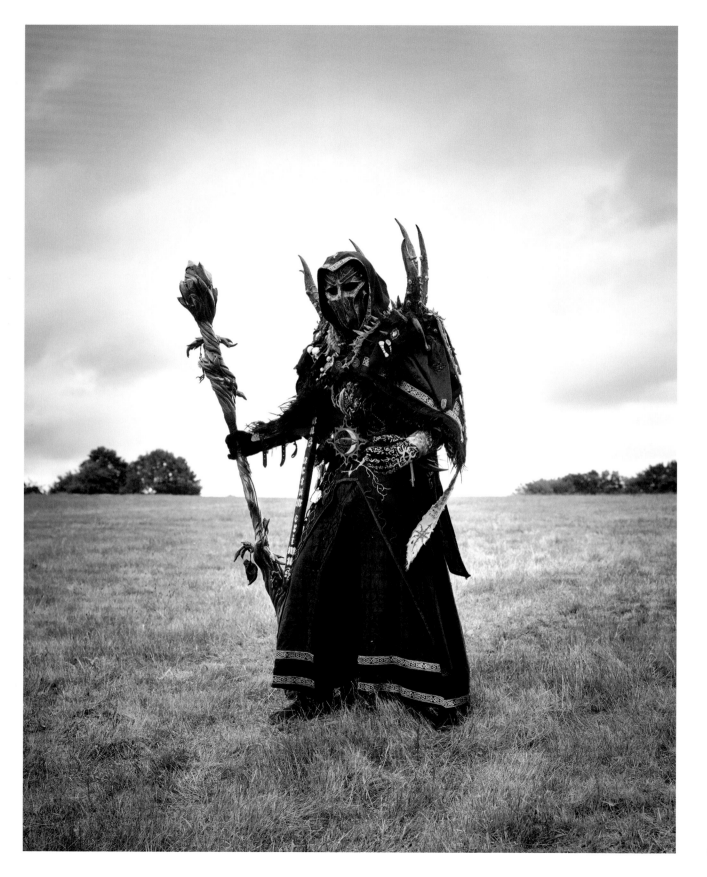

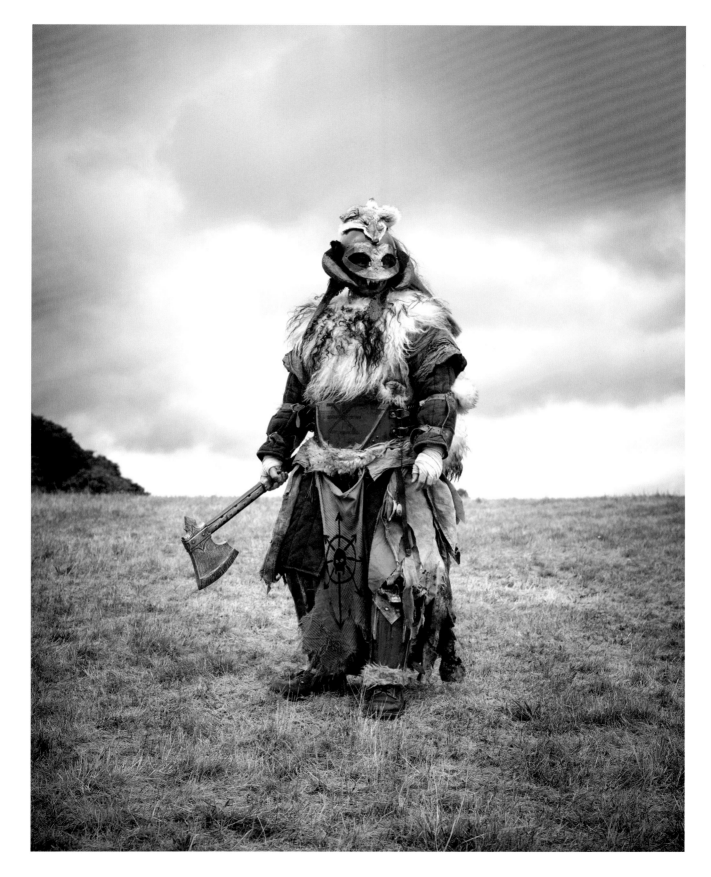

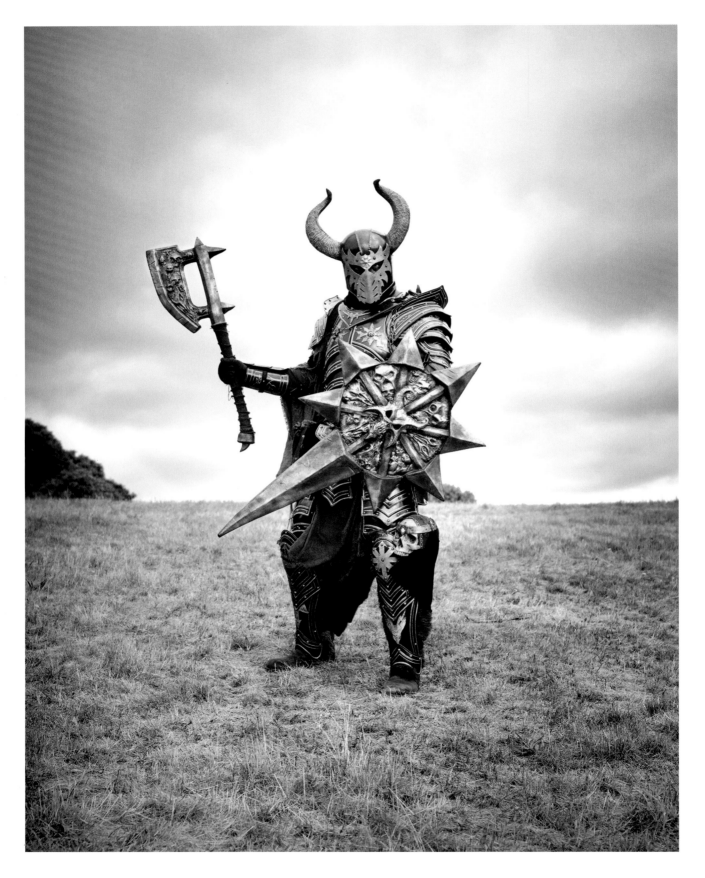

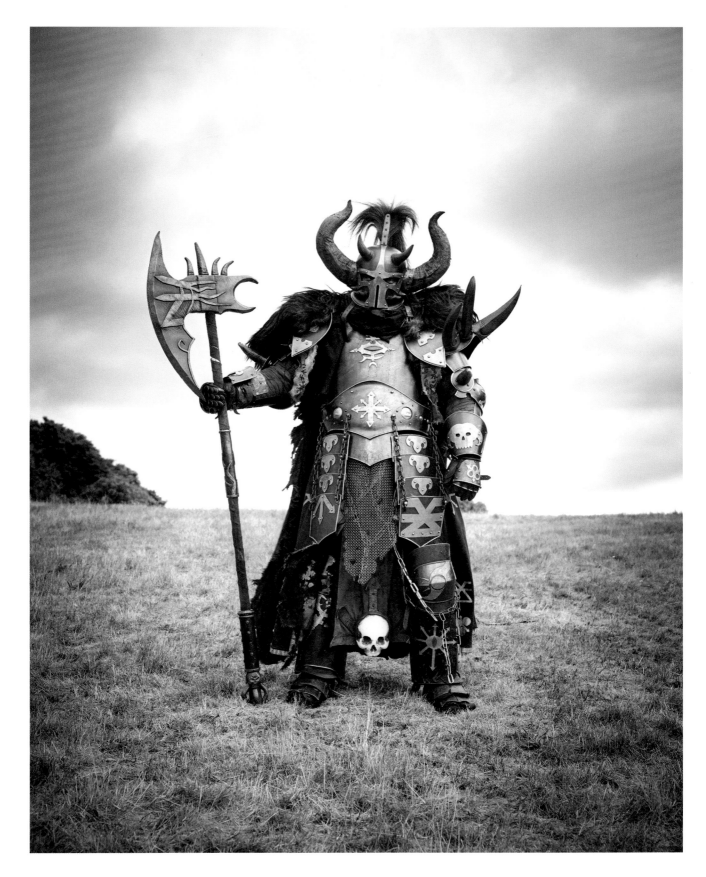

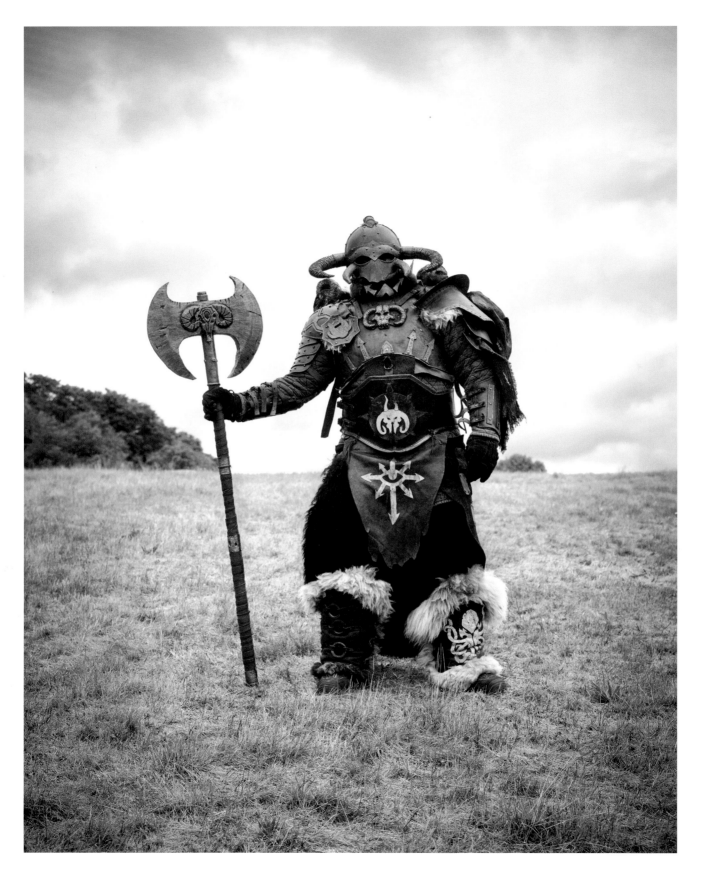

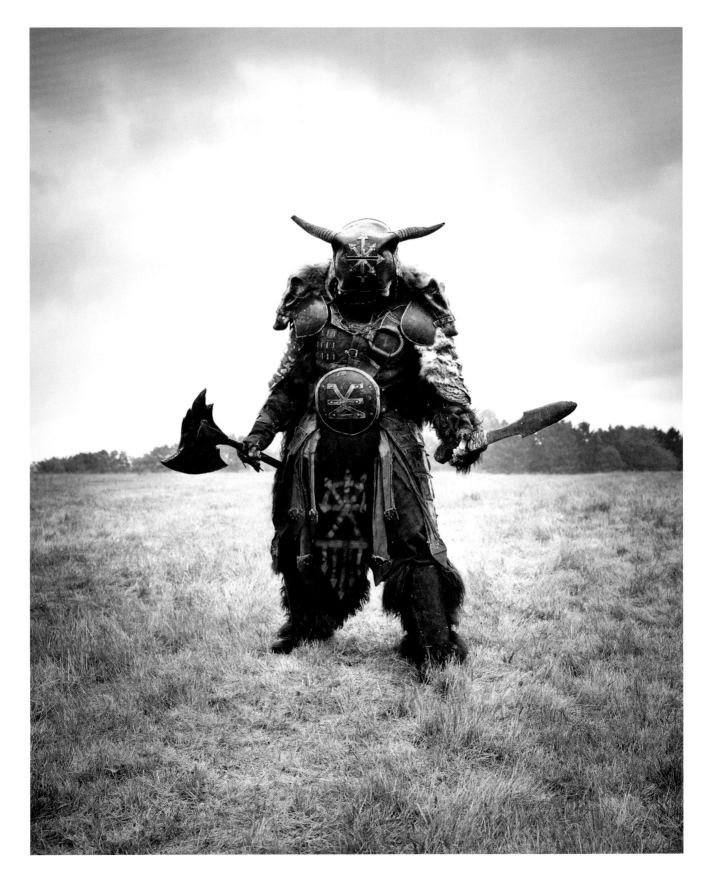

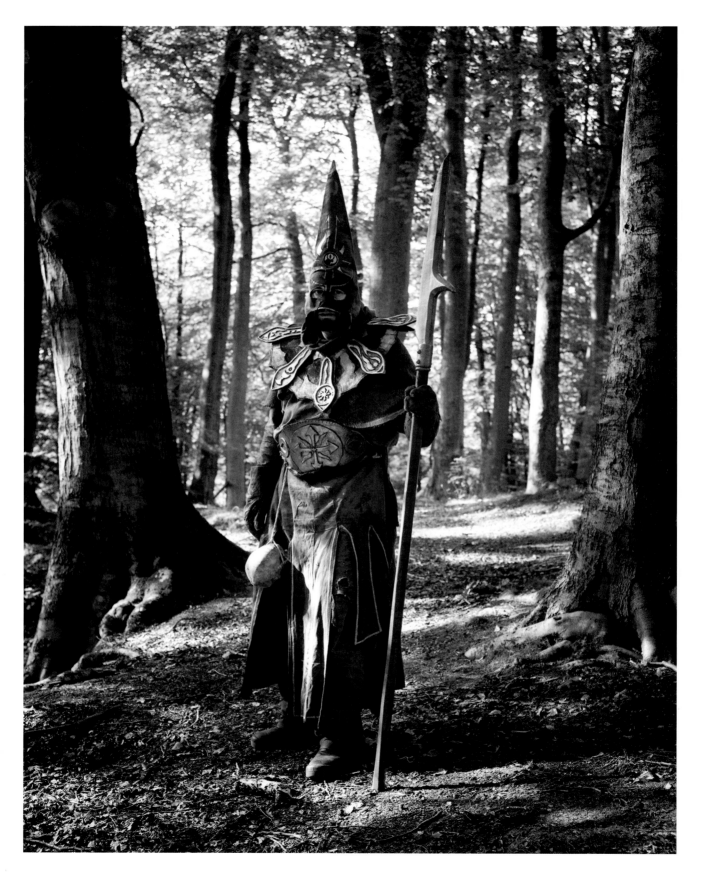

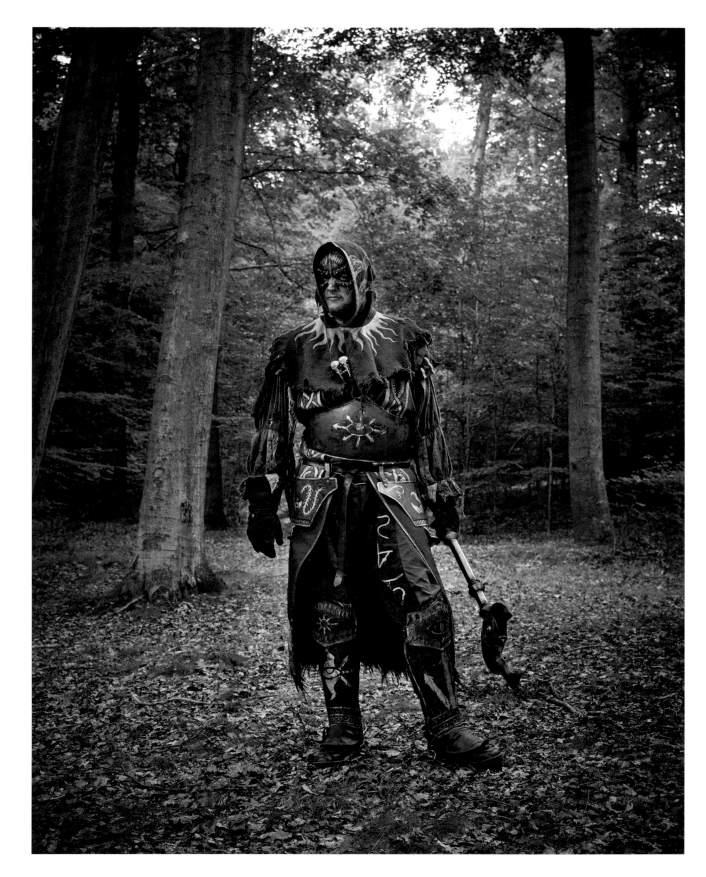

151
S./p.

Ungwe – Krieger des Slaanesh, Horden des Chaos.

Ungwe – Warrior of Slaanesh, Legions of Chaos.

152
S./p.

Irileth – Weiblicher Calendria-Elbe.

Irileth – Female Calendrian Elf.

153
S./p.

Anuron – Männlicher Calendria-Elbe.

Anuron – Male Calendrian Elf.

154
S./p.

Faren Otharson – Anführer der Waldfalken, die Waldfalken bewachen die östliche Grenze des Landes Aron.

Faren Otharson – Leader of the Forest Hawks, who guard the eastern border of the land of Aron.

155
S./p.

Hohenheide – In seiner Heimat ist er Späher und Grenzwächter, langjähriges Mitglied der „Zusammenkunft".

Hohenheide – In his homeland, he is both a scout and a border guard; he is also a long-standing member of the "Convention."

156
S./p.

Thukraz – Sein Rang ist der eines Hai-Ushatar beim Orkstamm der Grishmakkar.

Thukraz – His rank is that of a Hai-Ushatar in the Ork tribe known as the Grishmakkar.

157
S./p.

Tod und Verwesung – In unmittelbarer Nähe zum Lager der Orks.

Death and decay – In the immediate vicinity of the camp of the Orks.

158
S./p.

Bloodcrow Gerttreg – Mutter von Bloodcrow Yargol.

Bloodcrow Gerttreg – Mother of Bloodcrow Yargol.

159
S./p.

Bloodcrow Yargol – Sohn von Bloodcrow Gerttreg.

Bloodcrow Yargol – Son of Bloodcrow Gerttreg.

161
S./p.

Krashûk – *Shatogar* (Kriegspriester) vom Clan der Shrak'Kor (übersetzt „Die Gemeinschaft der Krähe" oder auch die „Blutkrähen" genannt).

Krashûk – *Shatogar* (warrior-priest) of the Shrak'Kor clan (translated "The Community of the Crow," also known as the "Blood Crows").

162
S./p.

Draghum – Halb Mensch, halb Drache, gehört zur Spezies der Ork.

Draghum – Half human, half dragon; belongs to the species of the Ork.

163
S./p.

Darûk – Frontkämpfer mit *Hashat* (Stangenwaffe/Hellebarde). Er hat den Rang eines Ushatar, gehört zum Clan der Shrak'Kor.

Darûk – Front-line soldier with a *hashat* (pole weapon/halberd). He has the rank of an Ushatar and belongs to the clan of the Shrak'Kor.

164
S./p.

Severo – Integrato im Drachenorden in seiner Heimat Aturien, Gefolgsmann im Lager der Krone.

Severo – Integrato in the Dragon Order in his homeland Aturien; an acolyte in the camp of the Crown.

165
S./p.

Konrad Krämer – Sohn eines Händlers aus Aquitan und Söldner im Dienste von Reynard de Gabile, Lager der Krone.

Konrad Krämer – Son of a trader from Aquitan and a mercenary in the service of Reynard de Gabile; camp of the Crown.

166
S./p.

Tristan – Aus dem Königreich Norador, Protector im Orden des Sternenlichts zu Ehren der Herrin Varda und Justitiar innerhalb des Lichtlagers.

Tristan – From the Kingdom of Norador; Protector in the Order of Starlight in honor of Lady Varda and Counsel in the camp of Light.

167
S./p.

Askey – Askors Sohn und Ritter beim Orden von Löwe und Lamm.

Askey – Askor's son and knight in the Order of the Lion and the Lamb.

169
S./p.

Friedrich Dörnberg – Langjähriger niederer Kriegsknecht, gehört zum Gefolge von Sir Helmbrecht von Morrstedt aus der Ostmark (angeheuert zur Bewachung des Pilgerlagers).

Friedrich Dörnberg – Veteran menial soldier; belongs to the entourage of Sir Helmbrecht von Morrstedt from the Ostmark (hired to guard the camp of the Pilgrims).

170
S./p.

Margôz ibn Na'man – Kriegsschamane vom Volk der Haradrim, hält Kontakt zu den Ahnen und Geistern, führt die Truppen im Kampf.

Margôz ibn Na'man – Warrior-shaman of the Haradrim people, who maintains contact with the ancestors and spirits and leads the troops in battle.

171
S./p.

Kimana – Tochter des Karim, stammt vom Volk der Lunkindar, Schamanin in Ausbildung.

Kimana – Daughter of Karim; from the Lunkindar people; shaman in training.

172
S./p.

Berengar – Gladiator, gehört zu den Germanen vom Stamm der Brukterer, er ist ein „Dimachaerus", kämpft mit zwei Schwertern und einem Dolch.

Berengar – Gladiator, belongs to the Germanic tribe of the Brukterer; a "dimachaerus" who fights with two swords and a dagger.

173
S./p.

Tertius – Primus Palus, Provocator.

Tertius – Primus Palus, provocator.

174
S./p.

Die edle Jungfer Clara Katharina Garibaldi – Tochter des Ritters Karl Anton Garibaldi, der im Königreich Florenau der Familie Lilienstein dient, Gesellschafterin der wortgewandten und gnädigen Komtess Mirabella Anna Ingrid Lilienstein, Lager der Krone.

The noble maiden Clara Katharina Garibaldi – Daughter of the knight Karl Anton Garibaldi, who serves the Lilienstadt family in the kingdom of Florenau; lady-in-waiting of the eloquent and merciful Countess Mirabella Anna Ingrid Lilienstein; camp of the Crown.

175
S./p.

Belegond von Rabenweil – Marschall zu Wilten, Kommandeur des Wiltener Tross (Wilten ist eine Baronie des Herzogtums Drackensteig in den Mittellanden).

Belegond of Rabenweil – Marshall of Wilten and commander of the Wilten retinue (Wilten is a barony in the Duchy of Drackensteig in the Middle Countries).

176
S./p.

Erik – Bogenschütze im IV. Thorsunder Schützenregiment der Thralianischen Armee, in Neu-Ostringen für die Feldpost zuständig.

Erik – Bowman in the 4th Thorsund Archer Regiment of the Thralian army; responsible for the field post in New Ostringen.

177
S./p.

Gustl – Spieß (stellvertretender Hauptmann / Oberhaupt), Imperialist.

Gustl – First Sergeant (Deputy Chief Officer/Chieftain), imperialist.

178
S./p.

Andra Kupferbart – Tochter des Grimmbart, Durak Khazadul – Zwergenviertel von Neu-Ostringen, zuständig für Lagerführung.

Andra Kupferbart (Copper Beard) – Daughter of Grimmbart, Durak Khazadul – dwarf district of New Ostringen, responsible for managing the stock.

179
S./p.

Breena Tiefschürfer – Tochter der Birrta Tiefschürfer, aus dem Clan der Steinspalter, Bergbau und Prospektion.

Breena Tiefschürfer (Deep Miner) – Daughter of Birrta Tiefschürfer, from the clan of the Stone Cutters; mining and prospection.

181
S./p.

Schwarzwind – Krieger und Codexwächter von den Schicksalsbrechern, Horden des Chaos.

Schwarzwind (Black Wind) – Warrior and Guardian of the Codex of the Fortune Breakers, Legion of Chaos.

182
S./p.

Karath ùn – Chaos Hexer und ungeteilter Priester aller dunklen Götter, Horden des Chaos.

Karath ùn – Chaos warlock and undivided priest of all dark gods; Legion of Chaos.

183
S./p.

Lokri Duraksson – Krieger und Hundezüchter, Stamm der Graelinger, Skorturs Zorn, Horden des Chaos.

Lokri Duraksson – Warrior and dog breeder; Graeling tribe, Skortur's Wrath, Legion of Chaos.

184
S./p.

Faudach – Heerführer Velekors, Horden des Chaos.

Faudach – Velekor's military commander, Legion of Chaos.

185
S./p.

Lord Velekor – Ungeteilter Champion des Chaos, Anführer der Horden des Chaos.

Lord Velekor – Undivided Champion of Chaos, leader of the Legions of Chaos.

186
S./p.

Hrotgar Hragarsson – Jarl der Skorturs Zorn, Stamm Skaelinger, Horden des Chaos.

Hrotgar Hragarsson – Jarl of Skortur's Wrath, Skaeling tribe, Legion of Chaos.

187
S./p.

Rhokas – Blutbändiger des Khorne, Schamane der Vargs und Bruder des Blutpacks, Horden des Chaos.

Rhokas – The Blood Tamer of Khorne, Shaman of the Vargs, and Brother of the Blood Pack; Legion of Chaos.

188
S./p.

Cyriel – Tzeentch-Kultist, Horden des Chaos.

Cyriel – Tzeentch cultist, Legion of Chaos.

189
S./p.

Marius der Geteilte – Chaoskrieger des Tzeentch.

Marius the Divided – Chaos warrior of Tzeentch.

It is the year 1288, and we are in a small city on the Sieg river with an abbey. The smell of blood hangs in the air. The Long Night is over, and now, as the oldest and most powerful Cainites have risen to divide the world of darkness among themselves and instate a new order according to their own ideas, a new era has begun. The War of Princes, their struggle for domains, influence, power, and vassals is in full swing, and new disputes and conflicts flare up night after night.

Novum ††† †† Castrum

There is also unrest in the fiefdom of the Black Cross, despite the fact that its ruler, Lord Hardestadt, governs his lands with resolute severity and keeps his vassals on a short leash. Yet far from all lords and princes have sworn submission, let alone allegiance, to Hardestadt. And those that have indeed done this are eager to bring the insurgents to their senses in order to take over their land. The Battle of Siegburg is but one of many, but it perfectly illustrates the extent of the fighting during these nights.

1494. Alexander VI sits on the papal throne, born as Rodrigo Borgia, a secularly inclined Renaissance prince who leads a self-indulgent life. He holds the Malleus Maleficarum in one hand and an ever-full wine chalice in the other. The Inquisition was highly successful in its rampage against the "Children of Cain" throughout Europe, and countless among them have found the finality of death at its stakes and pyres. These are dark, desperate times for the Cainites. Even among the most powerful Ancients of the Night, there is a sense of anxiety, since rumors fly fast that in the East the insurgents are bursting the chains of their blood oath.

Some say that it is only the huge influence of the Lasombra clan, which can also be felt every night in Cologne, which keeps the Catholic Church more or less at bay. Others are convinced that they use the Inquisition as a compliant tool to take action against their adversaries. Barely six months have passed since, at the Convent of Thorns, the founders around the mysterious Ventrue Hardestadt had laid the groundwork for an organization known as the Camarilla, which claims to speak for all Cainites throughout the world. But not all defer to this rule and recognize the value of such a union. Even Holy Cologne, the most powerful city north of the Alps, did not yet belong to the domains that jubilantly greeted the new order.

In these nights of turmoil, the Princess-Bishop of Cologne celebrates the anniversary of her reign. Yet while the celebration takes place in Cologne, she meets

✝✝✝ Novum Castrum ✝✝

Wir schreiben das Jahr 1288 und befinden uns in einer kleinen Stadt mit Abtei am Fluss Sieg. Der Geruch von Blut liegt in der Luft. Die Lange Nacht ist vorüber, und nun, da die ältesten und mächtigsten Kainiten sich erhoben haben, um die Welt der Dunkelheit unter sich aufzuteilen und nach ihren Vorstellungen zu ordnen, ist ein neues Zeitalter angebrochen. Der Krieg der Prinzen, ihr Ringen um Domänen, Einfluss, Macht und Vasallen ist in vollem Gange und neue Auseinandersetzungen und Konflikte entflammen Nacht für Nacht.

Auch in den Lehen des Schwarzen Kreuzes rumort es, obgleich ihr Gebieter Hardestadt seine Ländereien mit eiserner Härte regiert und seine Vasallen an der kurzen Leine hält. Doch längst nicht alle Fürsten und Prinzen haben Hardestadt bislang Gehorsam, geschweige denn Gefolgschaft geschworen. Und jene, die es taten, sind begierig darauf, die Aufrührer zur Räson zu bringen, um sich ihre Ländereien einzuverleiben. Der Kampf um Siegburg ist nur einer von vielen, doch er veranschaulicht sehr gut, in welchem Ausmaß in diesen Nächten gefochten wird.

1494. Auf dem Papstthron sitzt Alexander VI., geboren als Rodrigo Borgia, ein weltlich eingestellter Renaissancefürst, der ein ausschweifendes Leben führt. Er hat den Hexenhammer in der einen und einen nie versiegenden Weinkelch in der anderen Faust. Die Inquisition hat mit großem Erfolg Jagd auf die Kainskinder Europas gemacht, und durch ihre Pflöcke und Scheiterhaufen haben unzählige von ihnen den endgültigen Tod gefunden. Für die Kainskinder sind dies finstere, verzweifelte Zeiten. Selbst unter den mächtigsten Ahnen der Nacht herrscht die Angst, verbreiten sich doch Gerüchte wie ein Lauffeuer, dass im Osten die Aufständischen gar die Ketten ihrer Bluteide sprengen.

Manche sagen, nur der massive Einfluss des Clans Lasombra, der auch in Köln allnächtlich spürbar ist, halte die katholische Kirche noch einigermaßen in Schach. Andere sind der Überzeugung, dass sie vielmehr die Inquisition als willfähriges Werkzeug nutzen, um gegen ihre Feinde vorzugehen. Kein halbes Jahr ist es her, dass auf dem Konvent von Thorns die Gründer um den mysteriösen Ventrue Hardestadt den Grundstein einer Organisation gelegt haben, die sich Camarilla nennt und den Anspruch erhebt, für alle Kainskinder der Welt zu sprechen. Doch längst nicht alle beugen sich dieser Führung und erkennen den Wert einer solchen Union. Auch das Heilige Köln, mächtigste Stadt nördlich der Alpen, gehörte bislang nicht zu den Domänen, die die neue Ordnung jubelnd begrüßten.

with powerful, educated, and well-traveled Cainites from Cologne and the surrounding region, as well as from far away, in an inconspicuous convent to secretly set the course for what the future will bring.

New powers will shape the face of the domains of the Holy Roman Empire for the next centuries and overthrow the long-established order. It is now up to each individual to recognize the signs of the times and find a place for himself in a changing world.

In diesen Nächten des Umbruchs ruft die Fürstbischöfin von Köln zum Jahrestag ihrer Herrschaft. Doch während in Köln selbst die Feierlichkeiten stattfinden, trifft sie sich mit mächtigen, gelehrten und weitgereisten Kainskindern aus Köln, aus dem Umland, aber auch von weit her in einem unscheinbaren Kölner Konvent, um insgeheim die Weichen zu stellen für das, was die Zukunft bringen wird.

Neue Mächte werden das Gesicht der Domänen des römisch-deutschen Reiches für die nächsten Jahrhunderte prägen und die althergebrachte Ordnung verwerfen. Es ist nun an jedem Einzelnen, die Zeichen der Zeit zu erkennen und einen Platz zu finden in einer sich wandelnden Welt.

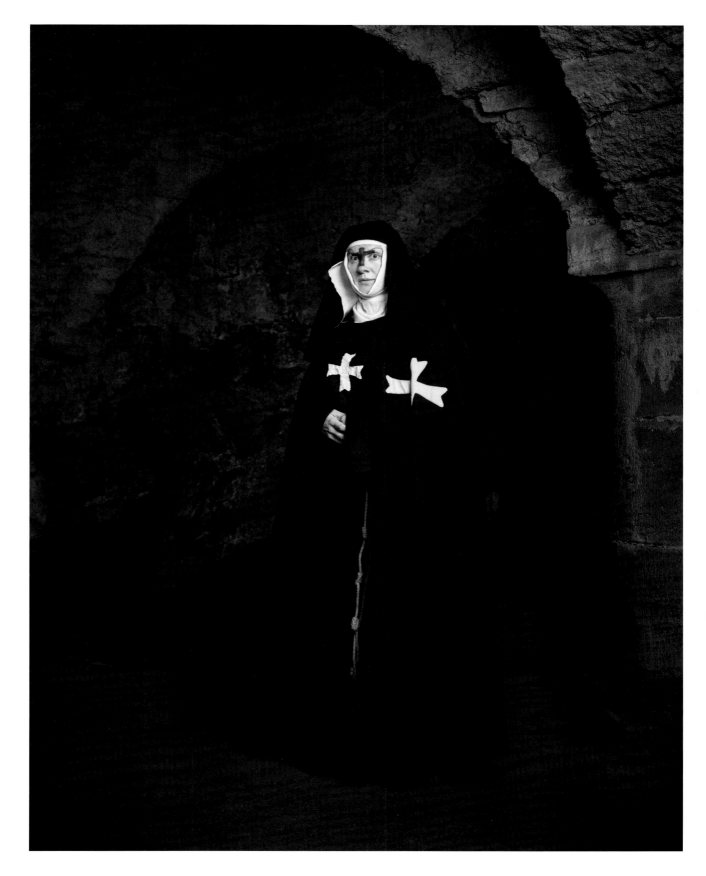

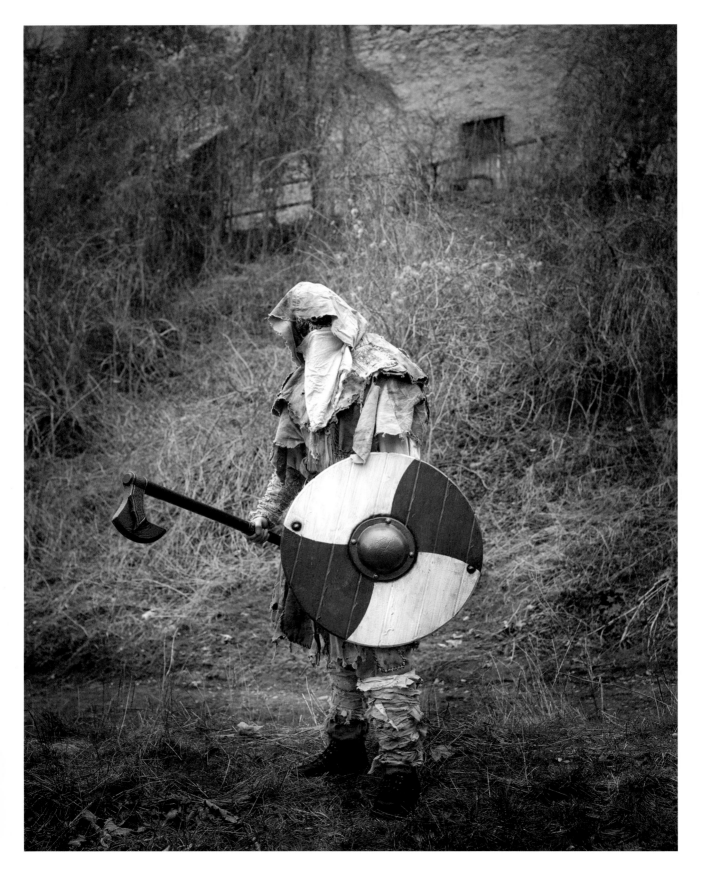

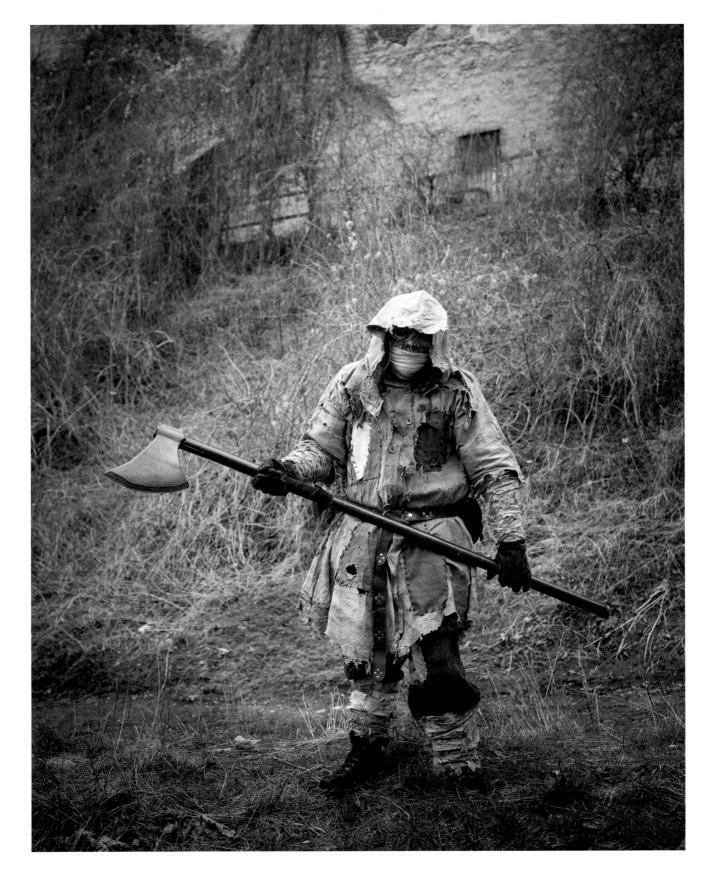

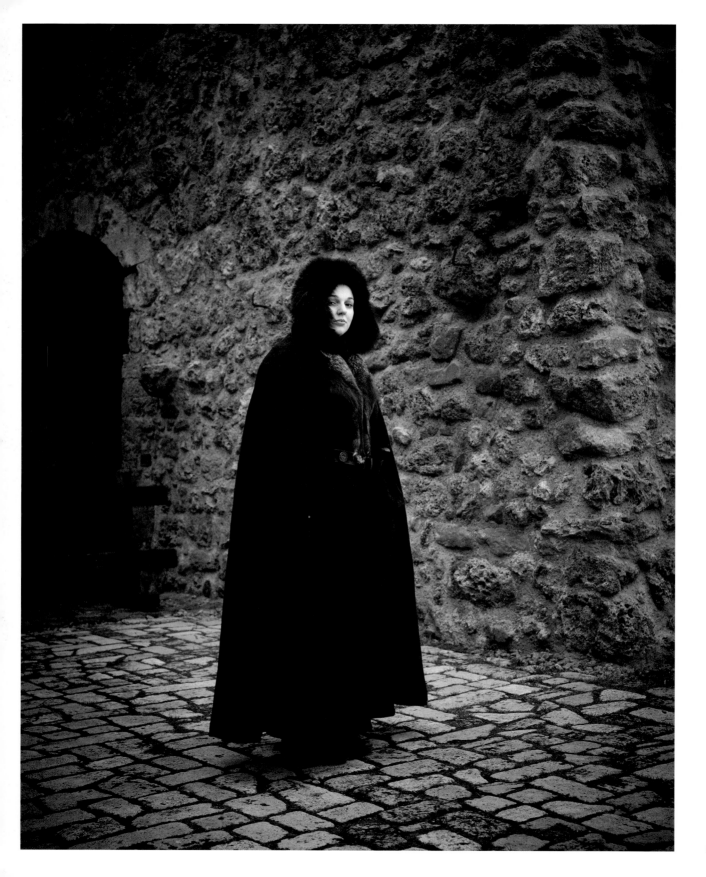

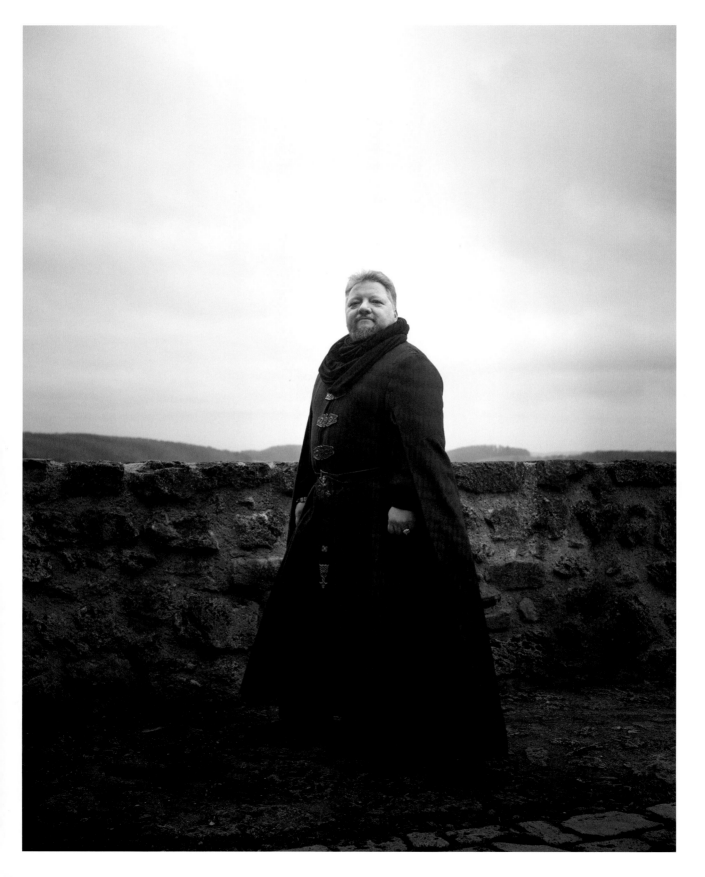

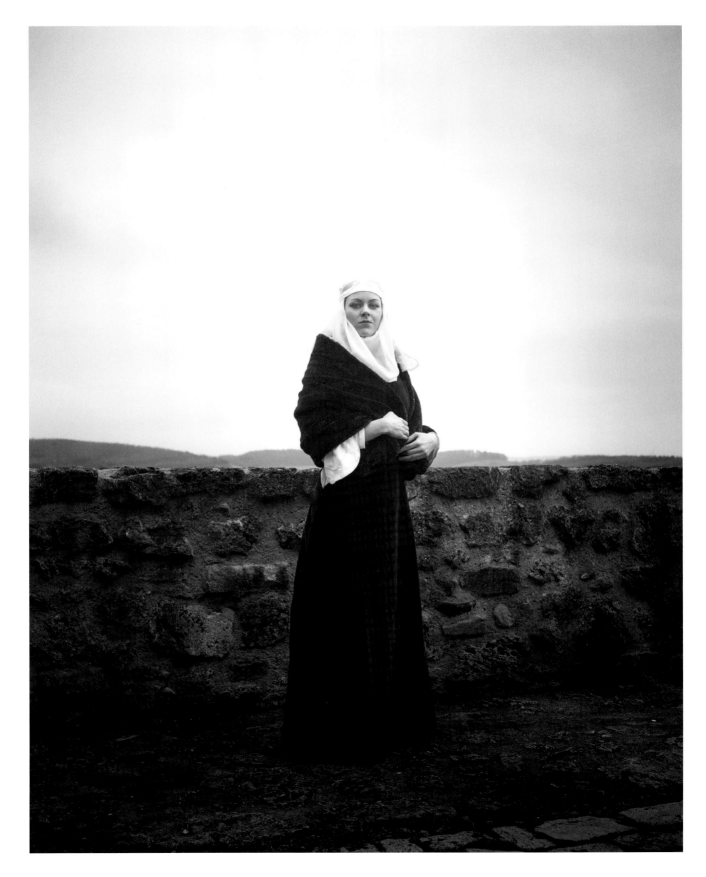

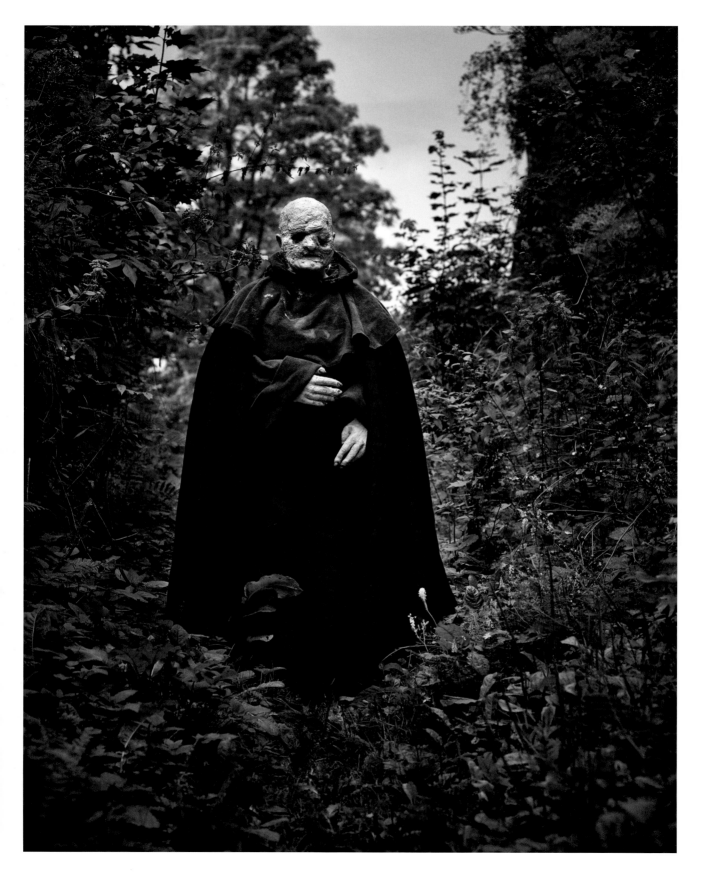

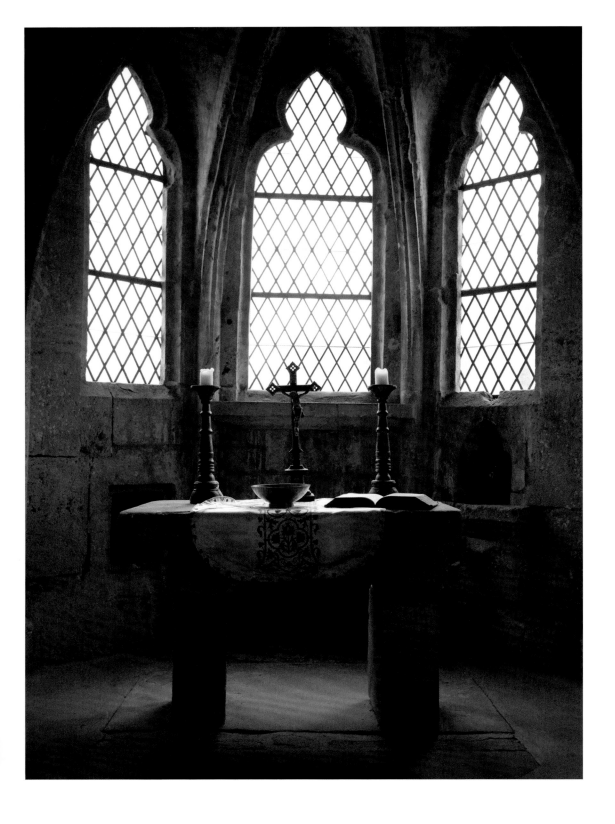

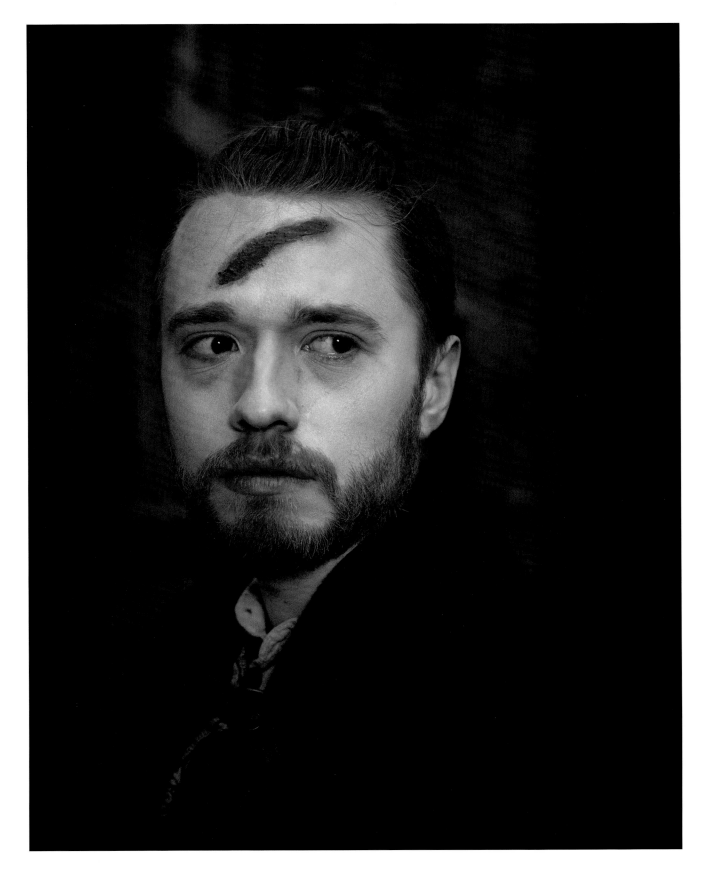

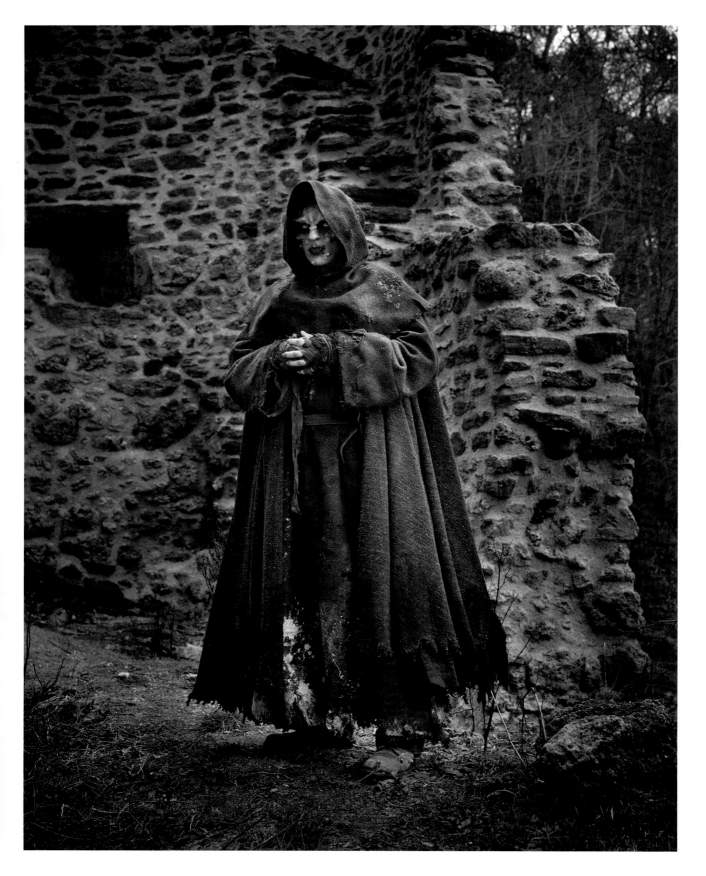

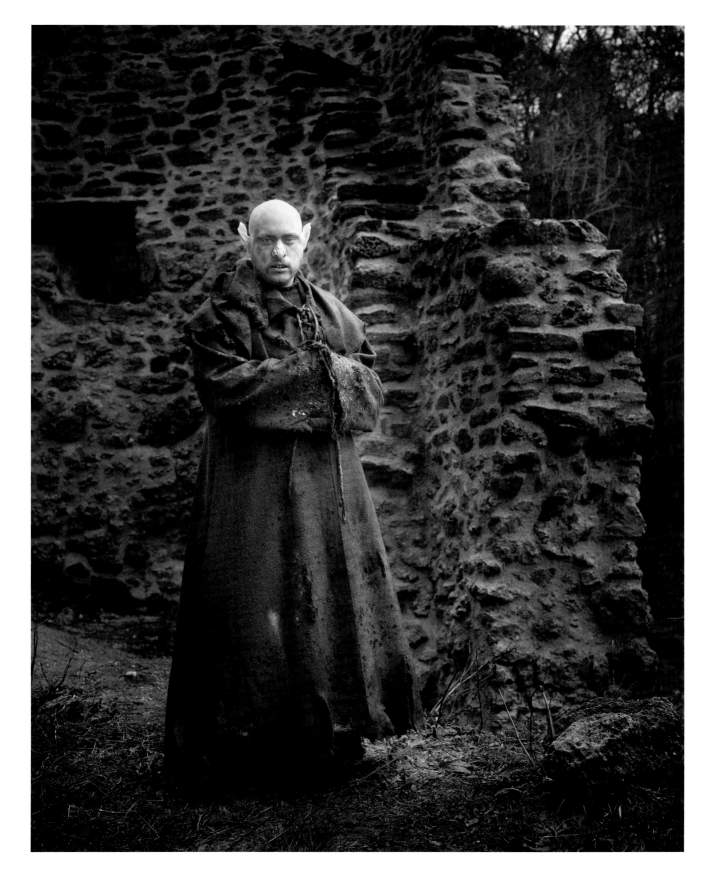

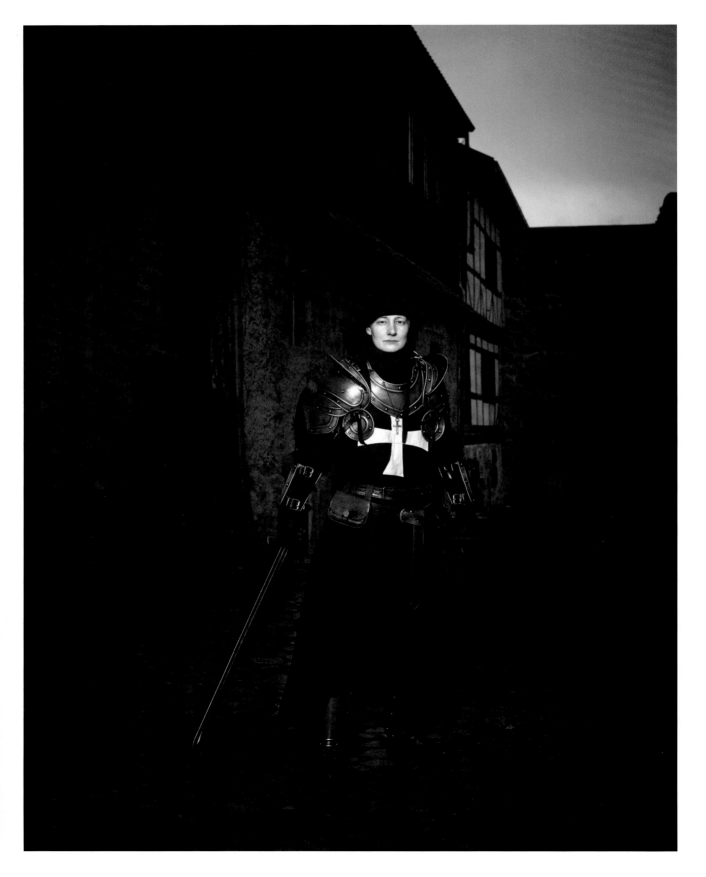

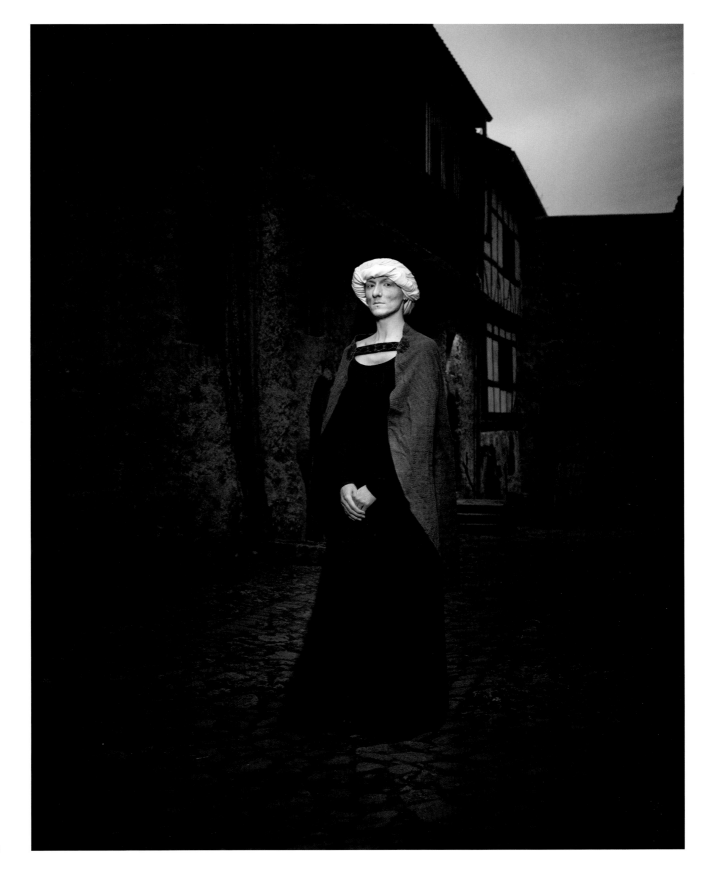

199
S./p.

Elisabeth von Köln – Ordensschwester und Priesterin der Asche, ein Neonat, ein Neugeborener, der die 100 Jahre seit seiner Schaffung noch nicht bzw. gerade so erreicht hat, vom Clan der Lasombra.

Elisabeth of Cologne – Nun and Priestess of the Ashes, a Neonate, a "newborn," who has not yet or just barely reached a hundred years since her creation; from the Lasombra clan.

200
S./p.

Felix – Neonat, Neugeborener vom Clan Nosferatu, ist mit seinem niederen Rang nicht zufrieden, hat sich das Ziel gesetzt, die Herrschenden und die Hohen Clans zu Fall zu bringen.

Felix – Neonate, a "newborn" from the Nosferatu clan, is not satisfied with his low rank and has set for himself the goal of bringing about the downfall of the rulers and the High Clans.

201
S./p.

Volker – Bruder von Felix, Ancilla (Diener) vom Clan der Nosferatu, stammt aus der Brut zu Köln und gehört mit Felix zu den Aktivsten im Clan.

Volker – Brother of Felix, Ancilla (servant) from the Nosferatu clan, comes from the Brood of Cologne and, together with Felix, is among the activists within the clan.

202
S./p.

Salome Weihs – Schülerin des Alchemisten und Kanzlers von Wipperfürth, Ludwig Lohenthal vom Clan der Ventrue, Clan der Kappadozianer, Domäne Wipperfürth.

Salome Weihs – Pupil of the alchemist and Chancellor of Wipperfürth, Ludwig Lohenthal of the Ventrue clan, Kappadozian clan, domain of Wipperfürth.

204
S./p.

Gereon von Rath – Ehemaliger Seneschall von Köln und Mitglied der Kölner Delegation, gehört zum Clan der Ventrue. Er hasst sich selbst für das, was er ist. Als Sterblicher war Gereon der Erstgeborene einer traditionsreichen Kölner Familie. Seine Familie stand schon in karolingischer Zeit an der Seite der herrschenden Erzbischöfe, ihre Geschichte reicht zurück bis in die Zeit Chlodwigs I.

Gereon von Rath – Former Seneschal of Cologne and member of the Cologne Delegation, Ventrue clan. He hates himself for what he is. As a mortal, Gereon was the firstborn of a long-established Cologne family. Already during the Carolingian period, his family stood at the side of the ruling archbishops; their history dates back to the time of Clovis I.

205
S./p.

Elena von Overbach – Seneschall von Siegburg, Clan der Toreador.

Elena von Overbach – Seneschal of Siegburg, Toreador clan.

206
S./p.

Agnes – Einfache Vasallin, Clan der Nosferatu.

Agnes – Simple vassal, Nosferatu clan.

207
S./p.

Kult- und Opferstätte – Wann hier das erste Blut vergossen wurde, ist unbekannt, es muss vor einer Ewigkeit gewesen sein.

Place of worship and sacrifice – When the first blood was shed here is unknown, but it must have been an eternity ago.

208
S./p.

Die Kanzel – Ort zur Verlesung wichtiger Schriftstücke, Pamphlete und Andachten.

The pulpit – Place for the reading of important writings, pamphlets, and devotions.

209
S./p.

Samuel Rubinstein – Diener des neuen Prinzen von Siegburg, Gideon, Clan der Malkavianer.

Samuel Rubinstein – Servant of the new Prince of Siegburg, Gideon, Malkavian clan.

212
S./p.

Bruder Marsilius – Mönch und Baumeister, Clan der Nosferatu.

Brother Marsilius – Monk and master builder, Nosferatu clan.

213
S./p.

Frater Julianus – Abt der Abtei St. Michael zu Siegburg, Ahnherr des Nosferatu-Clans.

Friar Julianus – Abbot of the Abbey of St. Michael in Siegburg, progenitor of the Nosferatu clan.

214
S./p.

Jonatha – Kind des Prinzen Ehrenfried zu Siegburg, Vogt der Domäne Siegburg, Clan der Ventrue.

Jonatha – Child of Prince Ehrenfried of Siegburg, bailiff of the domain of Siegburg, Ventrue clan.

215
S./p.

Irmgard – Vom Hof des Prinzen Ullrich, Clan der Malkavian.

Irmgard – From the court of Prince Ullrich, Malkavian clan.

In the early 2000s, "rainbow clouds" were spotted around the world and reports on "sky trumpets" (sound anomalies) published. In 2015, these phenomena grew in number, only to suddenly and completely disappear in May 2020.

Resistopia

Global Conflagration

One year later, on May 1, 2021 at 07:01 CET, civilian and military radar stations everywhere in the earth's ionosphere registered various unidentifiable signals, which appeared in irregular intervals and disappeared again after ten minutes. At 11:00 CET, global communication broke down and all power networks switched themselves off "autonomously." One hour later, at 12:11 CET, the orbital bombardment of the large metropolises and strategic hubs of our world began. The orbital fire continued for twelve hours, and 1.3 billion people died as a result of this global first strike.

A few hours later, the "rain of lights" began. This was the beginning of the invasion of the extraterrestrial power, which had in the meantime become known as Xenos. For three days and nights, green, comet-like lights fell from the sky across the entire planet – their "seekers," machine-like beings who killed everyone they found in the burning ruins of the cities or the hitherto untouched towns and villages.

After seven days and nights of cleansing, a further 900 million people fell victim to them. Then their spaceships came and the "animation" began. The bodies of countless deceased rose up with new vitality and an alien spirit. In this chaos, the survivors of the former nations combined their last resources and formed the Global Defense Army (GDA). With the most up-to-date military technology and well-trained soldiers, they hoped to bring a turnaround in this "War of the Worlds," but it was already too late...

The GDA had no chance. Within only four weeks, the Xenos took over dominion of our planet and killed more than ninety percent of the world population with their "Grand Cleansing." The remaining survivors fled to barely inhabited territories and strategically unimportant regions, forests, and mountains. It took nine full months marked by suffering and isolation (now known as the "Blackout") until the first secret paths of communication between the individual groups of survivors could be restored. And gradually the resistance took form.

Resistopia

Schon Anfang der 2000er-Jahre wurden auf der ganzen Welt immer wieder sogenannte „Rainbow Clouds" gesichtet und Berichte über „Sky Trumpets" (dt. Geräuschanomalien) veröffentlicht. Diese Phänomene häuften sich ab 2015 enorm, bis sie im Mai 2020 plötzlich vollständig verschwanden.

Weltenbrand

Ein Jahr später, am 1. Mai 2021 um 07:01 MEZ, wurden von zivilen und militärischen Radarstationen überall in der Ionosphäre der Erde verschiedene nicht zu identifizierende Signale aufgezeichnet, die in unregelmäßigen Abständen auftauchten und allesamt nach zehn Minuten wieder verschwanden. Gegen 11:00 MEZ brach plötzlich die weltweite Kommunikation zusammen und sämtliche Stromnetze schalteten sich nach und nach „selbstständig" ab. Eine Stunde später, um 12:11 MEZ, begann das orbitale Bombardement auf die großen Metropolen und strategischen Knotenpunkte unserer Welt. Das orbitale Feuer hielt zwölf Stunden lang an und 1,3 Milliarden Menschen starben bei diesem globalen Erstschlag.

Wenige Stunden später begann der „Lichterregen". So startete die Invasion der außerirdischen Macht, die inzwischen „Xenos" genannt wurde. Drei Tage und Nächte fielen überall auf der Erde grüne, kometenartige Lichter vom Himmel, ihre „Sucher", maschinenartige Wesen, die jeden töteten, den sie in den brennenden Ruinen der Städte oder den bisher unberührten Kleinstädten und Dörfern fanden.

Nach sieben Tagen und Nächten der Säuberung waren ihnen weitere 900 Millionen Menschen zum Opfer gefallen. Dann kamen ihre Schiffe und es begann die „Beseelung". Die Körper der unzähligen Toten erhoben sich mit neuer Kraft und fremdem Geist. Gemeinsam formten die Reste der ehemaligen Nationen in diesem Chaos mit ihren letzten Ressourcen die „Global Defence Army", kurz GDA. Mit neuester militärischer Technologie und gut ausgebildeten Soldaten sollten sie die Wende in diesem „Weltenkrieg" bringen, doch es war zu spät…

Die GDA hatte keine Chance. Innerhalb von nur vier Wochen übernahmen die „Xenos" die Herrschaft über unseren Planeten und töteten bei der „Großen Säuberung" über 90 Prozent der Weltbevölkerung. Die restlichen Überlebenden flüchteten sich in kaum bewohnte Gegenden und strategisch unwichtige Regionen, Wälder und Berge. Es brauchte ganze neun Monate (inzwischen als

And now...

It is 2024, and the battle continues. Today, most of the remaining civilians live in small enclaves in the nowhere of sparsely populated areas or deeply secluded in the underground systems of the former civilization. The Resistance, consisting of tough survivors and the remaining members of the old armies, has combined forces to fight against the Xenos. "We are organized in the underground and have established paths of communication and a chain of command. Humankind continues to be threatened by complete extinction. But we fight on, for WE are the Resistance."

„Blackout" bekannt) voller Leid und Isolation, bis die ersten geheimen Kommunikationswege zwischen einzelnen Gruppen von Überlebenden wieder hergestellt werden konnten. Und langsam formte sich der Widerstand.

Und jetzt...

Wir schreiben inzwischen das Jahr 2024 und der Kampf geht weiter. Heute leben die meisten verbliebenen Zivilisten in kleinen Enklaven im Nirgendwo dünn besiedelter Landstriche oder tief versteckt in den unterirdischen Systemen der ehemaligen Zivilisation. Die „Resistance", bestehend aus zähen Überlebenden und den Resten der alten Armeen, hat sich zusammengeschlossen, um gegen die „Xenos" zu kämpfen. „Wir sind im Untergrund organisiert und haben Kommunikationswege und eine Kommandostruktur etabliert. Die Menschheit steht auch weiterhin kurz vor ihrer kompletten Auslöschung. Doch wir kämpfen weiter, denn WIR sind der Widerstand."

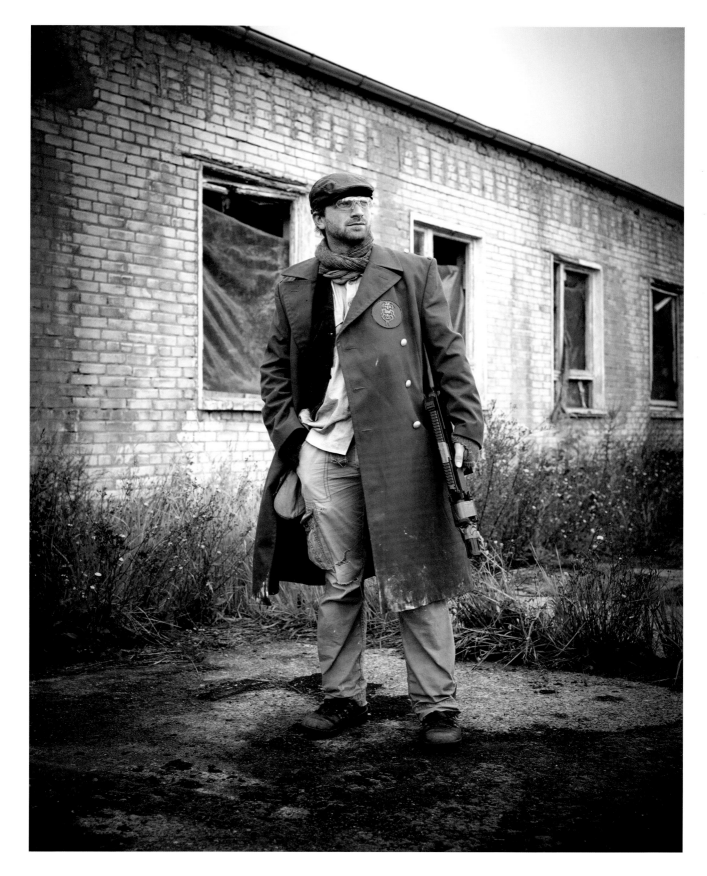

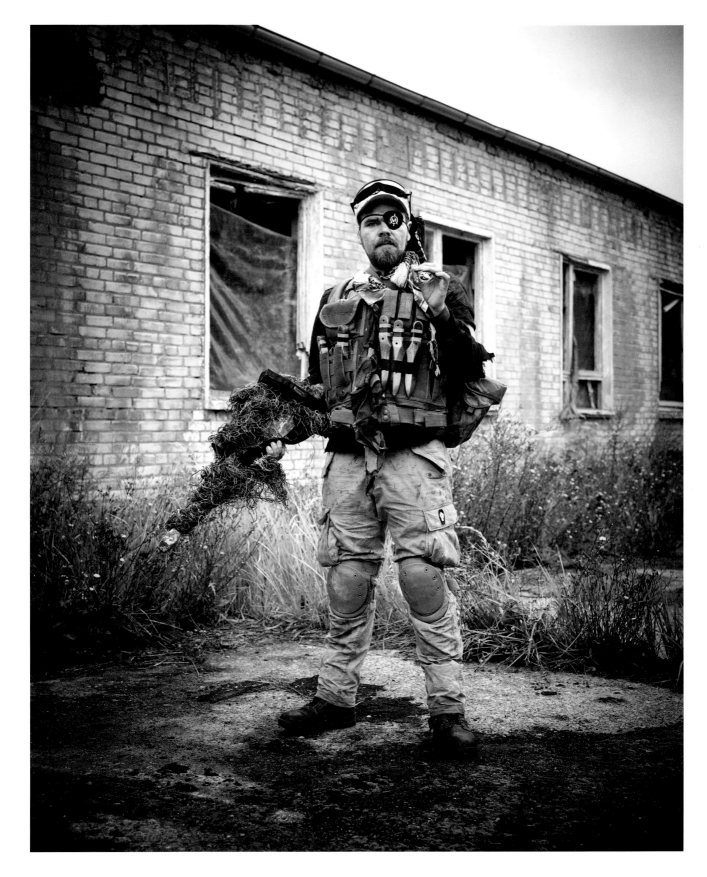

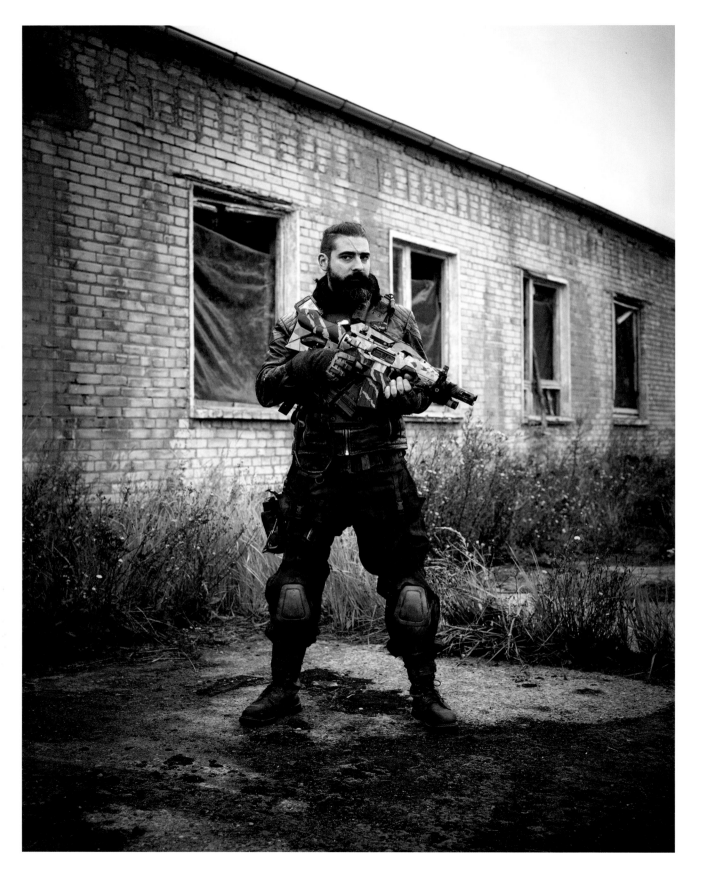

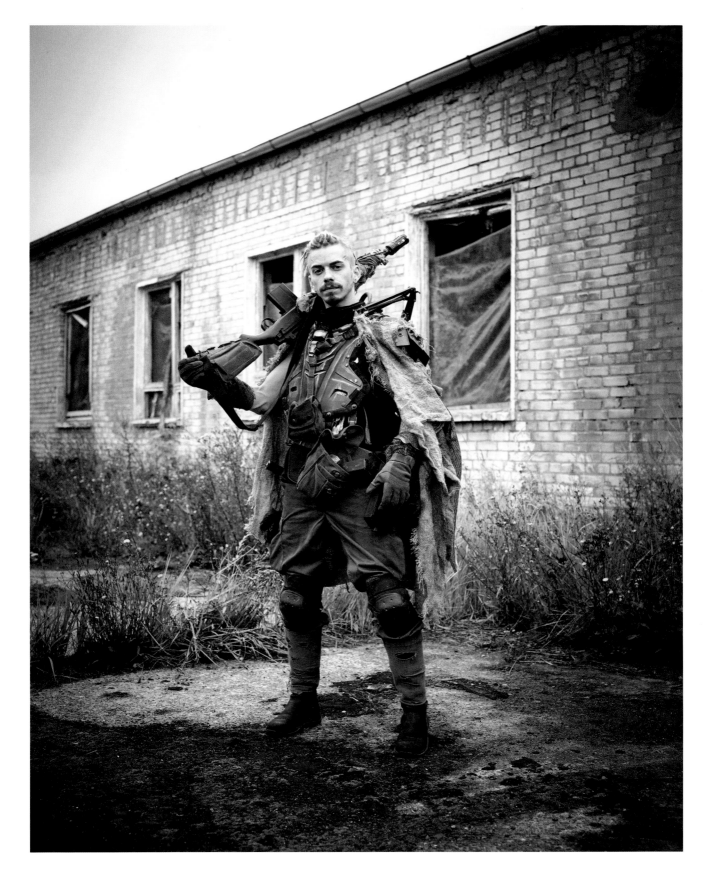

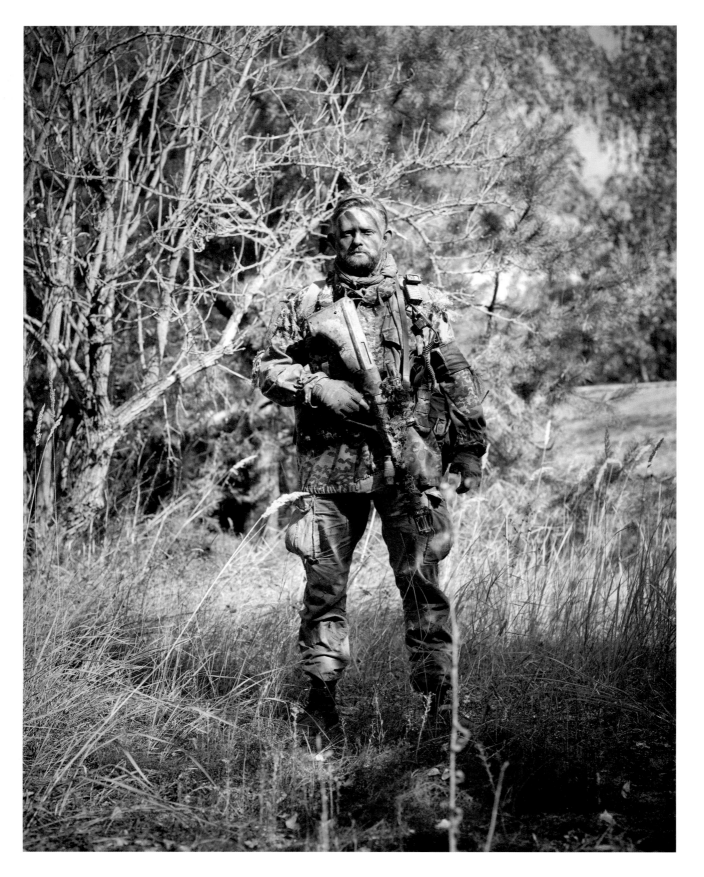

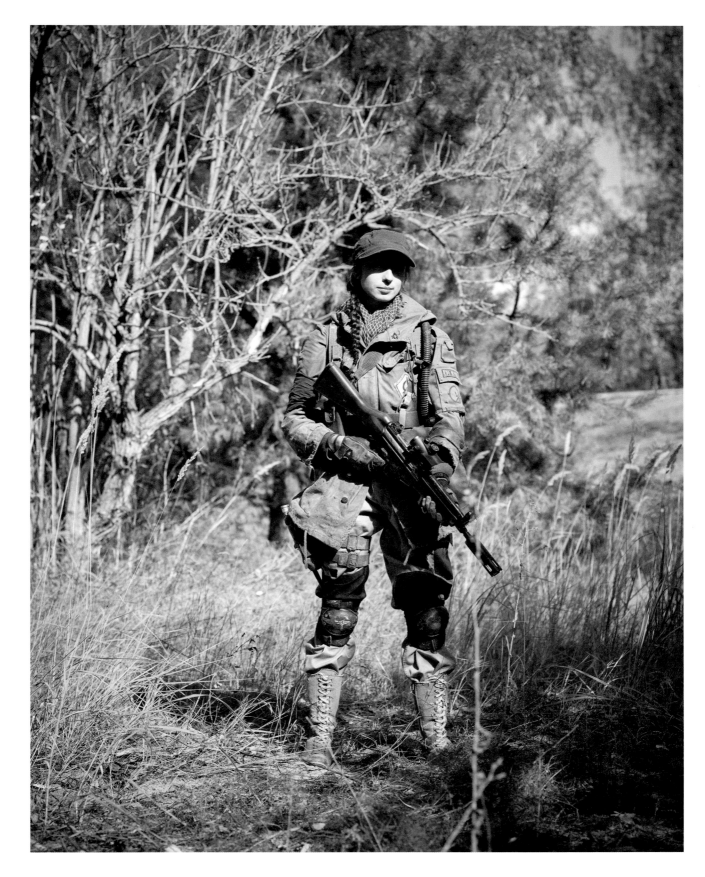

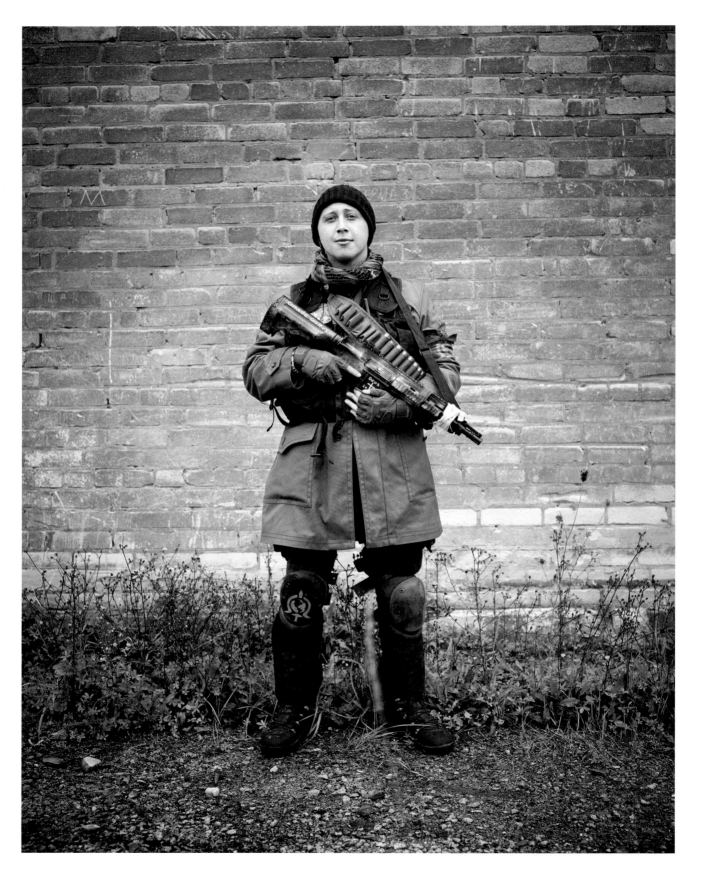

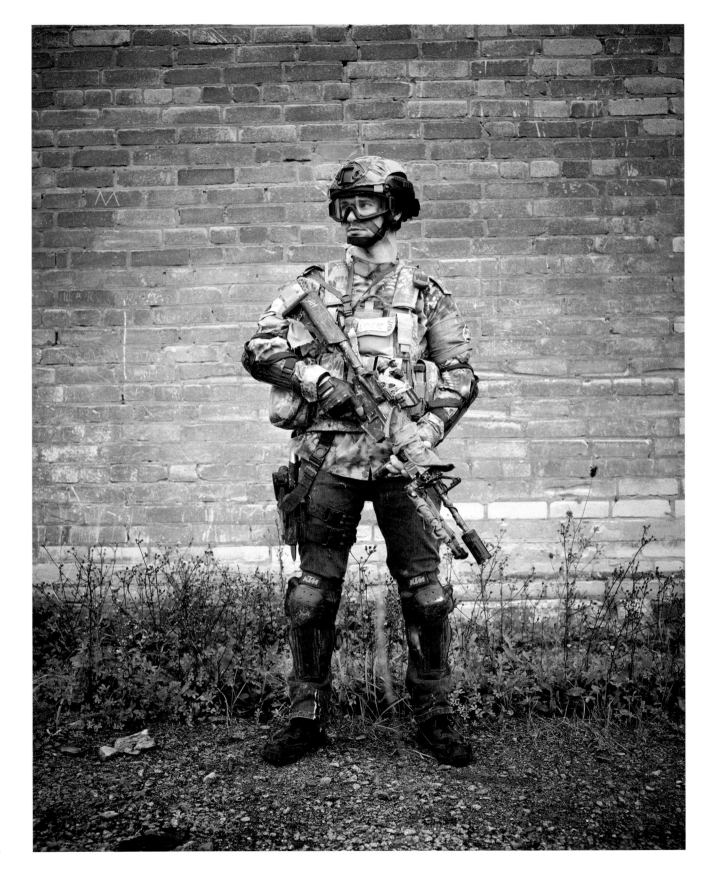

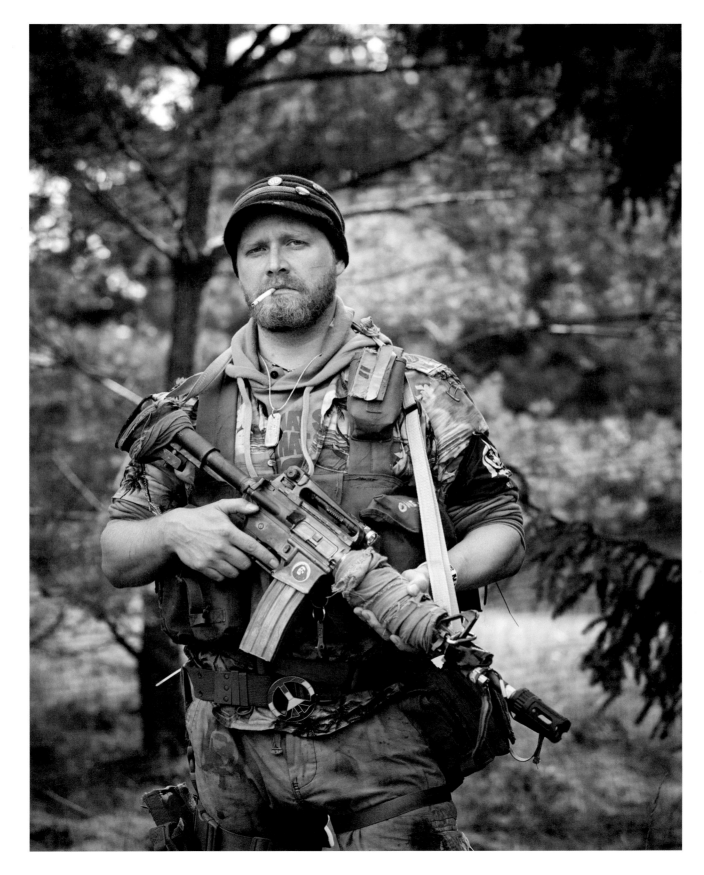

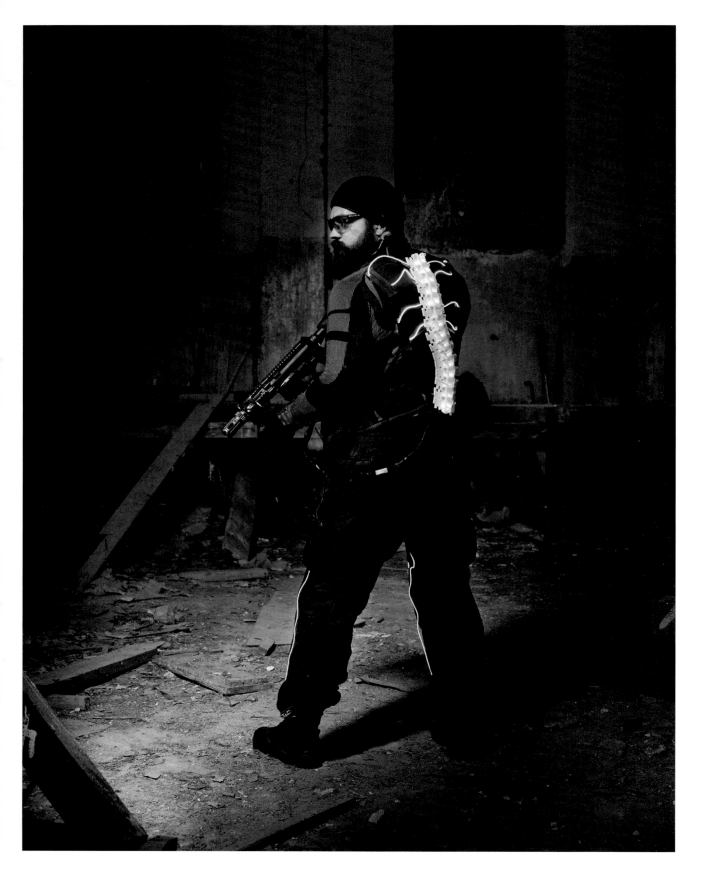

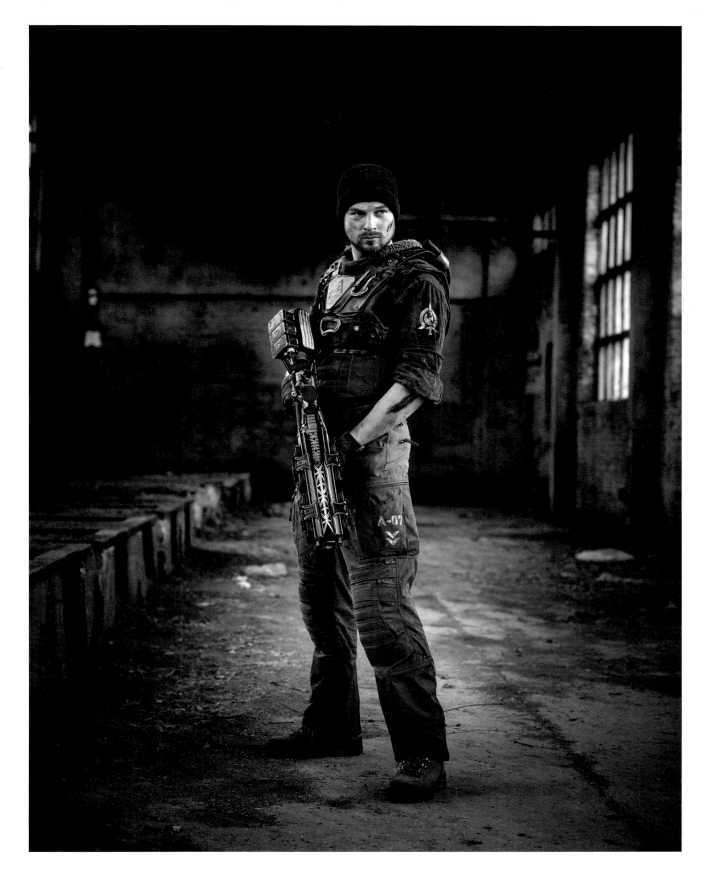

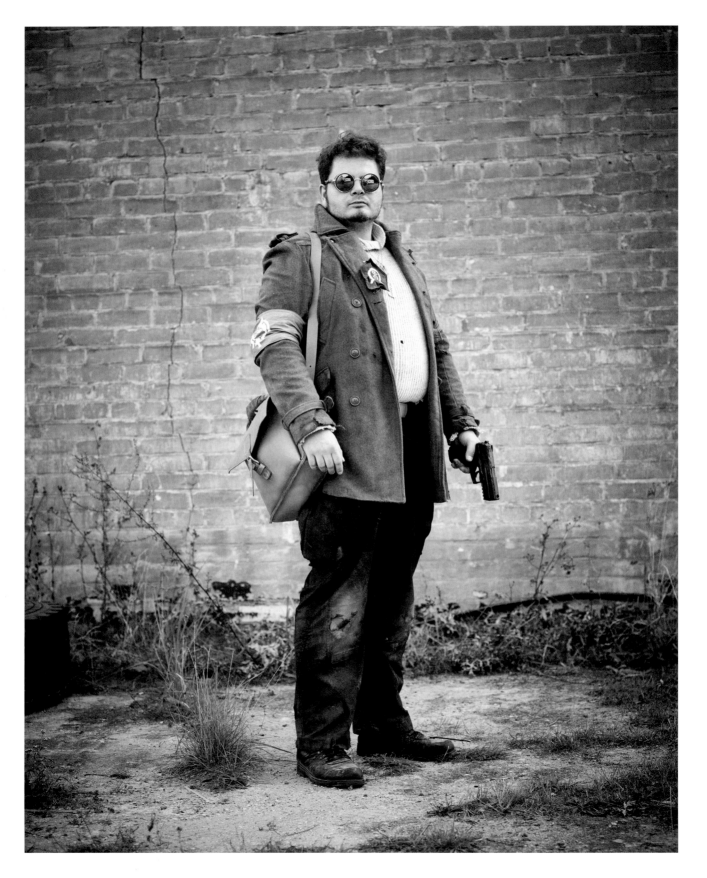

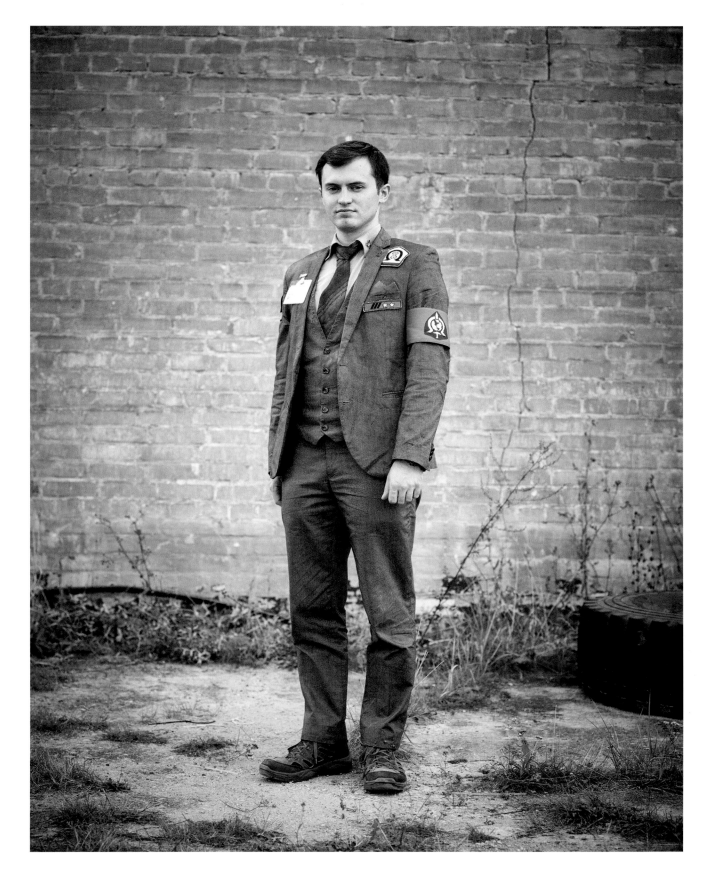

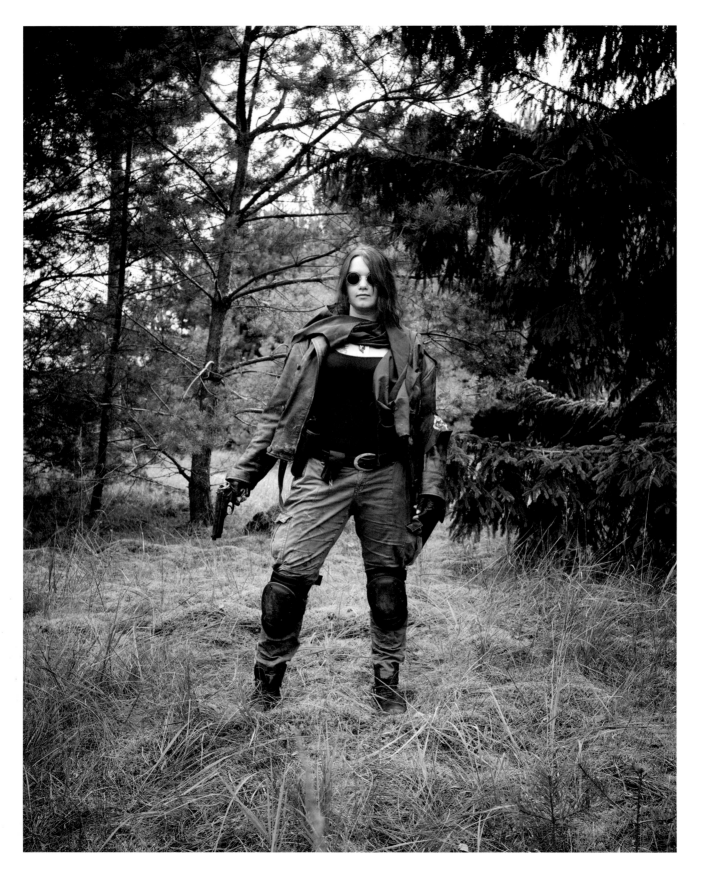

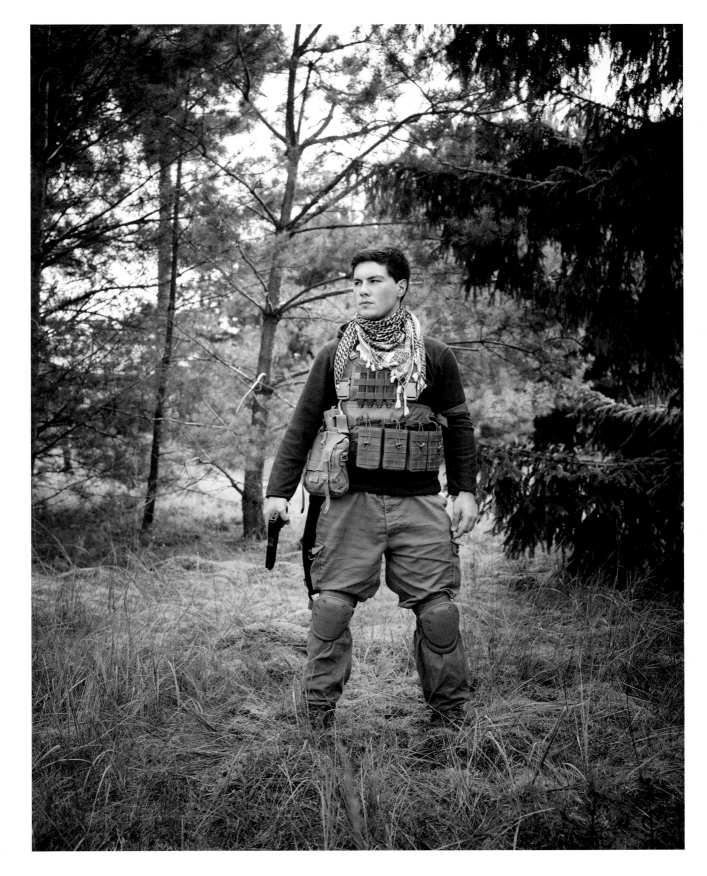

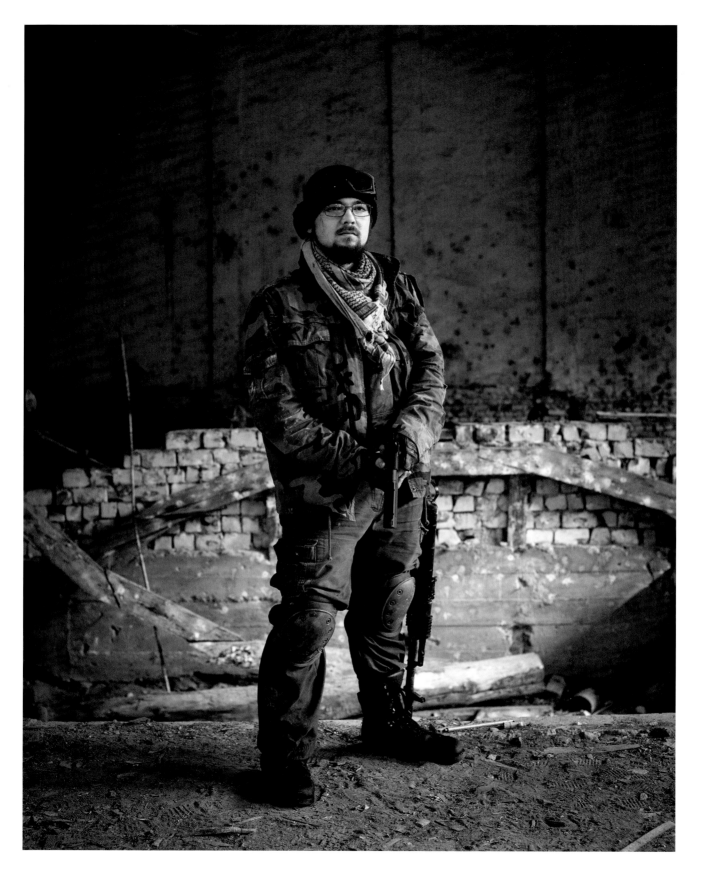

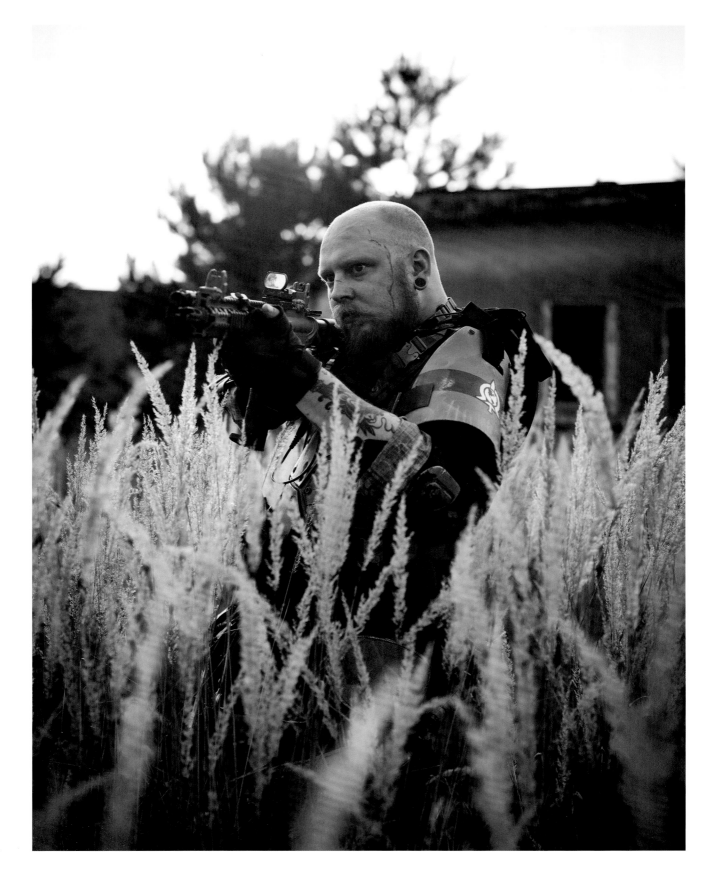

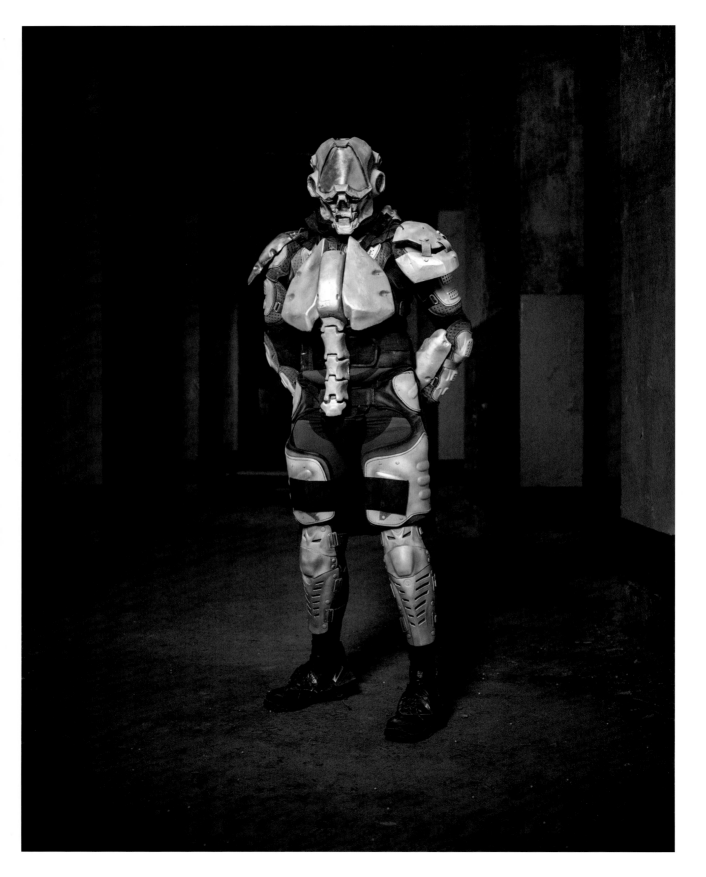

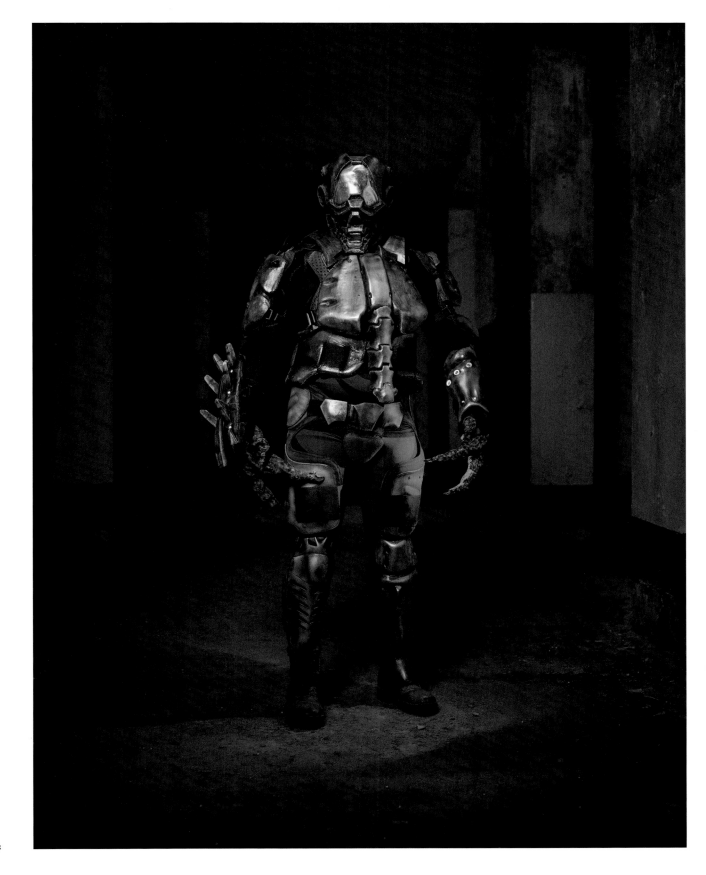

223
S./p.

Billy alias Timmy – Handelt mit diversen Gütern und Meth von bester Güte und Reinheit, gehört zu den Roaches.

Billy alias Timmy – Deals with various goods, as well as with meth of the finest quality and purity; belongs to the Roaches.

225
S./p.

Robert E. Lee Barnes – Späher und Nahkampfspezialist bei den Angry Beards.

Robert E. Lee Barnes – Scout and close-combat specialist with the Angry Beards.

226
S./p.

Claud – Sergeant Specialist MK II und Anführer der Angry Beards. Trägt eine eigens für ihn modifizierte Version eines Plattenträgers, ebenso gehört ein Flachmann mit Schnaps zur Standardausrüstung der Angry Beards.

Claud – Special Sergeant MK II and leader of the Angry Beards; wears a version of a plate carrier modified especially for him. The standard equipment of the Angry Beards also includes a flask with hard liquor.

227
S./p.

Corporal Richter – Korporal bei den Angry Beards, Vorname ist nicht bekannt, noch gibt es genaue Infos zu seiner Identität.

Corporal Richter – Corporal with the Angry Beards; his first name is not known, and there is no precise information on his identity.

228
S./p.

Sepp Gruber – Korporal, einziger Überlebender der Widerstandsgruppe „Fireflys", stammt aus Tirol und bekämpft die Aliens mit größtem Hass.

Sepp Gruber – Corporal, sole survivor of the resistance group known as the „Fireflys"; comes from Tyrol and fights against the aliens with the greatest rancor.

229
S./p.

Amy Foster alias „Bambi" – Feldforscherin bei dem Kampftrupp „Fireflys", stammt aus dem Großraum Nürnberg, hat irische Wurzeln und ist inzwischen verstorben.

Amy Foster alias "Bambi" – Field researcher with the „Fireflys" combat troop; comes from greater Nuremberg, has Irish roots, and has since died.

230
S./p.

Sebastian „Pray" Paulsen – Dienstrang: Sergeant MK2, gehört der Gruppe „Die Allianz" an und ist dort Truppführer, stammt aus Nürnberg, Stützpunkt „Noris 3".

Sebastian "Pray" Paulsen – Rank: Sergeant MK2; belongs to the group known as the Alliance, where he is squad leader; comes from Nuremberg; Base Noris 3.

231
S./p.

Mathew Walker – Berufssoldat und Korporal bei den Angry Beards, amerikanischer Herkunft, war jedoch vor der Invasion deutscher Staatsbürger.

Mathew Walker – Career soldier and corporal with the Angry Beards; comes from America but was a German citizen before the invasion.

232
S./p.

Plan des Kampfgebietes um die B13

Map of the combat zone around B13

233
S./p.

Jonathan-Felix Mayer – (Callsign: Rainbow) – Widerstandskämpfer MK2, Physiotherapie und Begleitschutz, Search & Rescue Einheit „S21".

Jonathan-Felix Mayer – (call sign: Rainbow) – Resistance Fighter MK2, physiotherapist and escort, search & rescue unit S21.

234
S./p.

Experimentelle Waffe 003 – Fake Prime Einheit, Teil des Alien-Kollektivs, NSC Charakter.

Experimental weapon 003 – Fake prime unit, part of the Alien Collective, NSC character.

235
S./p.

Eugen „Jay" Schwab – Feldwebel Mark III, Spezialist, Truppenführer, Aufgabe: Höhere technische Operationen im Felde, Rufsignal: Snapping Turtle.

Eugen "Jay" Schwab – Specialist Sergeant Mark III, Troop Leader, job: Advanced Technical Field Operations, group name / callsign: Snapping Turtle.

236
S./p.

Dr. Herbert Gruber – Selbsternannter Parawissenschaftler und Parahistoriker, offiziell eingestellt als Psychologe in der Forschungsabteilung des Stützpunkts B13, im Einsatz verstorben.

Dr. Herbert Gruber – Self-proclaimed para-scientist and para-historian, officially psychologist in the research department of the base B13; died while on a mission.

237
S./p.

Dr. Manfred Gehring – Xenopathologe und Leiter des Forschungslabors auf dem Stützpunkt des Clusters „Berlin 13".

Dr. Manfred Gehring – Xeno-pathologist and head of the research laboratory at the base of the cluster Berlin 13.

238
S./p.

Dr. Katrin Traum – „Rorschach" – Psychologin, Medic in Ausbildung, Rang: RF Mark 2, Trupp: S21, SAR-5, 30 Jahre alt.

Dr. Katrin Traum – "Rorschach" – Psychologist, medic in training; rank: RF Mark 2; troop: S21, SAR-5; 30 years old.

239
S./p.

Jes Berg – Musste seine Ausbildung zum technischen Zeichner aufgrund der Alien-Invasion abbrechen, er ist 20 Jahre alt und stammt aus Lippstadt in Westfalen. Bis auf seinen Stiefbruder, Heinrich Berg, wurde seine ganze Familie ausgelöscht. Zurzeit erhält er beim Core eine Ausbildung zum Sanitäter.

Jes Berg – Was forced to abandon his training as a technical draftsman because of the alien invasion; he is twenty years old and comes from Lippstadt in Westphalia. With the exception of his stepbrother, Heinrich Berg, his entire family was wiped out. He is currently receiving Core training as a medical orderly.

240
S./p.

Ein FAKE – Von einem Alien-Parasiten besetzter toter Menschenkörper. Kämpft als Soldat in der Alien-Armee der Grey gegen die Menschheit.

A FAKE – The body of a deceased human occupied by an alien parasite. He fights against humanity as a soldier in the alien army of the Greys.

241
S./p.

Kjel „Arclight" Larsson – Commander der B13, ehemaliges Mitglied der „Deathwatch" Exo Einheit, aufgewachsen in Ostfold (Norwegen), 34 Jahre alt.

Kjel "Arclight" Larsson – Commander of B13; former member of the "Deathwatch" Exo unit; raised in Ostfold (Norway), 34 years old.

242
S./p.

Grey Soldat – Mitglied der Soldatenkaste im Xenos-Kollektiv mit nahezu undurchdringlicher Rüstung, tödlichen Plasmawaffen und „Boss-Enemy"-Verhalten.

Grey Soldier – Member of the soldier caste in the Xenos Collective with nearly impenetrable armor, lethal plasma weapons, and "boss enemy" behavior.

243
S./p.

Grey Commander – Einer der Befehlshaber aus dem Xenos-Kollektiv. Als Schaltstelle in der Vernichtungsmaschinerie gegen die Menschheit stellt der Commander den personifizierten Tod auf dem Schlachtfeld dar.

Grey Commander – One of the commanders of the Xenos Collective. As a key figure in the extermination machinery against humanity, the commander personifies death on the battlefield.

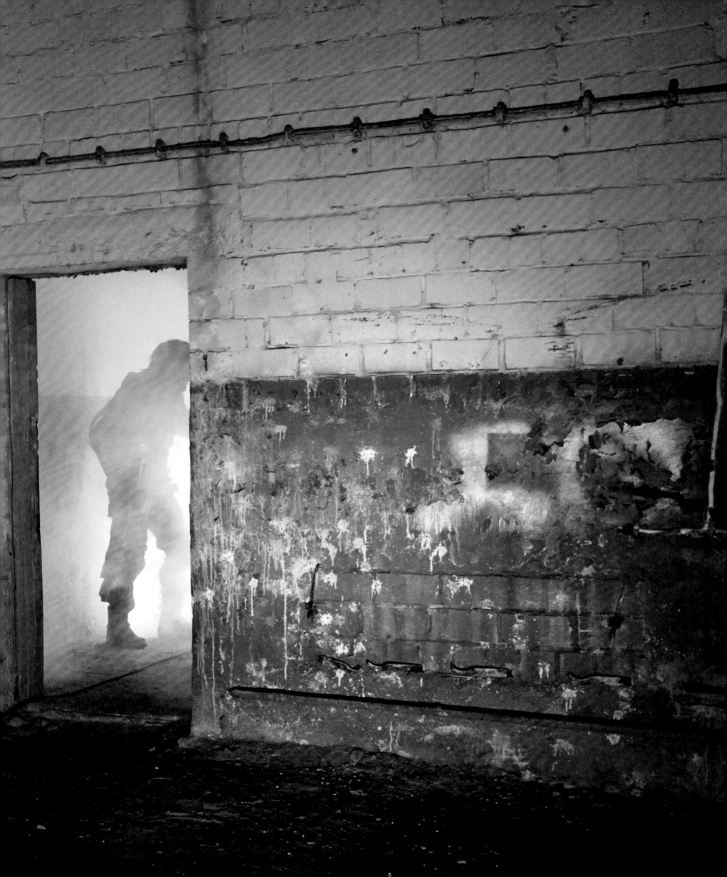

I would like to extend my gratitude to all live role-players around the world, especially to those who stood in front of my camera. You have inspired me! Thanks to the Legende LARP ORGA / Akira Weikert and Chris Krieger; applause for Tortuga Die Legende! Thanks to Stefan Gross, my first supporter. Thanks to LOST IDEAS for the three great campaigns FATE, Zombie Apocalypse, and Resistopia – I always felt welcome in Mahlwinkel! Thanks to EPIC EMPIRES Event UG; yes – that was indeed epic! Thanks to Ramona Rittman and Sebastian of Novum Castrum – I met many pleasant vampires at the Tannenburg castle! Thanks to Sayo, Toni, Bodo, Andrea, and Mike of the Great Show in Fred Rai City – great setting, great characters, great show!

Many thanks to all of you at Kehrer Verlag. It was truly a pleasure to work together with you! Thank you very much for your faith in this book.

Thanks to Richard Garriott de Cayeux for his great words and values. You have contributed something truly special to this book!

Thanks to Jakob Wagner for his support in Fred Rai City and his enthusiastic words about the LARP project. Thanks to Frank van Groen for making his lighting equipment available to me on numerous occasions, as well as for his belief in me and my work! And a very big thank you to Christoph Mauerer for his trust.

Last but not least, I wish to express my great appreciation to PHASE ONE Germany. Thank you for supporting me with your fantastic camera system! It made all the difference!

Dedication

This is my first book and part of an ongoing dream that began many years ago, and it means a great deal to me. I would thus like to dedicate this book to all the people who gave me their trust, their recognition, and the strength to follow and realize my dream. I would like to take this opportunity to extend my heartfelt gratitude to Darja Gontscharov. Thank you for your time, your energy, and your love! You mean everything to me! I would also like to dedicate this book to Jürgen Lachera, who taught me how to ride a bicycle and has given me so much more as well. You are my Heumann! Finally, I also dedicate this book to my mother, because she was such a wonderful person and raised me with so much love. I love you, Mama!

·· **Dank** ··

Ich möchte mich bei allen Live-Rollenspielern auf der Welt bedanken, vor allem bei denen, die vor meiner Kamera standen. Ihr habt mich begeistert! Danke an Legende-LARP-ORGA... Akira Weikert und Chris Krieger, Applaus für Tortuga die Legende! Danke an Stefan Gross, meinen ersten Unterstützer. Danke an LOST IDEAS für die drei großartigen Kampagnen FATE, Zombie Apokalypse und Resistopia, ich habe mich immer willkommen gefühlt in Mahlwinkel! Danke an EPIC EMPIRES Event UG, ja – das war episch! Danke an Ramona Rittman und Sebastian von Novum Castrum, ich habe viele nette Vampire auf der Tannenburg getroffen! Danke an Sayo, Toni, Bodo, Andrea und Mike von The Great Show in Fred-Rai-City, großartige Kulisse, großartige Charaktere, großartige Show!

Vielen Dank an euch alle beim Kehrer Verlag, es war wirklich eine Freude, mit euch zu arbeiten! Vielen Dank für euer Vertrauen in dieses Buch.

Danke an Richard Garriott de Cayeux für seine großartigen Worte und Werte. Du hast diesem Buch wirklich etwas Besonderes hinzugefügt!

Danke an Jakob Wagner für seine Unterstützung in Fred-Rai-City und seine begeisterten Worte über dieses LARP-Projekt. Danke an Frank van Groen, der mir seine Licht-Ausrüstung viele Male zur Verfügung gestellt hat, für seinen Glauben an mich und meine Arbeit! Ebenfalls ein ganz dickes Dankeschön an Christoph Maurer für sein Vertrauen.

Am Schluss möchte ich noch ein besonders großes Dankeschön an PHASE ONE Germany aussprechen. Danke für die Unterstützung mit euren fantastischen Kamerasystemen! Es hat den Unterschied gemacht!

Widmung

Dies ist mein erstes Buch und Teil eines andauernden Traums, den ich bereits seit vielen Jahren habe, und es bedeutet mir sehr viel. Daher möchte ich dieses Buch all den Menschen widmen, die mir ihr Vertrauen, ihre Anerkennung und Kraft gegeben haben, meinen Traum weiter zu verfolgen und zu verwirklichen. Insbesondere und von ganzem Herzen möchte ich an dieser Stelle Darja Gontscharov danken. Danke für deine Zeit, deine Energie und deine Liebe! Du bedeutest mir alles! Auch möchte ich dieses Buch Jürgen Lachera widmen, der mir das Radfahren beigebracht hat und mir noch so viel mehr gegeben hat. Du bist mein Heumann! Nicht minder widme ich dieses Buch meiner Mutter dafür, dass sie so ein guter Mensch war und mich mit so viel Liebe aufgezogen hat, ich liebe dich, Mama!

© 2018 Kehrer Verlag Heidelberg Berlin,
Boris Leist und Autoren / and authors

Definition S. 3 / Definition p. 3	Wikipedia. Die freie Enzyklopädie. (Hg.) und Autoren. Wikipedia. The Free Encyclopedia. (Ed.) and authors.
Vorwort / Preface	Richard Garriott de Cayeux
Texte / Texts	Tortuga die Legende: Legende Orga e. V.; The Great Show – Fred-Rai-City: Christoph Schmid / Atakanies LARP e. V. – The Daltons / Westernorga; F.A.T.E, Zombie Apocalypse, Resistopia: Lost-ideas; Epic Empires: EPIC EMPIRES e. V.; Novum Castrum: Ramona Rittman, Sebastian Stabroth
Verlagslektorat / Copy Editing	Tom Grace, Petra Joswig, Heide Sommer
Übersetzungen / Translations	Gérard A. Goodrow, Alexandra Titze-Grabec
Gestaltung / Design	Kehrer Design Heidelberg (Aurel Fischer, Loreen Lampe)
Bildbearbeitung / Image Processing	Kehrer Design Heidelberg (Patrick Horn)
Gesamtherstellung / Production	Kehrer Design Heidelberg

Printed and bound in Germany
ISBN 978-3-86828-739-4

 Kehrer Heidelberg Berlin
www.kehrerverlag.com